Medieval Ivories and Works of Art

THE THOMSON COLLECTION
AT THE ART GALLERY OF ONTARIO

Medieval Ivories and Works of Art

THE THOMSON COLLECTION
AT THE ART GALLERY OF ONTARIO

John Lowden and John Cherry

SKYLET PUBLISHING /
THE ART GALLERY OF ONTARIO

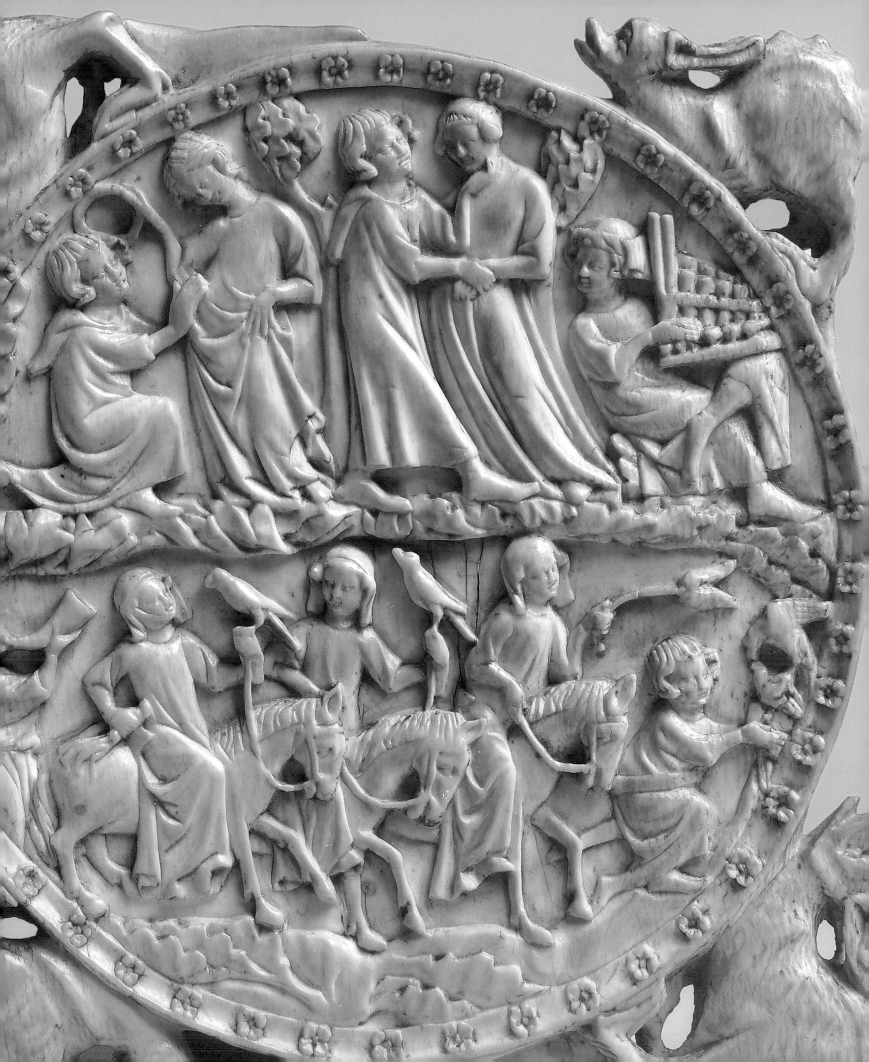

Contents

Foreword

KENNETH ROY THOMSON, 2nd Baron Thomson of Fleet, or Ken as we all knew him, was an extraordinary human being. He built upon his father's legacy to construct one of the most successful global business empires. He amassed with an ever-growing passion what is undoubtedly the finest collection of art ever in private hands in Canada. He was the catalyst for and the enabler of Transformation AGO, and he still retained the common touch. Ken derived great joy from his interaction with people from all walks of life – whether pointing out to total strangers intriguing bargains at the local Loblaws, or sending a photograph (perhaps not of museum quality) he had taken of you with his basic camera at an event the night before.

At a lunch following a TD board meeting after Ken flipped one of his brightly coloured signature ties over his shoulder to avoid attracting the soup of the day, I asked him how he became interested in art. He began seriously collecting in 1953 when he spotted two miniature ivory busts in a Bournemouth antique shop. Shortly thereafter, Ken became excited by the prospect of acquiring an exquisite boxwood figure and was admonished by his advising dealer: "You must not look like that when you see it. You must control yourself and look very solemn. You will put the price up with enthusiasm like that." Ken took the advice to heart, but it was an enduring struggle to restrain his natural enthusiasm for marvellous works of art.

Over the years, Ken developed an ever more discerning and refined eye, but his guiding rule in acquiring art was, "If your heart is beating,

you know it was made for you." I remember Ken confessing that, while assembling his collection, he viewed the Art Gallery of Ontario as a competitor but, as time passed, he came to envisage the AGO as the ideal vehicle for keeping the collection intact and exhibiting it to the people of Canada so that they could experience the same pleasure as he did from his art. "It might make people see and enjoy objects previously unfamiliar to them.... It might open up their horizons. I do not see how you can walk past these beautiful objects, look at them, and not see the glory of art and its creation." Accordingly, Ken determined to donate his unsurpassed collection and to work with Matthew Teitelbaum and Frank Gehry to transform the Art Gallery of Ontario.

Ken wanted the works displayed in an atmosphere where the viewer could feel "at home." At one time, he contemplated music in the galleries, and he liked the idea of a series of rooms that led one into the other so that people could walk through "chapters" of his collection.

Ken remained intimately engaged in the Gehry project to the end. He continued to purchase works of art to enhance the quality of the Thomson Collection and with exceeding generosity took steps time after time to encourage the realization of Transformation AGO at the highest level. I remember Ken leaning over at a curatorial discussion of the David Milne exhibition in 2005 and saying, "I don't want to jinx it, Charlie, but I think our project is going to be the best." That seemed appropriate, because everything about Ken Thomson was the best.

A. CHARLES BAILLIE, O.C.
PRESIDENT, ART GALLERY OF ONTARIO

Introduction

MY FATHER COMMUNED WITH OBJECTS. The journey lasted a lifetime. The pursuit was manic and often solitary. My father channelled his energies and unravelled passions that allowed him a solace few could possibly comprehend. Deep friendships developed around this journey of perception and discovery. The facets seemed endless and were reflected. The legacy was a collection of objects that defied linear logic.

Some collectors derive pleasure from the status of ownership; others sustain interest through economic motives. The inherent value of an artwork is gauged by the heart. Experience is often visceral and radiates to one's core. The journey of an art collector is compelled by complex internal forces, from melancholy to wonderment.

My father's course evolved over the years and interactions around art became the barometer of life. He would extract the deepest pleasure from human companionship; artists, collectors, dealers, researchers and any soul with whom he might share his enthusiasm were enlisted for their visceral response to Group of Seven sketches or a Gothic diptych. My father's letters attest to the profound role of communication in his daily life. The art often turned out to be incidental to the friendships that lasted a lifetime. In all spheres the essence of my father's spirit was immersed within the act of consideration, rather than the prospect of possession. The formations of these collections represent a lifetime's journey inspired by the human condition.

The objects within the various collections remain tangible evidence of an immense ambition around the visual experience. My father followed his innermost convictions and had the courage to press his feelings. In some instances, he stood alone as a precursor to the subject or established new thresholds of value. The dogged determination drew the admiration of friends and foes alike, as primal competitive instincts emerged from this gentle soul. My life with father in this realm created a unique bond between us. The human spirit was constantly engaged in all its myriad of shapes and forms. The imprint was quite extraordinary, as the journey became an exploration of the human condition. Father's curiosity seemed insatiable and the objects were conductors through which the widest spectrum of human spirit coursed. The pursuit of art allowed father to make sense of the world and celebrate life in all its resplendent forms.

DAVID THOMSON

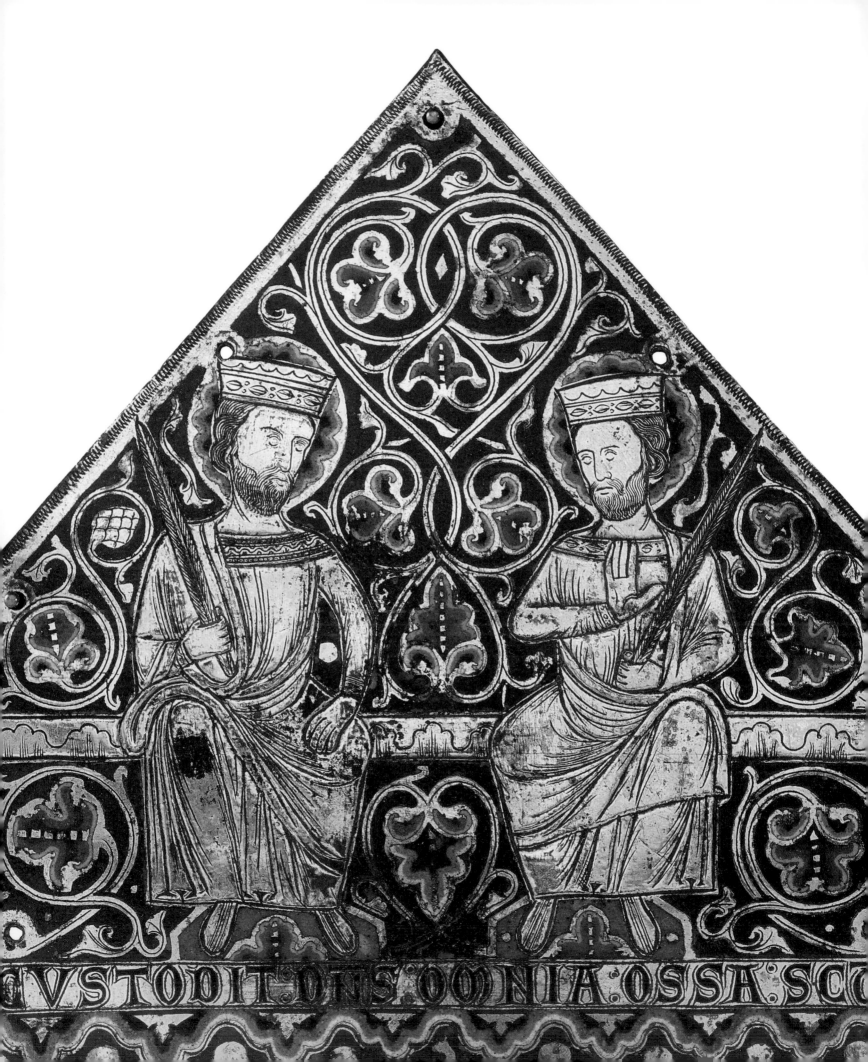

Byzantine and Romanesque

Byzantine triptych wings

Constantinople, c. 950–75
Height 174.5 mm, width (each panel) 60.1 mm,
(together) 120.4 mm, depth 8 mm;
weight 75 and 83 g

Acquired from AXIA, 1999

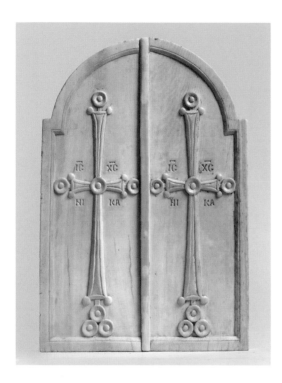

BIBLIOGRAPHY

A. Cutler, 'A Byzantine Triptych in Medieval
Germany and its Modern Recovery', *Gesta*, 37
(1998), pp. 3–12 (connecting the triptych and
its wings)
See also Steenbock 1965, nos. 40–41 (for the
example of Henry II and his consort)

These wings were originally joined to an ivory plaque with a semicircular top decorated with an enthroned figure of Christ flanked at the level of his head by busts of his mother Mary and Saint John the Baptist (called the Prodromos, 'forerunner' [of Christ]), surmounted by busts of Archangels Michael and Gabriel, all identified by large and very carefully carved inscriptions. The Mother of God and the Baptist, who holds a processional cross, appear by their gestures to intercede with Christ on behalf of the petitioner, and Christ, by his gesture of blessing, accepts their requests. The archangels, each of whom holds a sceptre and an orb surmounted by a cross, appear to guard Christ in his heavenly setting.

The wings continue the theme of intercession and blessing. At the top to either side are Archangels Uriel and Raphael, who echo the gesture of the Theotokos. Below are Saints Paul and Peter, one holding a book with a jewelled cover like the book held by Christ and the other a processional cross, and they support the theme of intercession by the gestures of their right hands. Below them are two bishop saints – both wearing the episcopal scarf-like *omophorion*, decorated with crosses – and holding similar books. They are identified as Saints Basil and Nicholas. Each makes a blessing. When the wings are swung forward about 30 degrees, so as to support the triptych, the extraordinary skill with which the sculptor foreshortened the flanking figures so that they appear to communicate across the space with the central Christ can be seen. When the wings are swung closed they display two symmetrical crosses, with flaring arms terminating in circular designs, each inscribed 'Jesus Christ. Conquer!' (IC XC NIKA). There are traces of gilding on the crosses and around the inscriptions. It is notable that the right door is carved with a projecting fillet, which closes neatly over the edge of the left door (explaining why the weight of the two panels is different).

In the early eleventh century the central panel of the triptych was mounted on the cover of a Gospel lectionary donated to the Cathedral of Minden by its Bishop Sigebert (1022–36). Although the ivory has been reset it is still associated with the lectionary, now in the Staatsbibliothek Preussischer Kulturbesitz in Berlin. Sigebert himself must have dismantled the Byzantine triptych, for the present wings were mounted by him on a companion volume, a lectionary of the Acts and Epistles, which, alas, does not survive. In choosing to display Byzantine ivories on the covers of Latin books Sigebert was not a pioneer (as Cutler claimed) but was imitating Emperor Henry II and his wife Kunigund, who donated two volumes for use in the liturgy of Bamberg Cathedral (dedicated in 1012) which were made specially to fit two Byzantine ivory diptychs. JL

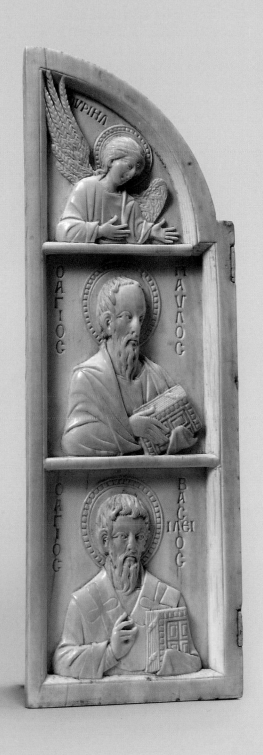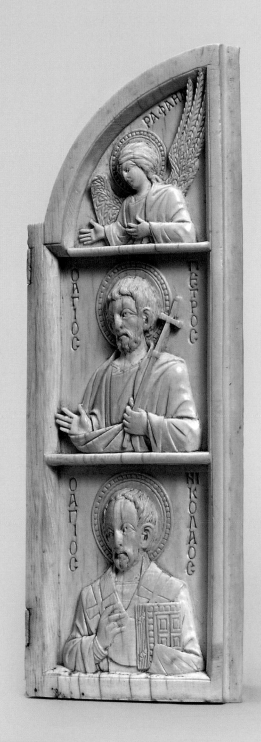

2, 3

Two Byzantine enamel plaques
Saint Philip and Saint Mark

Constantinople, late 11th or early 12th century
Diameter of each 31 mm

Acquired from Sam Fogg, London, 2004

BIBLIOGRAPHY

Unpublished
See further Klaus Wessel, *Die Byzantinische
Emailkunst* (Recklinghausen, 1967), no. 37 (Holy
Crown of Hungary), 40 (medallions from the
Metropolitan Museum), 41 (medallions on
the Dumbarton Oaks icon frame); Éva Kovács
and Zsusa Lovag, *The Hungarian Crown and Other
Regalia* (Budapest, 1980); Helen Evans and
William D. Wixom, *The Glory of Byzantium: Art
and Culture of the Middle Byzantine Era, AD 843–1261*
(New York, 1997)

Saint Philip and Saint Mark are identified on these two enamel medallions by the inscriptions in Greek on either side of each of their heads. Their well-proportioned figures have well-defined eyebrows, almond-shaped eyes and clearly defined hair, producing strong individual expressions on their faces. Philip was an Apostle whose remains were translated to Constantinople and thence to the church of the Twelve Apostles in Rome. Mark was an Evangelist whose relics were brought from Alexandria to Venice, where the church of Saint Mark was built to receive them. These richly coloured roundels are of very high quality. They are formed in the *cloisonné* enamel technique, in which the gold strips were bonded onto a thin, smooth base-plate of gold, creating the lines which define the figure, whilst the intervening spaces were filled with coloured glass, in a powder or paste, and then fired to produce the enamel. The very delicate gold strips enable the folds of the drapery and the very expressive faces to be portrayed. A thin panel of gold, carefully cut to shape so as to outline the enamel, forms the front surface.

Stylistically they relate to other surviving Byzantine enamels, notably those on the Crown of Saint Stephen (the Holy Crown of Hungary) now in Budapest and those incorporated in the lower of the two Byzantine triptychs in the famous Stavelot Triptych, from the great imperial Benedictine abbey of Stavelot in the diocese of Liège in Walloonia in present-day Belgium (now in the Pierpont Morgan Library, New York). The Stavelot Triptych was almost certainly made for Wibald, Abbot of Stavelot from 1130 to 1158. Wibald, after a visit to the Emperor Manuel I Commenus in Constantinople, brought back to his abbey a reliquary for fragments of the True Cross; this is probably to be identified as the lower triptych inserted into the Stavelot Triptych. If so, the Stavelot Triptych would have been commissioned shortly after his return, and before his death in 1158. The enamels on the Crown of Saint Stephen have been dated to between 1074–77. Therefore these two medallions may be dated in the late eleventh or early twelfth century.

The medallions are probably from a series showing Christ in the centre flanked by the Archangels and followed by the Apostles and other saints. Other roundels of the same type are in the Metropolitan Museum of Art, New York, and the Musée national du Moyen Âge, Paris. Such enamel roundels were used to adorn sacred works of art such as the covers of icons, books or reliquaries. Examples of such circular medallions may be found on a Gospel book in the Biblioteca Pubblica of Siena, ascribed to the tenth century, an icon frame in Dumbarton Oaks, Washington, and a cover for a reliquary at Saint Mark's, Venice, ascribed to the eleventh century, which contains a relic of the True Cross. JC

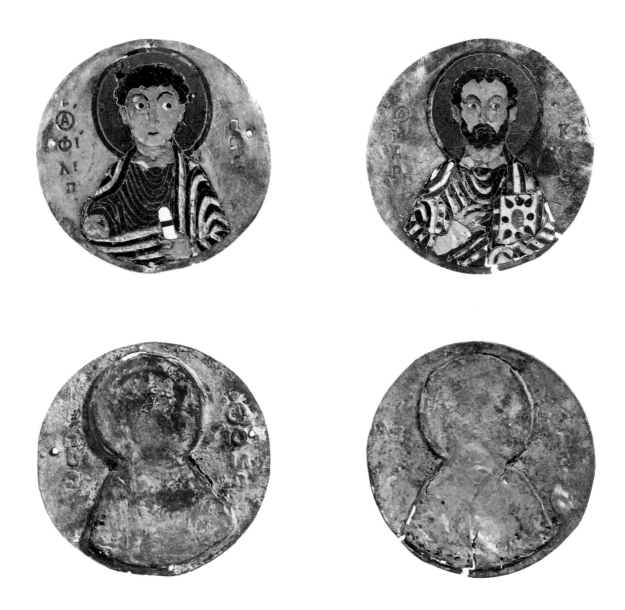

4

Romanesque walrus-ivory plaque

England?, *c.* 1125–50
Height 101.3 mm, width 32.7 mm, diameter 7.6 mm
(bottom), 7.0 mm (top); weight 38 g

Acquired from Maria Baer, London, 1977

BIBLIOGRAPHY

Unpublished
See further Steenbock 1965, nos. 73, 110
(book covers for comparison)

This small ivory is cut from a walrus tusk, as is most obvious on the back, where a conspicuous strip of crystalline material (a feature not found in elephant ivory) can be seen. The glossy, almost buttery appearance is also characteristic of walrus ivory. The ivory panel is divided into four registers each subdivided into two small scenes. First, the Visitation, and the Nativity in a church-like structure with a star in the gable. Second, the Adoration of the Magi, with the star now outside, and the Virgin and Child again in a church-like interior. Third, Herod in an aedicule ordering the Massacre of the Innocents, which takes place in a walled city to the right. Finally, the Baptism of Christ by John, with an unusually large bird representing the Holy Spirit, and the Marriage Feast at Cana, with jars of wine across the foreground, three figures seated at table and a servant holding aloft a cup of wine at the left. The choice and sequence of iconography makes better sense if the tablet is considered as merely the first part of a series of scenes from the life of Christ, but there is no evidence to suggest that one or more panels of similar size completed the narrative. Possibly the panel was originally mounted on the cover of a Gospel book or lectionary, but the back of the panel has no trace of such mounting. Had it been mounted alongside a second panel of similar dimensions, the two would have formed a rectangle consistent with the proportion of height to width of most books (100:65). Alternatively, the second panel might have been mounted on the back cover.

The panel has no close relatives, but comparison with manuscript illumination suggests it could have been carved in England around the second quarter of the twelfth century. JL

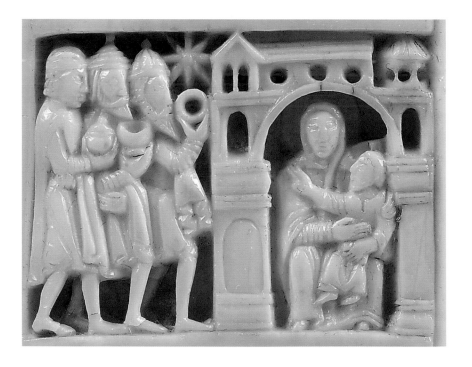

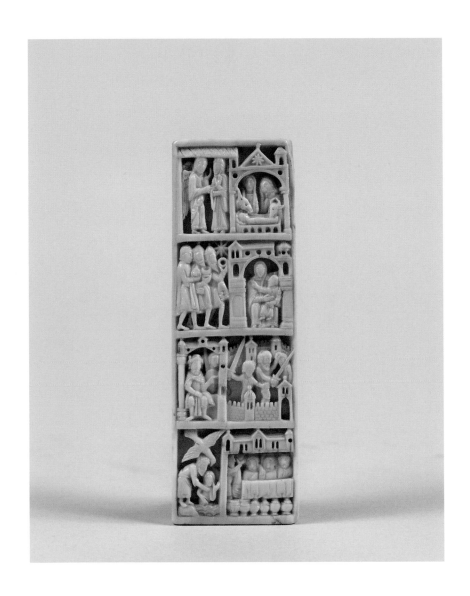

5

Mosan enamel of Adam in a Tomb

Mosan region, c. 1150–60
Copper with enamel
Height 47 mm, width 49 mm, depth 3 mm

From the Victor Gay collection, Paris; sale, Paris,
March 23–26, 1909, lot 47; later in Bauml and
Simon Seligmann collections, Paris; sale, Sotheby's,
New York, January 29, 1999, lot 17

Produced in the Mosan area, so-called after the River Meuse/Maas (primarily that part in modern Belgium), this enamelled plaque probably came from the base of a cross, or possibly from the cover of a book. It is pinned for attachment in each corner. It shows Adam, who, created by God, together with Eve had fallen from Grace by eating fruit of the Tree of Knowledge of Good and Evil and thus committed the original sin. By his sacrifice upon the cross Christ had brought about the possibility of man's delivery from this sin. Medieval writers tried to establish historical links between the Fall and the Crucifixion by maintaining that Adam's burial place was at the site of the Crucifixion. The present representation of Adam, with a halo, rising from a tomb, may reflect this belief.

A twelfth-century Mosan cross, preserved at Orbey in eastern France, has a circular enamel of Adam at its base, with, at the top of the cross, an enamel of Saint Michael and, on the lateral arms, Saint John and, originally, the Virgin (now lost). Saint Michael, with the inscription *Angelus Domini*, is the angel who both presides at the Last Judgement and triumphs over evil in the war in heaven. Thus the figure of the resurrected Adam on the present enamel complements the themes of Judgement and Resurrection. There is also a fragment of a bronze cross foot, perhaps produced in Hildesheim *c.* 1120–40, now in the Goethe-Nationalmuseum, Weimar, that shows Adam praying in a sarcophagus.

The plaque is in the *champlevé* technique of enamel, in which the field (*champ*) of the copper alloy is dug out in a number of compartments for the enamel, leaving raised dividing strips. The enamels were set in the appropriate cavities of the plaque either during the fusion of the plate or by hammering or incision with an appropriate tool. The metal surface was then gilded. The technique was popular in the twelfth and thirteenth centuries. JC

BIBLIOGRAPHY

Philippe Verdier, 'Emaux mosans et rhino-mosans dans les collections des Etats-Unis', *Revue Belge d'archéologie et d'histoire de l'Art*, XLIV (1975), p. 37, note 4 (previous publication of the present enamel)
See also *Trésors des Eglises de France* (exhibition catalogue, Musée des Arts Décoratifs, Paris, 1965), p. 455, no. 861 (the Orbey cross); Nigel Morgan, 'The iconography of twelfth-century Mosan enamels', in *Rhein und Maas: Kunst und Kultur 800–1400* (exhibition catalogue, Cologne, 1972), pp. 263–78; *Das Reich der Salier* (exhibition catalogue, Sigmaringen, 1992), pp. 370–71 (the Weimar cross foot)

6

The Virgin and Child

Spain, late 12th century
Painted fruitwood, height 61 cm

Acquired from Sam Fogg, London, 2002

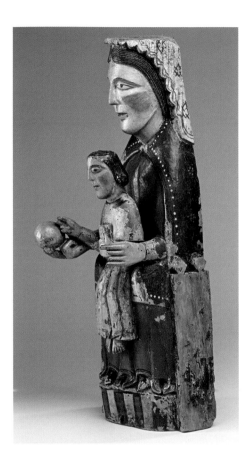

BIBLIOGRAPHY

Unpublished
See further *Catalunya Romànica*, vol. 6 (Barcelona, 1992), p. 214; *Historia del arte de la iglesia catalana* (Barcelona, 1989), p. 60 (Madonna at San Esteve de Tuixen); I.H. Forsyth, *Throne of Wisdom: Wood Sculptures of the Madonna in Romanesque France* (Princeton, 1972)

This impressive painted fruitwood sculpture shows the Virgin and Child majestically enthroned, in the type known as the Sedes Sapientiae (throne of wisdom) or, primarily in the Byzantine tradition, Theotokos (God-bearer). These are titles given to Mary in recognition of her role as Mother of God, who gave birth to Jesus Christ and is presenting Christ to the world. Just as Christ made his divinity manifest in human form, so Mary was human in nature but Theotokos by divine will. Mary also provides the throne for Christ. Statues in this form are known from all over Europe, and there are many survivals in particular from France, Spain and Italy.

The present statue shows Mary in a stiff, hieratic pose, seated on a throne with red and gold vertical stripes on the front. The figure of Christ is detachable. The sculpture has been an object of great devotion, and has therefore been much repaired and repainted. At least three layers of paint were discovered during examination and the latest of these were removed.

Mary holds an object that may have been an orb or apple in her right hand. The figure of Christ has a hieratic pose similar to his mother's. He holds a book in his left hand, close to the body, while his right hand is raised, possibly in blessing. The two lower fingers are curved back while the thumb and first two fingers are projecting straight out and would have held an object, perhaps a sceptre. The upper part of Christ's head is damaged and has been painted brown, which may have obscured any evidence that Christ was crowned. He is dressed in a long red tunic with black painted scroll patterns on the side of the leg. The upper part of his body has a cloak worn down to just above the elbows; the underside of the upper cloak and the bottom of the tunic are painted grey blue with brown cross-hatching. Mary wears a veil with a wavy edge decorated with red and blue patterning. Her hair is parted in the middle and flows down each side of the face in straight lines. She wears a dark blue cloak, with double red lines and white spots, which is decorated with a pattern of three red spots. This is worn over a red tunic that reaches down to her feet.

Many wooden statues of the throne of wisdom type have been found in France, particularly the area of the Auvergne, and have been extensively studied by Ilene H. Forsyth. Statues from the Pyrenees have significant differences from the Auvergne group: Christ is usually supported on one knee of the Madonna, who is heavily proportioned and has broad facial features. These sculptures are often modest in execution and have been heavily overpainted. Among a number of such wooden Virgins preserved in Catalonia and Andorra, a closely comparable *Virgin with Child* preserved at the church of Saint Stephen in Tuixen, Catalonia, is thought to show Byzantine influence in the late twelfth or early thirteenth century. JC

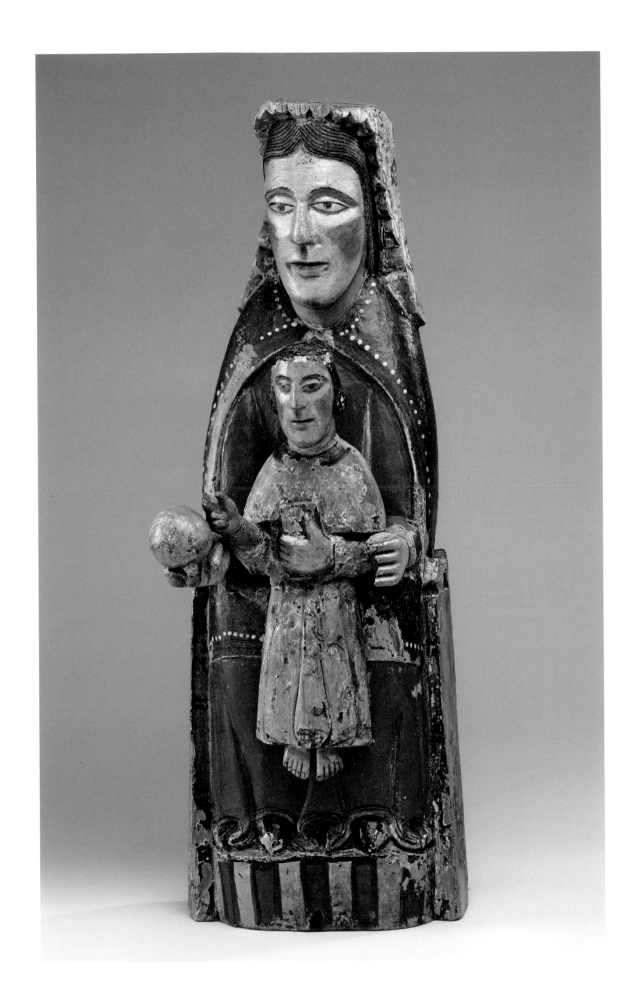

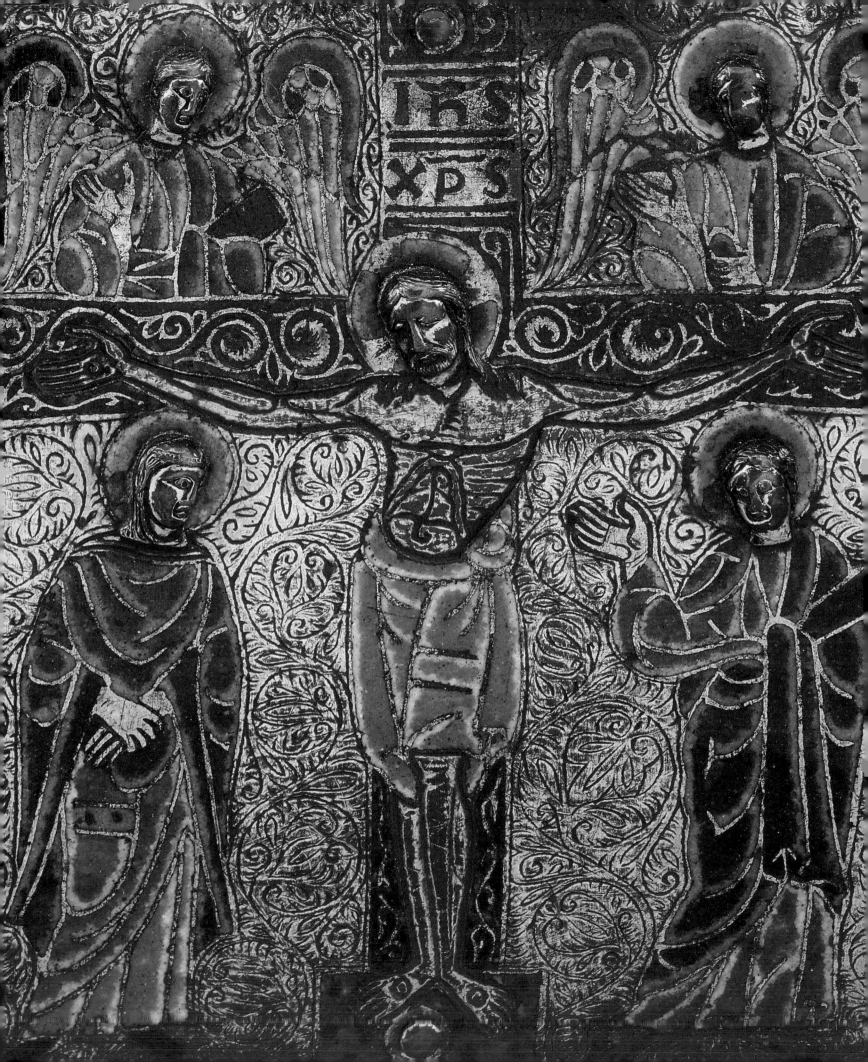

Châsses and reliquaries

Christians have venerated holy relics, the material remains of Christ, his Apostles and saints, for centuries. Pilgrims sought relics. Crusades were organized to save holy places and holy relics from the rule of the heathen. Churches were built and expanded to house relics. They provided a close link with the spiritual world of the past and were able to cure the sick and to cause miracles to happen in the present. Since they had such power and were so treasured, they were often encased within precious receptacles, known as reliquaries.

Relics may be divided according to their different levels of importance. The more important were those associated with the events of Christ's life, or the physical remains of a saint. A martyr's relics were often more prized than the relics of other saints. Less important relics were clothes or objects which the saint had worn or touched. Lastly, there were objects that had been in association with a more important relic. By the law of the Church, known as Canon Law, there had to be a relic in or under any altar in a Catholic church upon which Mass was to be offered.

Many relics came from the catacombs in Rome, for example those of Saints Peter and Paul which were venerated at the abbey of Cluny in France. The veneration of relics influenced the building of churches, since pilgrims needed to circulate around the tomb or reliquary shrine. The abbey church of Cluny had an ambulatory built around the outside so that the passage of pilgrims would not disturb the services in the choir.

Precious containers for relics might take the shape of a flask or a purse, or reflect the form of the relic if it were a head or an arm. These were the more common forms for the primary class of relics. Other relics were kept in caskets, known by their French name, *châsses*. There was a remarkable production of *châsses* in Limoges in south-west France in the late twelfth century, reflecting the importance of the veneration of Saint Valerie and Saint Thomas Becket. For neither saint were there a great many primary relics available and it is likely that many such *châsses* contained secondary relics. Of the three *châsse* fragments in the Thomson Collection, one contained relics of the Early Christian Four Crowned Martyrs; the contents of the two others are not known. JC

BIBLIOGRAPHY

Marie-Madeleine Gauthier, *Highways of the Faith* (Fribourg, 1983); Henk van Os (ed.), *The Way to Heaven: Relic Veneration in the Middle Ages* (The Hague, 2000)

7

The Madrid Châsse

Limoges, 1180–90
Height 16.8 cm, length 22.9 cm, depth 8.3 cm

In an unidentified Spanish monastery until the
19th century, then in Madrid before 1905; Stoclet
collection, Brussels, until 1965; Kofler-Truniger
collection, Lucerne, 1965–71; Keir collection,
London, until 1997

BIBLIOGRAPHY

Marie-Madeleine Gauthier and Geneviève
François, *Medieval Enamels: Masterpieces from
the Keir Collection* (London, 1981), no. 1 (where
compared with the *châsse* in Auxerre)
See also *Enamels of Limoges 1100–1350* (exhibition
catalogue, New York, 1996), pp. 128–29,
no. 24; Marie-Madeleine Gauthier, 'Une châsse
limousine du dernier quart du XIIe siècle', in
Melanges offert à René Crozet (Poitiers, 1966),
pp. 937–51

The two *châsses* known as the 'Madrid' and 'Malmesbury' *châsses*, now together, form a fascinating comparison. They were both made at Limoges in central France, a centre of European enamel production in the late twelfth and thirteenth centuries. They are both *châsses* (a *châsse* is a reliquary with a gabled roof that echoes the shape of a small church) and would have contained relics, although it is not known which relics were contained.

The *châsses* are of the early group of Limoges enamels known as '*à fonds vermiculé.*' This type takes its name from fine ornamental motifs with tight scrolls engraved on grounds of gilt copper which decorate the background. The technique originated in ninth-century Islamic art, whence it spread to Byzantium before reaching Europe in the mid twelfth century. It appears on the borders of the great shrine of Santo Domingo of Silos in Spain, which dates from shortly after 1150, as well as on a number of objects produced for Henry the Lion, Duke of Saxony, in the period 1165–75. A *châsse* enamelled with scenes of the life of Saint Martial of Limoges, made between 1165 and 1175, is among the earliest examples to have survived.

Delicately varied shades of blue enamel decorate the surfaces of the Madrid *châsse*. The front and back are very different. While the back has an overall pattern of quatrefoils enclosed in circles, the front has, on the

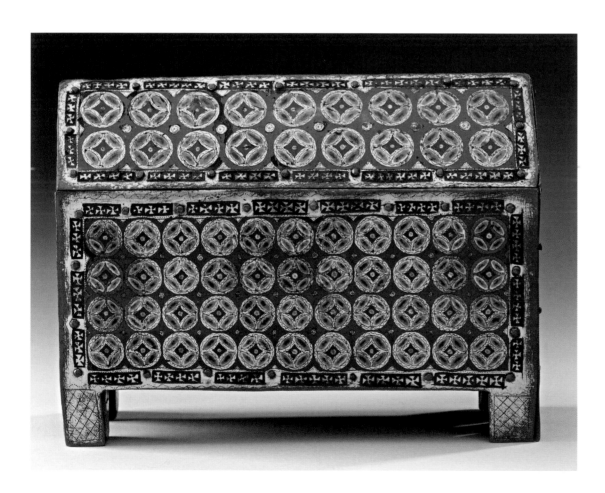

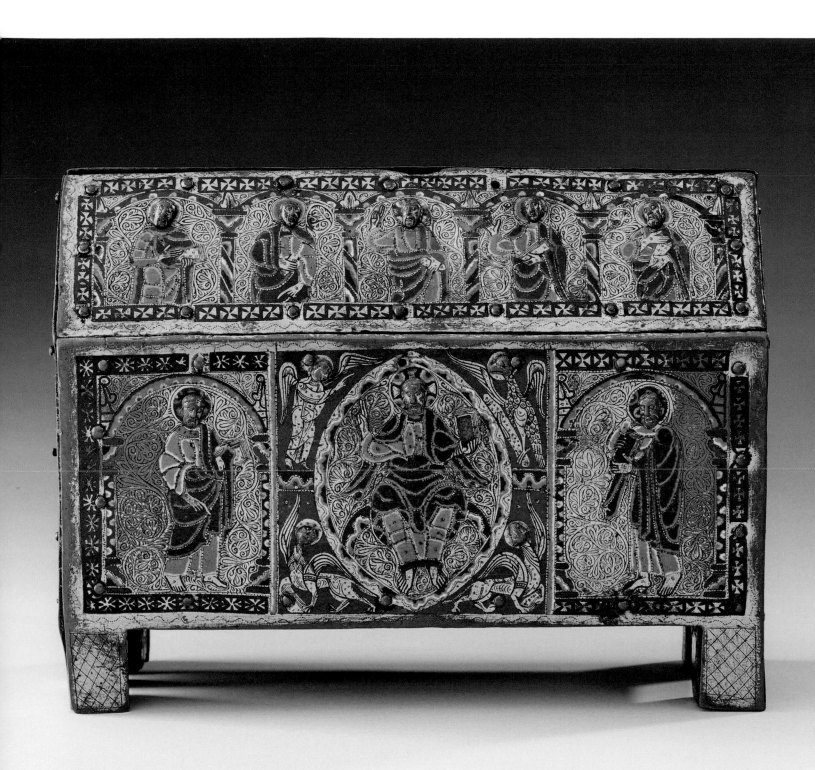

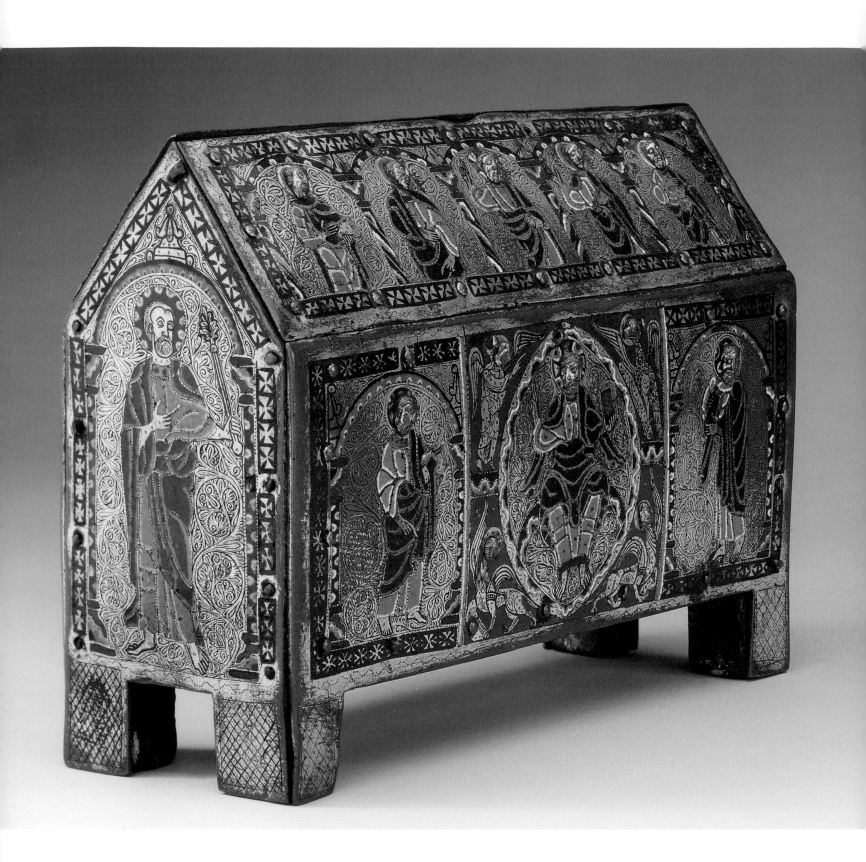

lower part, the enamelled figure of Christ in Majesty, posed in a mandorla, against a *vermiculé* background, surrounded by the symbols of the four Evangelists against a blue background. The four Evangelist symbols represent the four beasts of Ezekiel's vision. On either side is an Apostle under an arch holding a book. Their haloes are enamelled. On the upper part Christ is shown standing, turning towards and blessing the figure to his right, who is the only one of the four figures to be holding a scroll rather than a book. At the ends of the *châsse* are single figures under arches. These have been identified as a bald Saint Paul, blessing, and Saint Peter, holding a key that looks remarkably like a sceptre.

The enamel plaques are attached to a structure of oak, which is in seven parts. Half of the base has been used for access and in 1966 was recorded as having been replaced recently. The wood had been painted red from the beginning to protect it against humidity.

There are about forty *châsses* of this *vermiculé* type known. The themes represented on them fall into three types. The first shows scenes from the life of Christ and saints such as Saint Valérie, Saint Stephen or Saint Martial, who were much venerated in the Limoges region. The second shows Apocalyptic and mystic scenes such as Christ in Majesty among the Apostles, and the third alludes to theological reflection and to liturgical experience by using geometrical shapes such as circles and mandorlas and by constructing a pattern through the disposition of the figures.

Marie-Madeleine Gauthier, the great scholar of Limoges enamel, suggested that the upper part of the present *châsse* shows the transmission of the Law from Christ to the Apostles, based on Matthew 16: 18; 19: 27–30; 28: 20. Christ blesses Saint Peter who holds the scroll. Saint Peter, first bishop of Rome, provided the direct link between Christ and the Roman church.

It is not certain what relics were kept in this *châsse*. Since it shows Christ in Majesty amidst saints, it may have held a selection of relics from the Holy Land. JC

8

The Malmesbury Châsse

Limoges, c. 1190–1200
Gilded copper, enamel and rock crystal
Height 26 cm, length 32 cm, depth 11 cm

Exhibited in 1788 at the Society of Antiquaries of
London by Thomas Astle, who had bought it at
Richard Bateman's sale in 1774 for £2. 7. 6d; Astle died
in 1803; the *châsse*'s location is then unknown until
it appeared in the sale of Major H. Chase Meredith
at Sotheby's, July 17, 1930, lot 1; acquired 1988

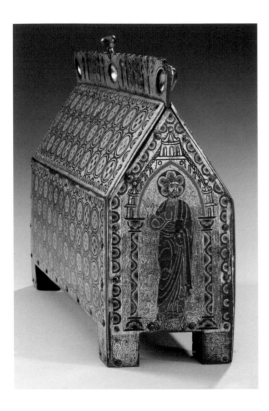

BIBLIOGRAPHY

Thomas Astle, *Vetusta Monumenta*, vol. II (1789),
pl. LI; T. Borenius, 'The Meredith reliquaries',
Burlington Magazine (1930), pp. 134–36; S. Caudron,
'Les Émaux champlevés de Limoges et amateurs
britanniques du XVIIIe siècle', *Bulletin de la Société
Archéologique et Historique du Limousin*, CIII (1976),
pp. 137–68; S. Caudron, 'Connoisseurs of
champlevé enamels in eighteenth-century
England', *Collectors and Collections: The British
Museum Yearbook*, vol. 2 (1977), pp. 9–34
See also Marie-Madeleine Gauthier, 'Une
châsse limousine du dernier quart du XIIe siècle,
themes iconographiques, composition et essai
de chronologie', in *Melanges offert à René Crozet*
(Poitiers, 1966), pp. 937–51; *Enamels of Limoges
1100–1350* (exhibition catalogue, Metropolitan
Museum of Art, New York, 1996), pp. 128–29,
no. 24 (for the New York *châsse*)

Since the Malmesbury *châsse* is also part of the Limoges group '*à fonds vermiculé*,' it provides a wonderful opportunity for comparison with the Madrid *châsse*. The chief difference between the two is that the present *châsse* has the Christ in Majesty above the Crucifixion. The Christ in Majesty is beautifully enamelled in blue and green and holds a red book. The Greek letters alpha and omega (which symbolize the beginning and the end) are enamelled on each side of his head. He is posed in a mandorla with the Evangelist symbols around it, shown against blue enamel with green haloes.

Centered on the front panel of the Malmesbury *châsse* is the image of the crucified Christ in a knee-length loincloth. His torso is gilt against a deep-blue cross ornamented with reserved rinceaux. This French crucifixion provides an interesting comparison with the German Romanesque bronze corpus (no. 10). Very similar to the present *châsse* is another in the Metropolitan Museum, New York, which has the Crucifixion with the Virgin and Saint John and half-length figures in circles representing the sun and moon in place of the Christ in Majesty.

The history of the present *châsse* can be traced back to the eighteenth century. It appeared without provenance in a sale in the 1930s in London but its previous history was discovered by research in the 1970s and 1980s. In the late eighteenth century it was in the collection of Thomas Astle, a noted antiquary and collector, who had bought it at the sale of Richard Bateman of Old Windsor in 1774. Thomas Astle showed it at the Society of Antiquaries in 1788 and published a note on it in their great publication *Vetusta Monumenta*. He recorded that Bateman had purchased it in Wiltshire and that it was said to have contained a relic of Maidulf, a seventh-century Scottish missionary who was the legendary founder of the town of Malmesbury in Wiltshire. He further comments, "The crystals on the top of the reliquary, commonly called British beads, were worn by the Druids on solemn occasions, and afterwards served as the ornaments to the shrines and reliquaries of saints."

The *châsse* shows Christ in Majesty above the Crucifixion and Saint Peter and Saint Paul at the ends. Saint Peter is watching the keyhole and holding a key the end of which guards the hole of the lock which secured the small door to the reliquary inside. Malmesbury Abbey was dedicated to Christ and Saint Peter and Saint Paul. The saints depicted on the *châsse* would be appropriate to that abbey and the *châsse* may once have contained relics of those saints. JC

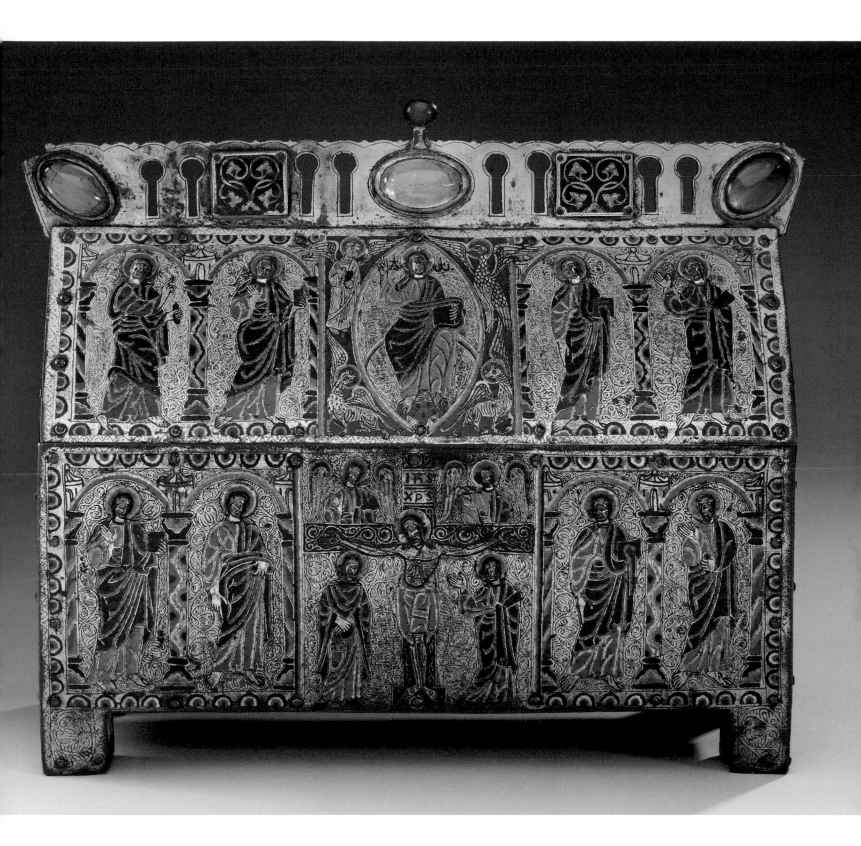

9

Plaque with two of
the Four Crowned Martyrs

Limoges, *c.* 1200
Copper and *champlevé* enamel
Height 24.4 cm, width 18.5 cm

In a number of Paris collections, then the Kofler
and Keir collections; acquired London, 2003

BIBLIOGRAPHY

Marie-Madeleine Gauthier and Geneviève
François, *Medieval Enamels: Masterpieces from the
Keir Collection* (London, 1981), no. 10; *The Keir
Collection* (sale catalogue, Sotheby's, New York,
November 20, 1997), lot 59
See also *Enamels of Limoges 1100–1350* (exhibition
catalogue, Metropolitan Museum of Art,
New York, 1996), pp. 267–68, no. 78 (Death of
the Virgin enamel)

This very impressive enamelled panel comes from the gable end or the transept of a large *châsse* which originally contained the relics of the Four Crowned Martyrs. So much is made clear by the inscription, which reads: CUSTODIT D[OMI]N[U]S OMNIA OSSA S[AN]C[T]OR[UM] (The Lord keeps all the bones of the saints: Psalm 33: 21). There is another such gable-shaped plaque with two martyr saints in the Fitzwilliam Museum, Cambridge (in Paris from 1847–50, it came to England before 1890 and was acquired by the Museum in 1904). This has the inscription EXULTABUNT D[OMI]NO OSSA HUMILIATA (The bones of the saints are exulted by the Lord: Psalm 50: 10). The two gable ends evidently came from the same very large *châsse*.

The Four Crowned Martyrs were four soldiers, killed by order of Emperor Diocletian (284–305). Their bodies are kept in four ancient sarcophagi in the crypt of the church of Santi Quattro Coronati in Rome, but other relics of the four saints were preserved in the treasury of Saint Sernin in Toulouse. The cult of these martyrs was not common, and it may well be that the large gable-ended *châsse* from which these two pieces come was in the church of Saint Sernin at Toulouse. The style of the enamelling on the plaque shows that it was made by a particularly skilled craftsman in Limoges. Elisabeth Taburet has commented: "It shows the fine supple folds of early Gothic art and strong characterization of the faces as well as a 'classical' search for idealization uncommon in Limoges enamelling. The faces are distinguished by their massive and elongated structure, their long, pronounced noses – slightly upturned – their small oval eyes lightly engraved on the surfaces of their faces, and their hair and beards coiffed in regular masses of finely combed locks."

There exist two other plaques in the same style. One is a rectangular plaque with the Death of the Virgin in the Louvre, Paris, and the other a pointed oval plaque with the figure of Saint James formerly in the Klosterhof collection in Glienicke Castle, later deposited in the Kunstgewerbe Museum in Berlin. The craftsman or workshop produced a range of shrines and other pieces.

Each one of this group shows an interest in the employment of inscriptions. The Death of the Virgin is inscribed REGINA MUNDI DE TERRIS ET DE . . . (Queen of the world, of the earth, and . . .), and may originally have been paired with another continuing the inscription and showing the Virgin as Queen of Heaven. Saint James has the word IACOBUS [James] on a band behind the figure. This use of inscriptions may indicate influence from more northern regions such as the Mosan area.

The group represents a major achievement in Limoges medieval enamelling. The series of enamels in the Thomson Collection, ranging from the Byzantine, the Romanesque and the different stages of Limoges enamel manufacture from the early *vermiculé* to this fine example of early Gothic influence, provides an opportunity for a very good understanding of the different types of early medieval enamelling. JC

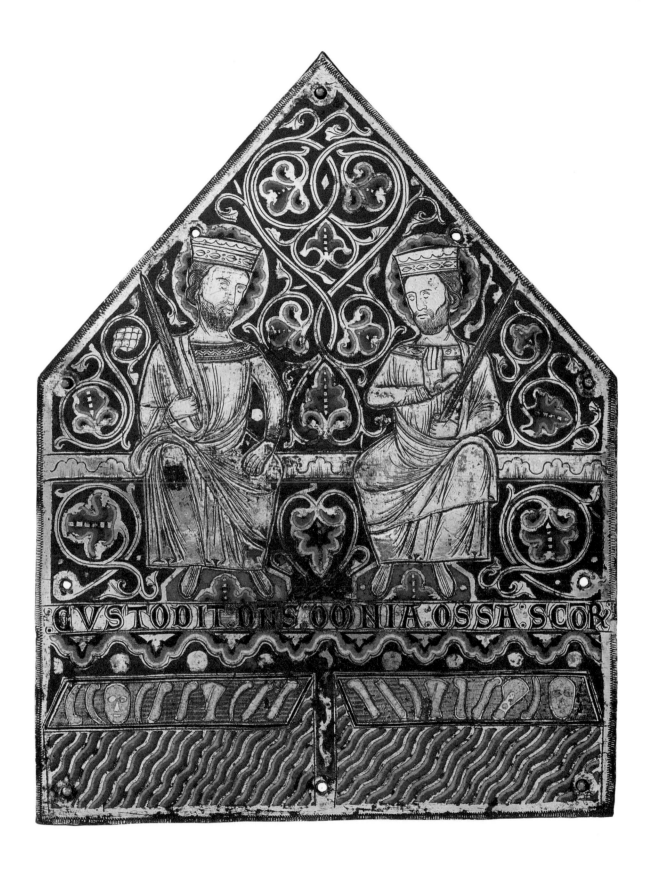

Romanesque bronze crucifix (corpus)

Germany, *c.* 1200
Height 25.7 cm, width 17.1 cm

From the Oscar Bondi collection, Vienna;
acquired from the Blumka Gallery, New York, 1990

Small bronze crucifix figures, serving as miniature copies of the great wooden crucifixes that provided a devotional focus for the worshippers in Romanesque churches especially in Germany, were very popular in northern Europe in the twelfth century. They were used either on altars or on processional crosses; later they were replaced by enamelled crosses, such as those made in Limoges in France. The graceful placing of the body (corpus) in the present example follows a traditional type seen in an eleventh-century bronze corpus at Ringelheim in Saxony. It shows Christ in Majesty. With moustache and beard, Christ is crowned with a four-lobed crown. His body is straight with uncrossed legs and his arms are raised. The head looks down. The loin cloth, with V-shaped folds, is knotted on the left-hand side of the figure. The hollow back and the holes in the hands and beneath the feet suggest that the corpus was affixed to a processional or devotional cross.

The style shows the hard and formal lines of the mature Romanesque style. This is particularly clear in the lines on the torso of the corpus and in the sharp-edged modelling of the legs and arms. The work was almost certainly made in Germany and most likely in Cologne, one of the major centres of art and craft in the twelfth century. JC

BIBLIOGRAPHY

Medieval Art from Private Collections, Carmen Gomez-Moreno (ed.), (exhibition catalogue, The Cloisters, Metropolitan Museum of Art, New York, 1968–69), no. 91
See also Peter Bloch, *Romanische Bronze-Kruzifixe* (Berlin, 1992)

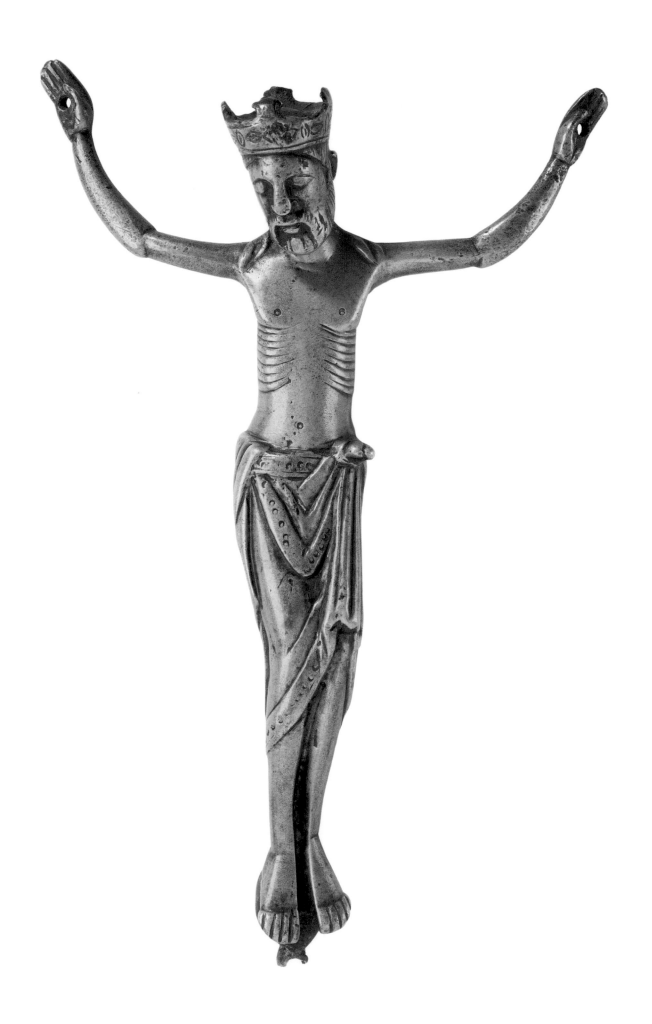

11

Bronze sleeping youth

Northern France, *c.* 1220–30
Height 37 mm, width 19 mm, depth 25 mm

Formerly Peter Wilson collection; sale, Sotheby's,
July 4, 1991, lot 14

Both the exact date and purpose of this small bronze figure of a sleeping youth are uncertain. He is a hunched male figure with his head bowed down between his folded arms, right arm placed above left. He is enfolded in a cloak wrapped tightly around his body with his feet emerging from beneath. He was meant to be seen from all sides, even the back, and was attached by a small pin at the bottom to a base plate.

The style of the figure, with the finely engraved centrally parted hair and the tight enveloping folds of his cloak, suggest that he was cast in the transitional period between Romanesque and Gothic, perhaps around 1220. There have been many suggestions for his original function. He may have been an Apostle from a Garden of Gethsemane scene, but no other three-dimensional Gethsemane scenes are known from this period. He may be compared to the four Evangelists who sit and support a coffin-shaped tomb from which Adam rises (see no. 5). One such figure once formed the base of a cross and is ascribed to Lower Saxony, in Germany, *c.* 1130. Other suggestions are that he was a figure of Joseph from the Nativity or a sleeping guardian from the Resurrection, or an allegorical figure comparable to the figure of Grammar of about 1150 in the Royal Door at Chartres Cathedral.

There is a most interesting parallel in the sketch of a sleeping male figure by the widely travelled architect Villard de Honnecourt, born in the early years of the thirteenth century, whose sketchbook is the greatest collection of drawings of the period. His drawing is usually dated to 1240, and is generally thought to have been the figure of a sleeping Apostle for a Garden of Gethsemane painting or sculpture. A second drawing by Villard of a sleeping Apostle has been compared to a Byzantine version of the scene in the *Hortus Deliciarum* (Garden of Delights) – a twelfth-century illuminated manuscript compiled by Herrad von Landsberg at the Hohenburg Abbey in Alsace – and in a mosaic in the Cathedral of Monreale, Sicily.

The present little figure may have supported a cross, a candlestick or an altar. However, there is no attachment at the shoulders or back and none of the supporting figures for such objects are secured at the base in the way that this one is. He remains an enigma. J C

BIBLIOGRAPHY

Marcel Aubert, *French Sculpture at the Beginning of the Gothic Period 1140–1225* (Paris, 1929); Hans Swarzenski, *Monuments of Romanesque Art* (London, 1954), fig. 548; *The Year 1200* (exhibition catalogue, New York, 1970), no. 84
See also F.R. Hahnloser, *Villard de Honnecourt* (Graz, 1972), pl. 46

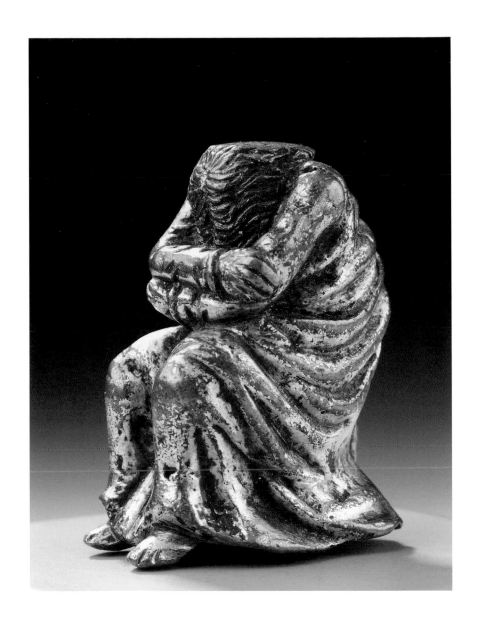

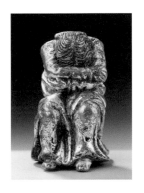 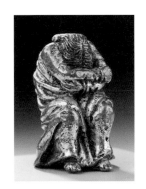 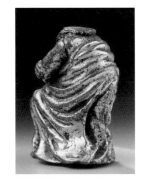

Glass panels showing the Baptism and Adoration of the Magi

Austria, *c.* 1290–1300
Two lights, each 82.3 × 84.9 cm

Formerly Liechtenstein Collections, stored at Rossau Palace, Vienna; collected by Prince Johan II (1840–1929); acquired from Sam Fogg, London, 2003

BIBLIOGRAPHY

Medieval and Renaissance Stained Glass 1200–1550 (London: Sam Fogg, 2004) pp. 28–35, no. 6
See also *Stained Glass before 1700 in American Collections: New England and New York* (Corpus Vitrareum Medii Aevi: United States of America, Checklist 1), Madeline Caviness and Jane Hayward (eds.) (Studies in the History of Art XV, Washington DC, 1985), pp. 104–05; Eva Frodl-Kraft, *Die Mittelalterlichen Glasgemälde in Niederöstterreich, Teil I* (Corpus Vitrearum Medii Aevii: Austria) (Vienna, 1972), II, 1, pp. 124–25; H. Rode, *Die Mittelalterlichen Glasmalereien des Kölner Domes* (Corpus Vitrearum Medii Aevi: Germany) (Berlin, 1974), I, pl. 55

Stained glass, as we call it, was the pre-eminent form of monumental painting in northern Europe throughout the Middle Ages. In Gothic cathedrals painted windows not only transformed the interior by their coloured luminescence but also, according to medieval belief, symbolized divine light. It reflected the statement *"Ego sum lux mundi"* (I am the light of the world; John 8: 12). Glass for windows was produced out of sheets of glass, which were coloured throughout and then painted with an opaque vitrifiable pigment. The application of yellow stain, a preparation containing silver sulphide, to white glass which turns yellow when fired did not commence until 1300 in the church of Esslingen near Stuttgart, Germany, and spread to England and France in the next twenty years.

This panel is from a major scheme of glazing which was of monumental scale and superb quality. It formed a Tree of Jesse, in which the descendants of Jesse are shown on the branches of a tree. The tree and Prophets represent the integration of Jewish history into the Christian West. The Prophets carry messages which confirm the coming of Christ, and scenes from the life of Christ prefigured by the Old Testament. A similar example, which is assigned to Swabia *c.* 1290–1300, may be seen in the Metropolitan Museum, New York.

In the present two panels the scenes shown in the main circles are the Baptism of Christ and the Adoration of the Magi. The inscriptions around each are taken from the Bible and from hymns. A green-leaf tendril ascends through both panels, uniting and framing the narrative images. These include Old Testament figures. Under the upper panel there are David and Jeremiah and beneath the lower panel are David and Isaiah, with appropriate biblical inscriptions.

A similar arrangement of roundels, with similar iconography (the Baptism above the Adoration), was used at Mönchengladbach, Westphalia, Germany. The type of the Baptism at Mönchengladbach is paired with a scene of the Cleansing of Naaman (II Kings 5: 1–10; Luke 4: 27). It may well be that there was similar pairing of scenes in this window. The arrangement of the present glass has been compared with that from the former Dominican church at Cologne (now in the Saint Stephen Chapel in Cologne Cathedral), in which similar Prophets are shown in leafy roundels holding scrolls. The bright colour range, especially the use of green and yellow, appears in Austrian glass such as that at the Cistercian abbey of Heiligenkreuz (*c.* 1280–95), and the style of the drawing reflects a western Austrian tradition. The dimensions of the panels suggest that they were not likely to have been placed in a new building of 1290–1300 but rather in windows in an older building. The provenance suggests that it may have been made for a church or chapel patronized by the Lichtenstein family. J C

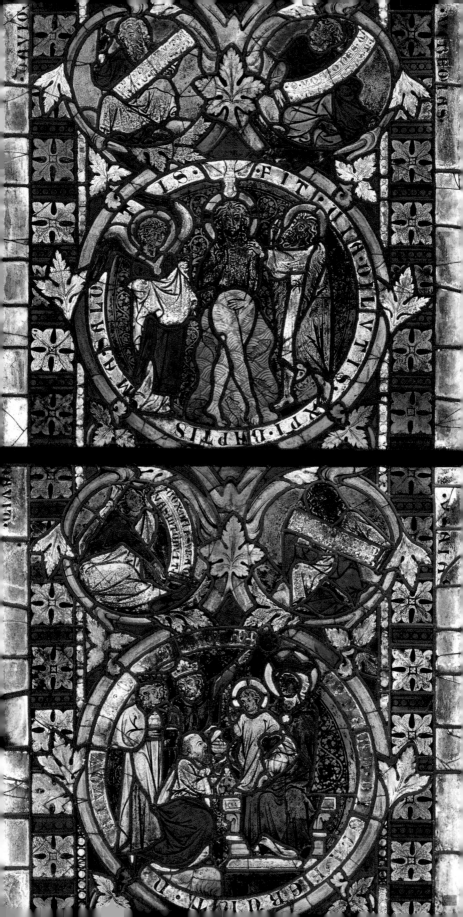

Gothic ivories and ivory carving in the Middle Ages

The principal source of ivory in the Middle Ages is assumed to have been the tusks of African elephants, though little is known for certain of the trade by which the tusks were brought to Europe. When elephant ivory was unavailable, other tusks, such as those of walrus, were utilized, especially in northern Europe (see no. 4).

Because elephant tusks are teeth, they are extremely durable. Apart from a thin outer 'skin' (*cementum*), which needs to be removed, the tusk can be used in its entirety. At its root in the jaw the tusk has a relatively soft dentine filling, which was removed. The resulting hollow cylinder might be used to make cylindrical boxes. Most of the tusk, however, is solid, save for a thin nerve canal which runs down its centre (see the back of no. 26), and which the craftsmen were at pains to avoid. All tusks curve in one plane, and as they grow longer the curve (in African elephants) begins to become a spiral, creating an awkward shape. Tusks continue to grow throughout the elephant's life, which may be sixty to seventy years or more. They can reach three metres in length, and may weigh as much as 100 kg. There is some evidence that unworked ivory was sold by weight, and a fourteenth-century French document cites a payment of 26 gold francs for a 26-pound piece of ivory.

The solid part of the elephant's tusk was generally cut into cylindrical sections (see diagram), curving like the tusk, which could be used entire, for example, for large statuettes of the Virgin and Child (such as no. 13). Alternatively, the curving cylinder could be sliced horizontally, much as a tree-trunk was sawn for planks, to provide rectangular panels for numerous

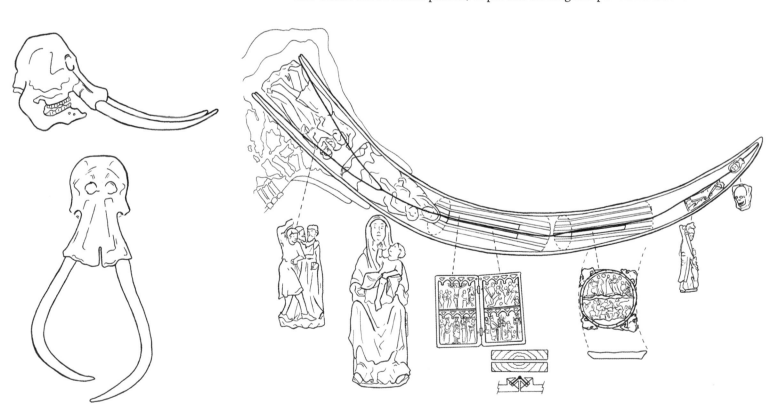

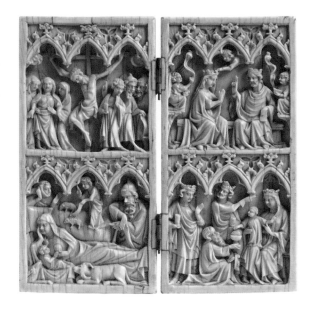

uses. The maximum usable width of the biggest tusks was only about 15 cm. Carved figures are rarely more than 35 cm tall. Larger ivory compositions in the round might be constructed from blocks glued and dowelled together, or multiple panels carved in relief might be mounted on some structure (see nos. 34, 35).

We know little about the workshops in which ivories were carved. Etienne Boileau's account of Parisian trades, *Le livre des métiers*, written around 1270, does not list ivory carving as a separate craft, but mentions it together with carving of other hard materials. Specialists in the making of combs (*pingniers*; for example no. 43), writing tablets (*tabletiers*; for example no. 26), knife handles (see no. 39), and other items employing ivory are also cited. Ivories, however, are remarkable for their anonymity. Even contemporary metalwork and manuscript illuminations generally reveal more about who made them, for whom, where, how much they cost, and various other pieces of information that it is interesting now to know. An intriguing exception is an ivory diptych (see left), probably made in Paris around 1350, which has a roughly contemporary inscription (see below) scratched on the outside: *Istas tabulas emit Petrus Garsie de Gom[ara] canonicus Oxomensis pro altari Beati Petri de Gomara* (Pedro Garcia of Gomara, canon of Osma [Cathedral, in Spain], bought these tablets for the altar of Blessed Pedro [de Osma?] at Gomara). Precious as this information is, it would be nice to know more. Did Pedro Garcia buy the ivories in Paris? Were they new when he acquired them? In presenting the diptych to an altar was Don Pedro participating in a well-established tradition?

Gothic ivories frequently present highly detailed and complex narratives, generally based on the biblical account, but also including elements derived from other popular devotional texts and sometimes from secular romances. Given the degree of similarity between different versions of the same theme, for example in the so-called Passion diptychs, which trace Christ's story – most frequently from the Entry to Jerusalem (Palm Sunday) to the Crucifixion (Good Friday) – scholars have long sought a pictorial source, mainly in the context of monumental sculpture or manuscript illumination. A comparison of details from the Entry to Jerusalem shows how closely related some of the ivories are: see overleaf, left to right, nos. 23, 24, 25, 26, 27). There are also points of close contact, for example, between some ivories and the sculpted tympanum of the Portail de la Calende at Rouen Cathedral of *c.*1300, or illuminated manuscripts associated with Jean Pucelle (d. 1334) or his follower Jean le Noir (active *c.*1330–75). But it is rarely possible to push these comparisons further and to suggest that the ivory carvers referred to some specific surviving model. A possible exception is the Nativity and Last Judgement diptych (no. 28), which may be related in part to the sculpted portal of the upper church of the Sainte-Chapelle in the royal palace on the Ile de la Cité in Paris (dedicated in 1248, but the portal destroyed in 1789/90.) Because there are many differences of detail between ivories, even when they share an overall

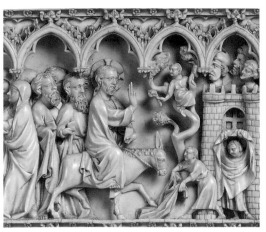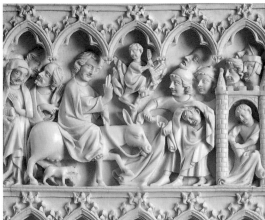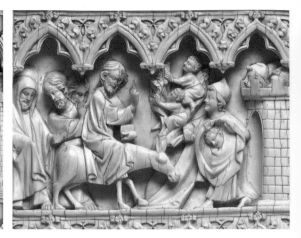

similarity, craftsmen must have been at liberty to reinterpret familiar visual narratives. Most ivories correspond to a relatively small number of basic types: statuettes (large or small), folding tabernacles, diptychs, writing tablets, mirror cases, boxes.

Paris was undoubtedly the centre of the trade in carved ivories from about 1250 to the early fifteenth century. But raw materials, craftsmen, patrons and finished objects could all move or be moved. A situation can readily be imagined in which a patron seeking an ivory might travel to Paris to acquire it, but, conversely, a sculptor looking for business might travel with his raw materials and tools in order to work in some centre where there was a demand for carved ivories, but few locals to satisfy it. In the fourteenth century ivory was probably carved and traded in numerous cities on the broad arc from Paris to Cologne, including the prosperous centres of what are now Belgium and northern France and the Rhine valley, even if they are for the most part treated together as examples of 'Parisian' production. England, Italy and Spain, for example, are also documented as places of ivory carving. It is prudent, therefore, to keep an open mind on questions of date as well as origin.

The status of ivories and their desirability, whether as objects for display in public museums or in private collections, fluctuated during the twentieth century. After a series of dispersals of famous medieval collections in the late nineteenth and early twentieth centuries, there was a spell of systematic cataloguing, lasting into the 1930s (notably volumes on the ivories in the British Museum by O.M. Dalton and in the Victoria and Albert Museum by M.H. Longhurst, and most remarkable of all Raymond Koechlin's *Les Ivoires gothiques français*, in three volumes, published in Paris in 1924). In the second half of the twentieth century, however, curators began to become increasingly anxious about the authenticity of some of even their most prized objects. An awareness of the high standards of craftsmanship achieved by modern sculptors seeking to satisfy the

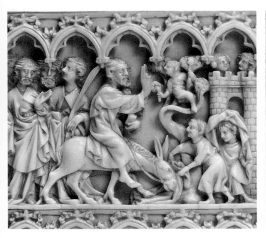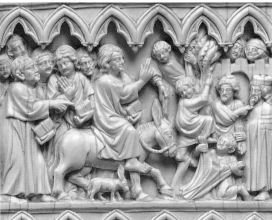

demand for Gothic or 'Neo-Gothic' objects began to cast a long shadow of doubt over many ivories. The situation cannot easily be resolved, for whereas it may be possible to prove an object is a nineteenth-century imitation ('fake') it is rarely possible to prove an object is indubitably medieval unless it has a long and trustworthy provenance. Pedro Garcia's diptych, mentioned above, is thus a rare exception. The position is delicate. The Thomson Collection, assembled since the 1960s, was formed in full cognizance of this situation, and as a result it contains remarkably few objects over which the gloom of suspicion lies. Indeed, the Nativity and Last Judgement diptych (no. 28) is a rare case of an object long thought to be a nineteenth-century product which is now considered to be medieval.

Vital evidence of the age of ivory can be provided by radiocarbon (sometimes called Carbon 14) dating. The process is destructive and requires a sample to be taken (usually drilled or scraped from the base or bottom edge of the ivory). When the result is calibrated, it points to the likely date of death of the elephant which grew the tusk, generally expressed as a dating bracket with a 95% probability of accuracy. In the case of a sample from a marine environment, *e.g.* walrus ivory, the calibration is at the present time less dependable, and the results should be treated with caution.

It will be appreciated that if an ivory tusk lay undiscovered or in store (or both) for a long period, the death of the elephant might predate the carving of the ivory by many years. On the other hand, an ivory that appears on stylistic and iconographic grounds to have been carved considerably before the radiocarbon date of its material is a fake. It must also be said that the hypothesis that nineteenth-century sculptors might have worked on previously uncarved blocks of ivory that were six or seven hundred years old (when fresh ivory was in plentiful supply and the two could not readily be distinguished, at least not until radiocarbon dating was pioneered in 1950), while not completely impossible to imagine, is extremely unlikely. JL

BIBLIOGRAPHY

Raymond Koechlin, *Les Ivoires gothiques français*, 3 vols. (Paris, 1924), I, p. 534 (document of sale of ivory by weight)

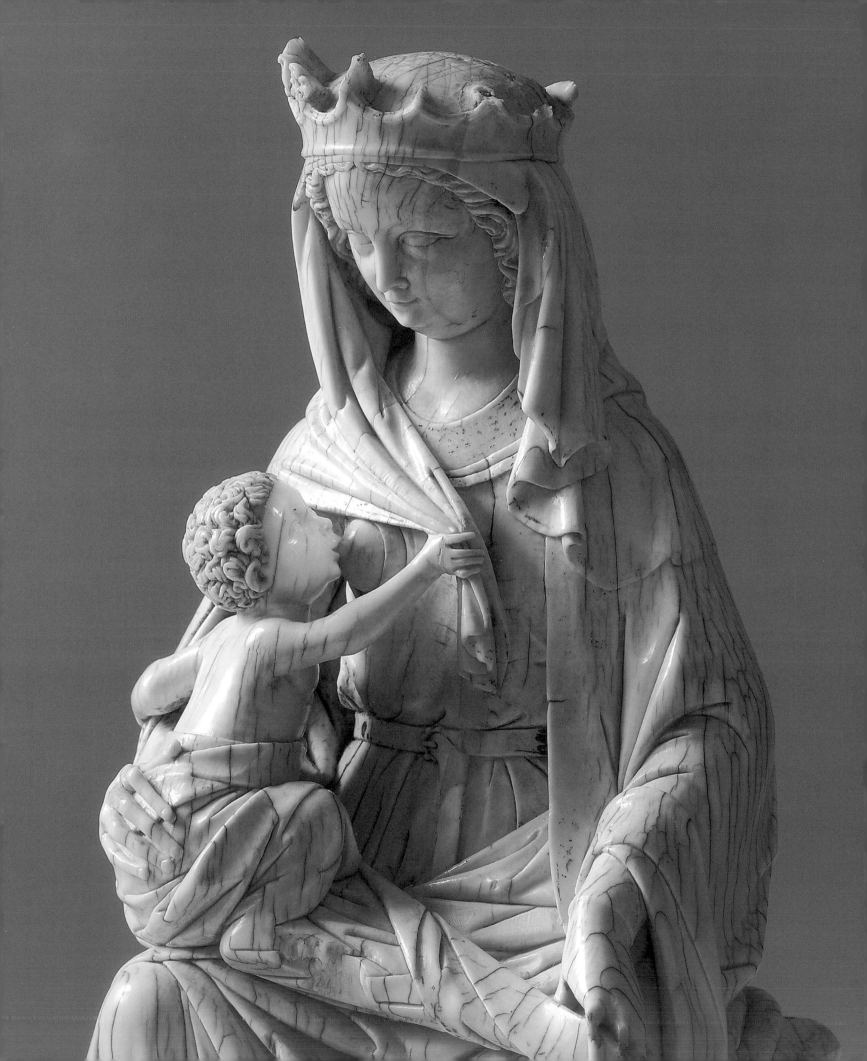

Ivory statuettes large and small

13

Enthroned Virgin and Child from the Mosan region

Meuse valley (Liège?), *c.* 1250
Height *c.* 315 mm, width 100 mm, depth 96 mm;
weight 2986 g

Formerly Jean de Meyer, Bruges; Martin Le Roy;
J. Marquet de Vasselot; sale, Sotheby's, New York,
January 29, 1999, lot 50

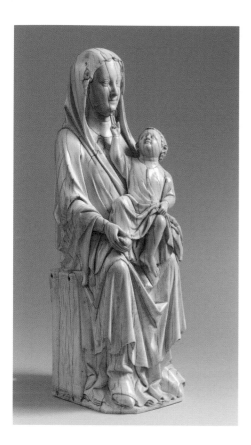

BIBLIOGRAPHY

Koechlin, no. 63, pl. XXV; Robert Suckale,
*Studien zur Stilbildung und Stilwandel der
Mandonnenstatuen der Ile-de-France zwischen 1230 und
1300* (Munich, 1971), esp. pp. 88–89; *Musée du
Louvre, Nouvelles Acquisitions 1980–1984* (Paris, 1985),
pp. 27–28, fig. 3; Deny Sandron, 'La sculpture
en ivoire du début du XIIIe siècle, d'un monde
à l'autre', *Revue de l'Art*, vol. 102 (1993), pp. 48–59,
esp. pp. 53–56 and fig. 17; sale catalogue,
Sotheby's, New York, January 29, 1999, lot 50

To make this massive statuette of the enthroned Virgin with the Christ Child on her lap the carver used an entire section of the elephant's tusk. The lower part is hollow owing to the dentine cavity (visible at the base). The nerve canal, which extends from the cavity through the centre of the tusk, is visible (it would seem) as a small patch of discolouration at the top of the Virgin's tunic, and again in her veil, to the left of her right eye. The curving shape of the tusk was cleverly disguised, and only the chamfered corner of the back of the throne at the left indicates adjustments that were necessary to accommodate the rectilinear and vertical composition to the awkward shape of the raw material. Four small holes in the lower half of the strictly vertical back, and further holes in the throne at either side, indicate that the ivory was once mounted, probably against a tabernacle of some sort, perhaps of silver gilt. (This combination of materials is detailed in fourteenth-century inventories.) As a result the drapery on the back of the Virgin was not carved with the continuing folds that characterize most such statuettes.

There is a striking contrast between the two figures. Christ is animated. He draws up his tunic with his left hand to reveal his bare left leg (a foreshadowing of the Crucifixion). He turns his head steeply to look up at the Virgin, and raises his right hand to touch the lower side of her chin tenderly, with his fingers in a gesture of blessing. His hair is carved in a spiral of gently curving locks. The Virgin by contrast is frontal and motionless. She corresponds to the traditional Romanesque type termed the *Sedes Sapientiae* (throne of wisdom; see no. 6). She holds Christ's right foot in her right hand, her thumb over the place where the nail will pierce him at the Crucifixion (the short, stubby toes of his right foot appear to be a replacement). It is perhaps also an awareness of Christ's future Passion that explains why his mother gazes steadily ahead, avoiding any suggestion of communication with her son.

The statuette, given its size and weight, was probably made originally to stand on an altar. But the signs of frequent handling which have polished and smoothed the back suggest that it may later have become an object of private devotion. Extensive traces of gilding and some polychromy are visible. In particular, the Virgin's clothing was decorated with a complex overall gilded pattern so as to resemble a precious silk imported from the Byzantine world or further east.

It can be said with some confidence on the basis of comparable examples (especially in wood) that the ivory was produced in the Mosan region in the middle of the thirteenth century. The ivory was first recorded in the collection of Martin Le Roy, at Paris, *c.* 1900, and was said to have come from the De Meyer collection at Bruges. A comparable seated *Virgin and Child* is in the Metropolitan Museum, New York, inv. no. 17.190.181. For the gaze of the Virgin, one may compare that in the Louvre, inv. no. OA 10901. JL

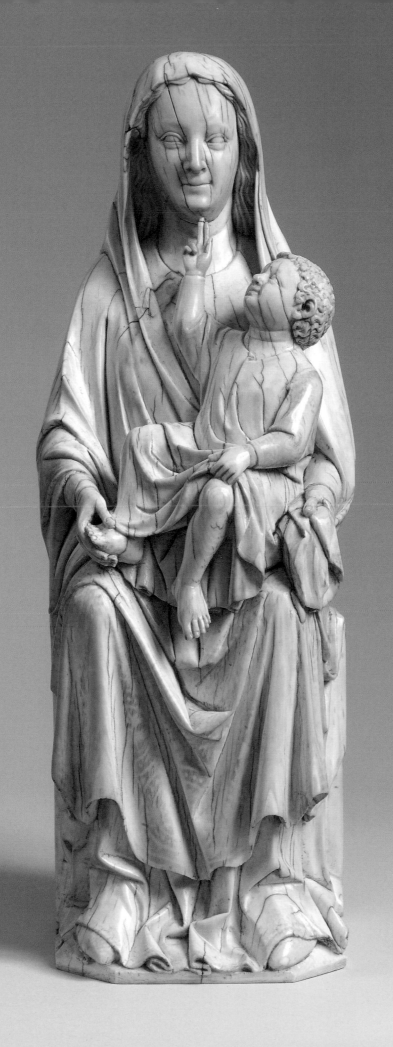

14

Virgin and Child enthroned with the Massacre of the Innocents

Paris, *c.* 1320–30
Height approx. 273 mm, width 105 mm, depth 87 mm; weight 1721 g

Formerly Minart collection, Douai (before 1924); sale, Sotheby's, London, December 2, 1969, lot 14; acquired from Sam Fogg, London, 2001

BIBLIOGRAPHY

Koechlin, no. 644 (illustration shows back) See also Williamson 1987, no. 22, pls. 118–21 (illustrating examples cited); Randall 1985, no. 271

This intriguing statuette of the Virgin and Child is a good example of how mistaken it is to imagine that Gothic ivories are predictable and never original in content. Viewed from the front the composition is not unusual except for its grand scale. The craftsman has used a solid section of ivory, hollow at the base near the end of the pulp cavity. The composition curves to the right, when seen from the front, to follow the curve of the tusk. The nerve canal, which exits on the Virgin's chest, has been hollowed out, perhaps to receive a jewel.

The Virgin sits with the Christ Child seated on her raised left leg. She looks down towards him and he turns towards her and returns her gaze, playing with her mantle cord with his (missing) right hand. With the splayed fingers of her left hand – the little finger bearing a conspicuous carved ring – she supports her son. Originally the Virgin was crowned, but she has lost the crown and top of her head – originally formed of a separate piece of ivory, glued in place – which is visually disturbing. Also missing owing to breakages are her right hand, Christ's right hand and his left forearm, along with some smaller areas of damage. A base for the statue is missing. The edges of the drapery were decorated with gilded patterns, traces of which survive. Christ's hair was also gilded, and there are traces of flesh paint on both figures. The Virgin's eyes are painted, but her gaze is somewhat cross-eyed, and it is doubtful this element is original. The Virgin tramples a beast-like devil beneath her left foot. A dowel hole in the Child's head, and some cuttings in his hair, suggest that he was once (but not originally) crowned, and may have been supplied in addition with a metalwork halo.

As the viewer moves round the statuette, or turns it in her or his hands, a complex composition on the back of the throne on which the Virgin sits becomes visible. At larger scale, centrally located, is the seated figure of King Herod, his legs crossed in an elegant fashion according to the typical formula for the representation of a ruler in the period. To either side is a painful scene of massacre. At the left a soldier plunges his dagger into the back of a struggling child, who hangs from his left hand, while the child's diminutive mother wrings her hands below. To the right another tall soldier brandishes a sword above a child, who hangs helplessly upside down as the soldier grasps his ankles. His mother bends low as she grips the child's arm and tries to drag him to safety.

There is an element of visual playfulness (albeit macabre) in the way that the Virgin sits on a throne on which is represented Herod seated on a throne. We can allow the possibility that some of the metalwork thrones in which comparable ivory Virgin and Child statuettes were originally set – they do not survive – could have been decorated with scenes in relief or perhaps in enamel. But, even so, no other medieval work in any medium combines the enthroned Virgin and Child with the Massacre of the Innocents in a comparable way. What then is the meaning of the combination? This can

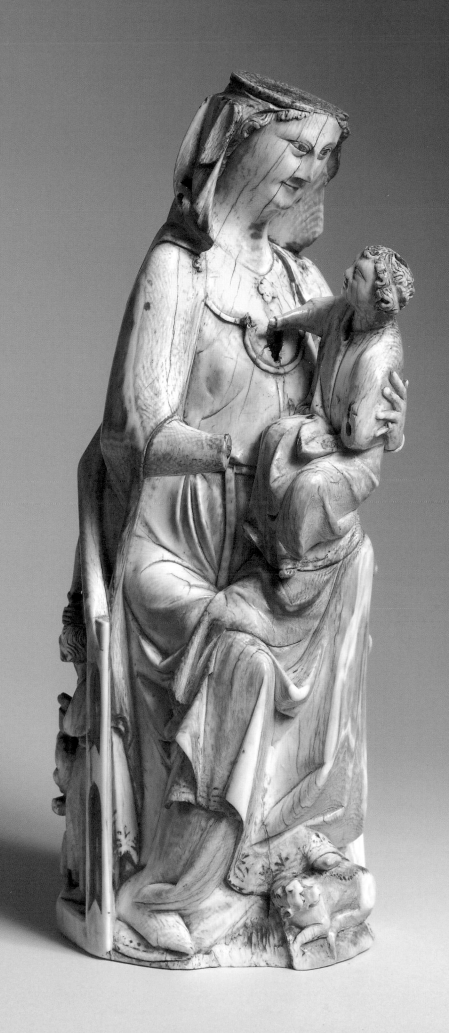

only be surmised. Perhaps the ivory was intended to stand on an altar dedicated to the Holy Innocents. It might even have been made for the high altar of the parish church of Saints-Innocents in Paris, if not for a side altar in that or some other church.

A number of comparable statuettes have been identified – Villeneuve-les-Avignon; British Museum (ex Wernher Collection); Thyssen-Bornemisza Collection; Victoria and Albert Museum, inv. no. 4685–1858; Walters Art Museum, Baltimore; Metropolitan Museum, inv. no. 30.95.114. The Wernher and Avignon Virgins also trample on similar beasts, and the throne in the Avignon and Baltimore statues is carved with an arcaded back, on which figures might once have been painted. JL

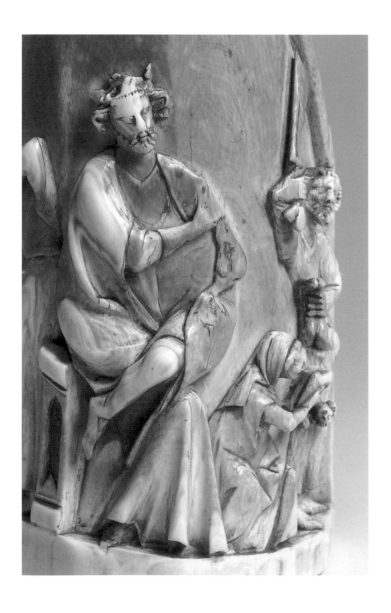

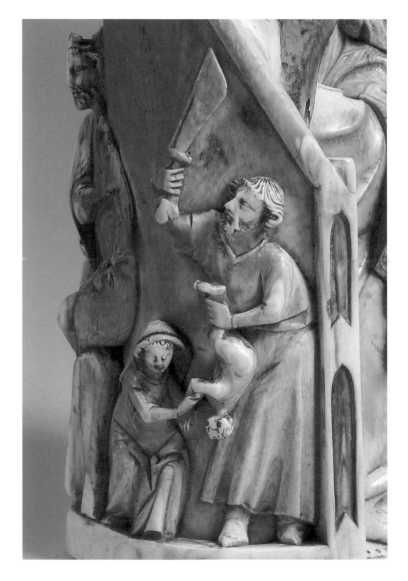

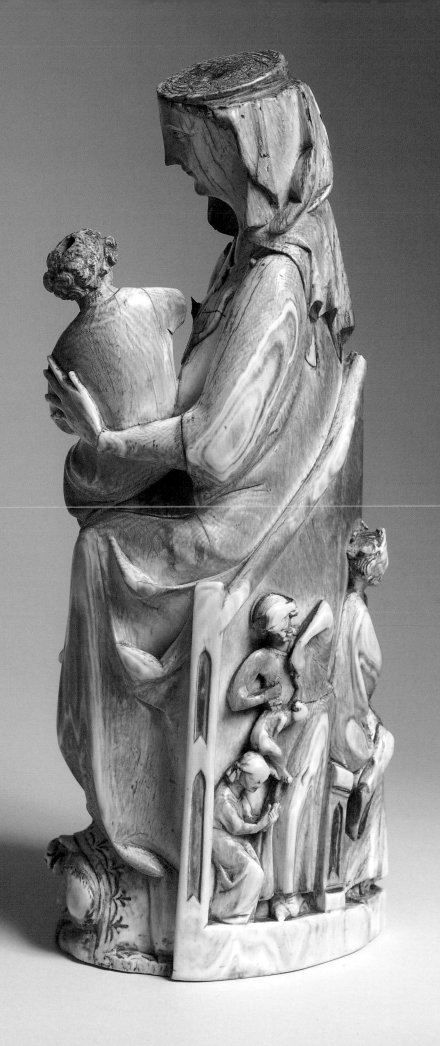

15

Enthroned Virgin feeding the Child

Paris, *c.* 1400
Height approx. 264 mm, width 135 mm,
depth 86.5 mm; weight 2282 g

Mme Bonnefille, France, said to have been acquired
by her father before 1939 in Reims; acquired from
Sam Fogg, London, 2000

This large statuette is superbly crafted and in excellent condition. The only serious damage is the loss of the finials of the ivory crown. The Virgin is, as usual, crowned and veiled, and she sits on a simple backless throne with her right foot raised on a cushion and directed towards the viewer, doubtless with the expectation that the foot would receive a pious kiss. The original base of the statue is lost, but it was probably of silver gilt, and the ivory shows traces that it was glued and dowelled in place. The craftsman used an entire section of the tusk, cut near the diminishing end of the pulp cavity, which is visible in the base. On the Virgin's right thigh sits the Christ Child (it is more usual for him to be on her left side). His upper body is bare (a prefiguration of the Crucifixion). He reaches up to suckle at the Virgin's right breast, taking her nipple in his mouth. He stretches the Virgin's veil with his right hand across her chest, and its end hangs in a pleated fold. The Virgin echoes his gesture, pulling the long sheet in which his lower body is wrapped across her lap with her left hand. The Child's feet are hidden in the sheet. The composition is unusual; it may be meant to encourage the viewer to think also of the dead Christ stretched out across the Virgin's knees and wrapped in his burial shroud. The hands of the Virgin are carved with particular delicacy. The ivory was conserved *c.* 1996–2000. There remain extensive small traces of gilding and polychromy. Radiocarbon tests provide a date of 600 ± 35 years BP, which, when calibrated, provides 95% probability of a date between 1290 and 1410. JL

BIBLIOGRAPHY

Galerie Charles Ratton-Guy Ladrière, *XVIIIe Biennale internationale des antiquaires* (Paris, 1996), pp. 5–6

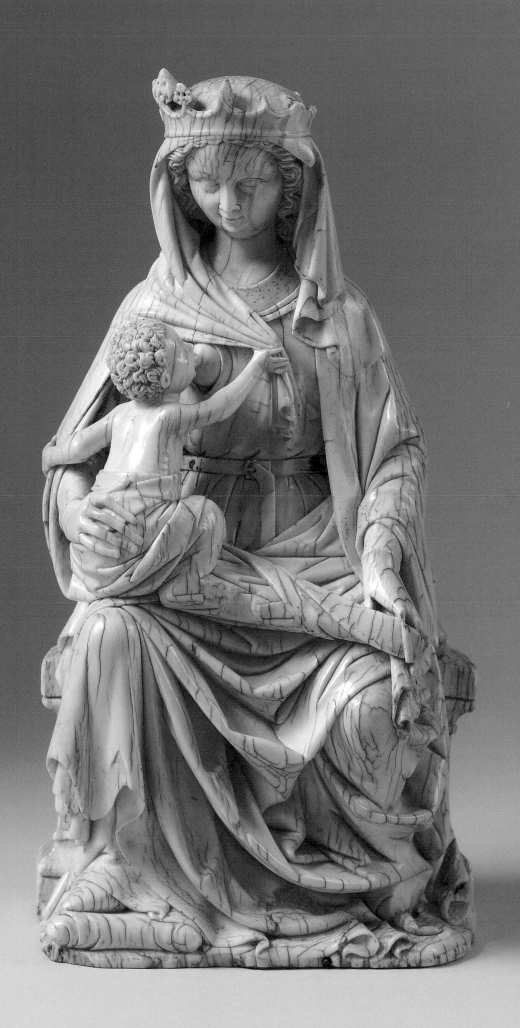

16

Italian Virgin and Child statuette

Central Italy, c. 1325–50?
Height approx. 228 mm, width 60.5 mm,
depth 37.5 mm; weight 510 g

Formerly Bernard Berenson; Frances M. Francis;
Henry Sales Francis; sale, Sotheby's, New York,
January 13, 1995, lot 1037; acquired from Daniel Katz,
London, 2000

BIBLIOGRAPHY

Bulletin of the Cleveland Museum of Art, vol. 50.7
(1963), p. 203, no. 25

This tall, slender statuette of the Virgin and Child, which at first appears to have been carved from a complete small tusk, in fact utilized half or less than half of the tusk's cylindrical form. The principal curve of the tusk is followed by the hollow back; the secondary curve causes the figure to lean to the right. The original base, necessary to correct the angle at which the tusk was cut, and to ensure stability, is lost. Hatching of the lower part of the back suggests the figure was glued in position, probably in a tabernacle of some sort. The drapery folds are roughed out on the back, but not finished to the same extent as the front. The figure of the Virgin is notably elongated. She supports the Christ Child on her right arm, and holds an unusually large bird against her chest with her left hand. The Child puts his left hand behind her head, and grasps a fold of her veil. Much of the hand and the contours of the veil have been smoothed away. With his right hand he makes a gesture of blessing. The eyes of both figures and the bird are inlayed with a dark material (jet?). This makes it clear that Christ turns his eyes to look at his mother, whereas she looks beyond him into the distance. The bird turns its head to look away from the Child. The Child's left foot, visible when the statuette is turned, is stretched out with the sole visible (perhaps to be kissed?). The statuette is of Italian manufacture. It was at one stage in Bernard Berenson's collection. JL

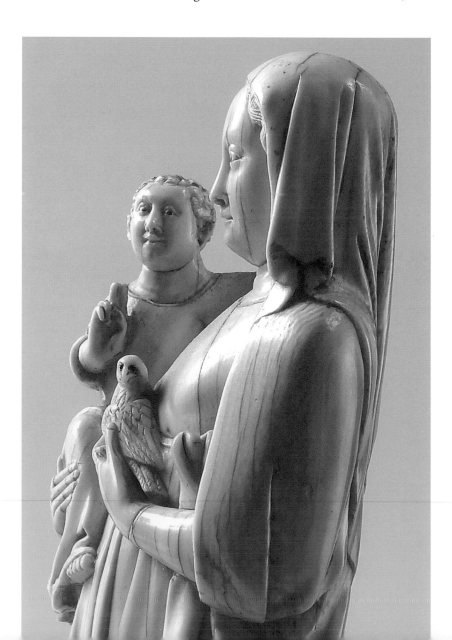

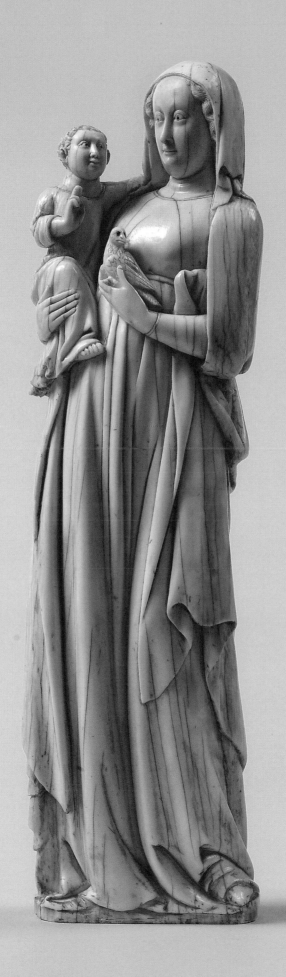

17, 18

Two small statuettes of the Virgin and Child

17 Normandy? c. 1300?
Height 128.8 mm, width 45.7 mm, depth 35.9 mm;
weight 179 g

Formerly Martin Le Roy, J. Marquet de Vasselot;
sale, Sotheby's, New York, January 29, 1999, lot 42

18 Paris? 1st half 14th century?
Height approx. 130 mm, width 65.7 mm,
depth 46.8 mm; weight 241 g

Formerly Breteuil collection; sale, Sotheby's, London,
June 26, 1961, lot 89 (ill. frontispiece); A.E. Gilou;
sale, Sotheby's, London, April 9, 1962, lot 87
(ill. frontispiece)

BIBLIOGRAPHY

17: Sale catalogue, Sotheby's, New York,
January 29, 1999, lot 42
See also Randall 1993, no. 4 (Virgin in Detroit),
no. 22 (Virgin in Boston)
18: Sale catalogues, Sotheby's, London, June 26,
1961, lot 89; Sotheby's, London, April 9, 1962,
lot 87

These two small statuettes of the Virgin and Child make an interesting comparison. In some ways they are very similar, in others strikingly different. Both focus our attention on the relationship between the Christ Child and his mother. The smaller ivory (no. 17) has been much worn by handling. The Virgin's crown, carved in ivory, has been worn down on all sides. Her face, however, is more worn in the area around the right eye, perhaps as the result of frequent kissing. The tender attitude of the medieval viewer towards the ivory may have been prompted by that between the son and his mother. The child spreads his arms wide to embrace his mother around her neck. She meanwhile supports and embraces her son. Although scarcely explicit, the image may be intended to evoke in the viewer a chilling anticipation of Christ's arms spread wide at the Crucifixion, and the supporting hands that lifted his lifeless body down at the Deposition. There may be another biblical echo, relating to a phrase from the Song of Songs: "His left hand is under my head, and his right hand shall embrace me" (2: 6, 8: 3), interpreting the bride and groom as the Virgin and her son.

In no. 18 the relationship between mother and son is also full of naturalistic detail. In contrast to the areas worn smooth in no. 17, in no. 18 the figures have not been rubbed, but have suffered various more dramatic losses as a result of breakages. Most notably, the Virgin has lost both her arms, and the Child has lost his left arm. The base is also missing. In view of the damage it is likely that the (tarnished) silver crown, which looks original, is a modern replacement. Certainly the top of the Virgin's head has been replaced with a piece of much paler ivory.

It is interesting to observe how differently the two compositions have been extracted from the ivory block. In no. 17 the left side of the composition (when seen from the front) is almost vertical, whereas the right side has been strongly cut away in a series of curves above the vertical side of the throne. The Virgin's right arm, however, especially at the elbow, appears to have been unnaturally restricted by the edge of the ivory block. In no. 18 the profile, when seen from the front, is undulating and heavily cut away on both sides. The twisting shapes of the figures in no. 18, and the contrasting angle of the heads of mother and son, are especially notable. Both statuettes seem to require an active participation by the viewer to explore the range of ideas that each represents, and the different viewpoints that reveal the relationship between mother and son.

Ivory 18 has extensive traces of gilding on the hems of both figures' clothing, and small traces of red and green on the Virgin. Both statuettes lack their original bases, but the base of no. 17 has been replaced in ivory, probably in modern times.

Ivory 18 is thought to be of Parisian manufacture. A less well-preserved statuette, with the Child in a similar position, is in the Museum of Fine Arts, Boston. The broad rounded face of no. 17 may suggest manufacture in Normandy by comparison with an ivory in Detroit. Ivory 18 was the first ivory acquired by Ken Thomson (April 9, 1962). JL

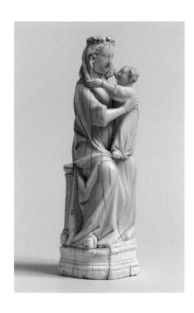

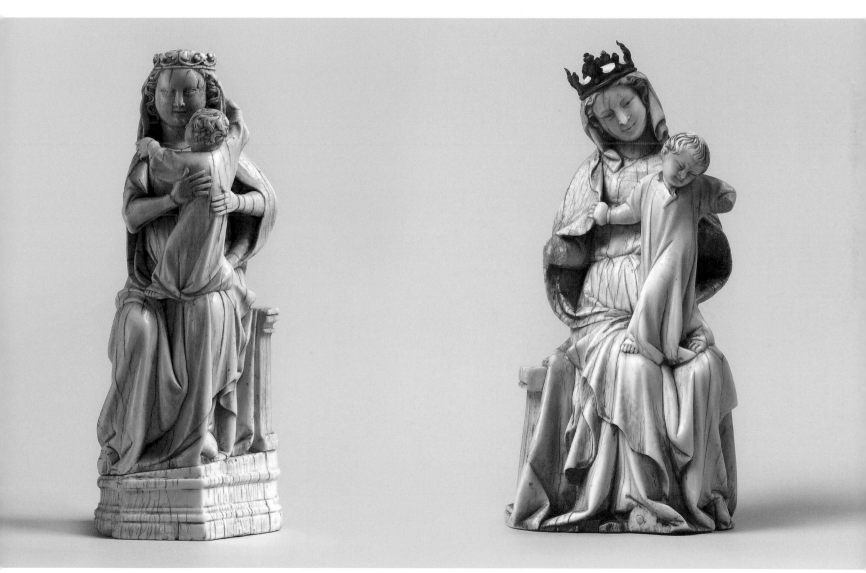

19

Saint Anne teaching the Virgin to read

France (Paris?), 2nd quarter 14th century
Height 100.8 mm, width 49 mm, depth 33.1 mm;
weight 117 g

Acquired from Brimo de Laroussilhe, Paris, 1998

This small and beautifully carved but extensively damaged statuette has an unusual subject (at least among Gothic ivories). The seated veiled woman wearing a wimple is the mother of the Virgin Mary, Saint Anne. She appears to gaze into the distance, avoiding eye contact with the viewer. On her lap she supports with her left hand an open book (both hand and book have breakages). Beside her right knee (that is, on the favoured side) stands the figure of her daughter, the Virgin, as a child. Saint Anne's right hand steadies the child, who holds open the book with her left hand. The Virgin's head, unfortunately, has been broken off, along with other fragile areas, such as the Virgin's lower right arm and hand. The head was originally attached to the shoulders by a dowel, for which the socket remains. Presumably the head broke off during manufacture and was replaced (the *Livre des métiers* permitted craftsmen to make repairs of this type, provided the piece that was inserted was the original). Or it could have been broken and repaired later. The original base is also missing. Unusually, the lower edge of the ivory cuts across the drapery of the two figures well above ankle height. This can hardly have been the original arrangement (compare nos. 17 and 18), and the ivory must have been cut at this point for reasons that are now obscure.

There are two closely related versions (Musée Vivenel, Compiègne; private collection), and also a wooden sculpture in the Thyssen-Bornemisza Collection, of a slightly different composition, in which Saint Anne supports the Virgin on her lap while the Virgin in her turn feeds the Christ Child on her lap. The attribution to a French, probably Parisian workshop, in the second quarter of the fourteenth century, seems assured. Very likely the statuette was made for the devotions of a woman, perhaps a religious involved in teaching, a widow who had retired to a convent, or indeed a pious mother who had chosen to remain 'in the world.' JL

BIBLIOGRAPHY

Unpublished
See further Sears in Barnet 1997, p. 21 (*Livre des métiers* reference); Koechlin, no. 710 (Compiègne *Saint Anne*); Randall 1993, no. 12 (private collection *Saint Anne*); Williamson 1987, no. 16 (wooden sculpture)

20

Saint John

Northern France, *c.* 1300–50
Height 68.6 mm, width 16 mm, depth 12.1 mm;
weight 19 g (including base)

Exhibited Colgate University, New York, 1983 to 1996;
sale, Sotheby's, London, July 4, 1996, lot 2

This small figure of a grieving Saint John is undoubtedly from a Crucifixion group. The back of the figure is flat, and the drapery folds do not continue, suggesting that the figure could not be seen in the round. Therefore the possibility that the saint stood on a crucifix, as has been suggested, should be ruled out. Instead the figure may have stood in front of a background of some sort, perhaps forming part of a tabernacle or altarpiece. It has been much worn by handling, and the top of the saint's head in particular looks as if it has been frequently kissed. Such devotion would presumably have taken place once the figure was removed from its original context. JL

 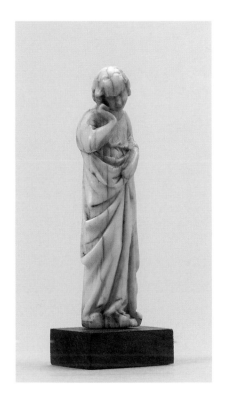

BIBLIOGRAPHY

Sale catalogue, Sotheby's, London, July 4, 1996, lot 2
See also comparable figures illustrated by W. Schenkluhn, *Nachantike kleinplastiche Bildwerke. Liebieghaus, Museum alter Plastik* (Melsungen, 1987), no. 35

21

Virgin and Child tabernacle/polyptych

Paris, 2nd quarter 14th century
Height approx. 243 mm, width 85.8 mm (closed),
210 mm (open), depth 47.6 mm (closed),
45 mm (open); weight 757 g

Formerly Van der Helle collection, Lille; Planquart
collection, Lille (no. 226); Max de Germiny collection,
Paris (in 1924); sale, Christie's, London, November 10,
2005, lot 147

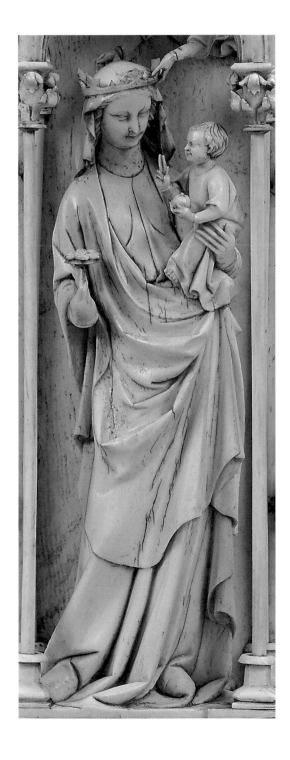

There were relatively few standardized types of object produced by craftsmen in ivory in the thirteenth and fourteenth centuries. One such, however, is the five-part tabernacle or folding polyptych. The example in the Thomson Collection is particularly delicately carved and well preserved. To fashion the tabernacle, the craftsman started out with a single large block of ivory. The chamfering off of the lower corners of the back of the main panel show how close the block was cut to the outside of the tusk. The chamfered edges were keyed for glue, presumably so that small strips of ivory could make up the rectangular outline. Because of the micro-architectural form of the tabernacle, it was vital that it be vertical and rectilinear, which meant ignoring the unavoidable spiral curvature of the tusk. The front face of the block (approximately 2.5 mm thick) was then sliced off, and divided in half to form two tall narrow 'doors' that would close the front of the tabernacle. The outside of the doors was left blank (there are traces of two silver catches) and the inside carved with figures in low relief. A similar thickness of ivory was also sliced off each side of the block, to form similar tall, narrow doors that could close off the sides of the tabernacle. Again, these were left blank on the outside and carved in low relief on the inside. Finally, the residual block was carved with the principal figures in such high relief that they appear to be in the round. This is remarkably skilful: it is hard to believe that the Virgin and Child are carved from the same block as the architectural setting (they are), for they appear to be free-standing figures, inserted into a space with a flat background and base plate. The exceptionally delicate columns were, however, turned separately on a lathe and then inserted in holes drilled in their respective bases and capitals. Finally the wings were hinged so that they could be opened in line with the back surface of the central tabernacle, and the tops of the wings were carved with gables surmounted by decorative crockets. The central block would originally have been surmounted by decorative metalwork, probably of silver, possibly gilded. This would also have had crockets, and probably a central pinnacle. Overall, the tabernacle/polyptych would have resembled a piece of precious metalwork, or some larger scale version of 'micro-architecture' in wood or stone.

The Virgin stands in the centre of the tabernacle, totally dominating her surroundings. She holds a flower (a rose?) in her right hand (compare the rosette decoration of the gables), and supports the Christ Child on her raised left arm. Mother and son look towards one another. Christ holds a fruit in his left hand and blesses his mother with his right. A wingless angel appears from a suggestion of heavenly clouds in the trefoil head of the arch to place a crown on the Virgin's head.

The wings of the polyptych are carved with a short infancy cycle: at the top left is the Annunciation with a small angel flying down to the Virgin. Alongside to the left is the Visitation, with the Virgin greeting Elizabeth,

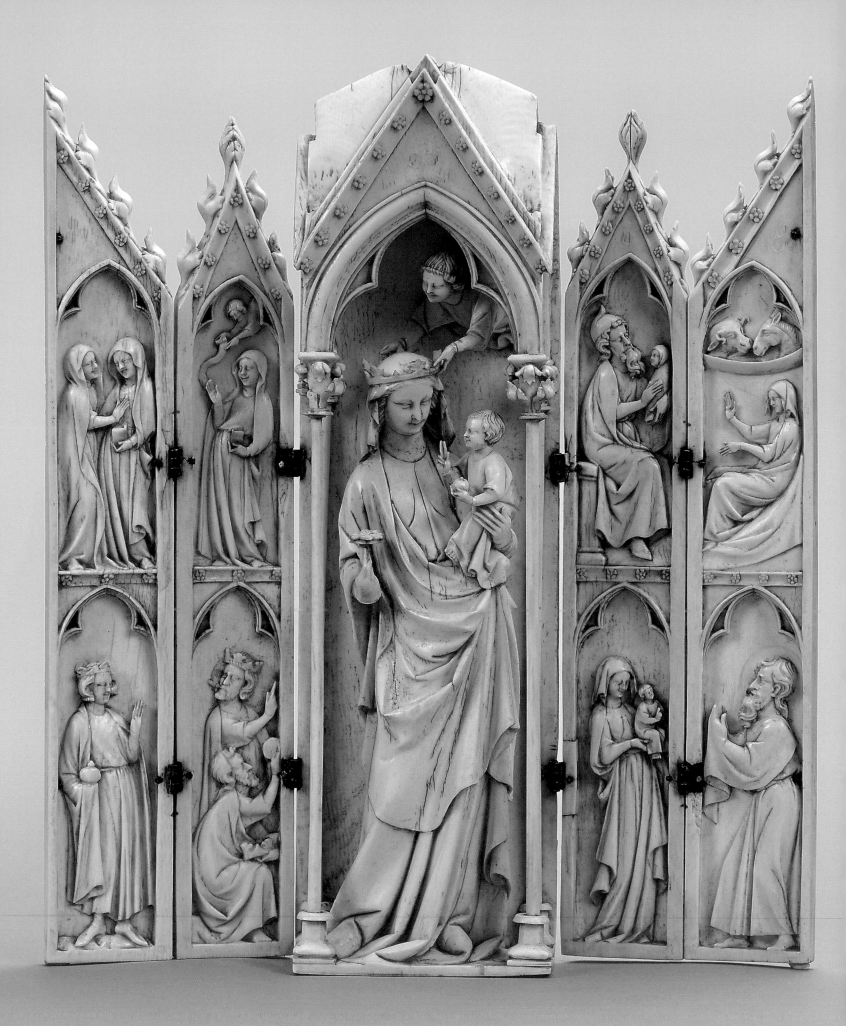

the mother of John the Baptist (Luke 1: 41–45). In the upper half of the wings to the right the seated Joseph, wearing a 'Jewish cap,' holds the swaddled Christ Child before him. At the right the Virgin raises both arms, indicating that she has just passed her son to Joseph. She reclines on a mattress. Above her the heads of the ox and ass appear behind a simple curving strip, representing the manger (in other examples this type of manger has a single supporting leg, and looks a little like a chalice). Below at the left are the three Magi of the Adoration. The first kneels and looks up at the central Virgin and Child, who appear, in contrast, of enormous size. He has taken off his crown, which he holds with his left hand, while with his right he reaches up towards the Child and offers him a round host. His companions look at one another. On the lower half of the right wing we see the Christ Child presented by Mary to the chief priest, Simeon. Simeon's hands are covered as a sign of respect, but the representation of his left hand beneath the drapery is carved with exceptional skill.

By general agreement such tabernacles are works of Parisian manufacture of the first half of the fourteenth century. There are two very similar examples in the Victoria and Albert Museum, inv. nos. 4686–1858 and 370.1871 . Slightly less close is Louvre OA 2857. There are a few traces of polychromy on the Thomson tabernacle, mainly in the trefoil arches. The polychromy of some of the comparable examples is much more extensive. JL

BIBLIOGRAPHY

Koechlin, vol. II, pp. 126, 129, no. 155; vol. III, pl. XL
See also Longhurst 1927–29, pls. VII–VIII (Victoria and Albert examples); Gaborit-Chopin 2003, no. 143, colour ill. p. 450

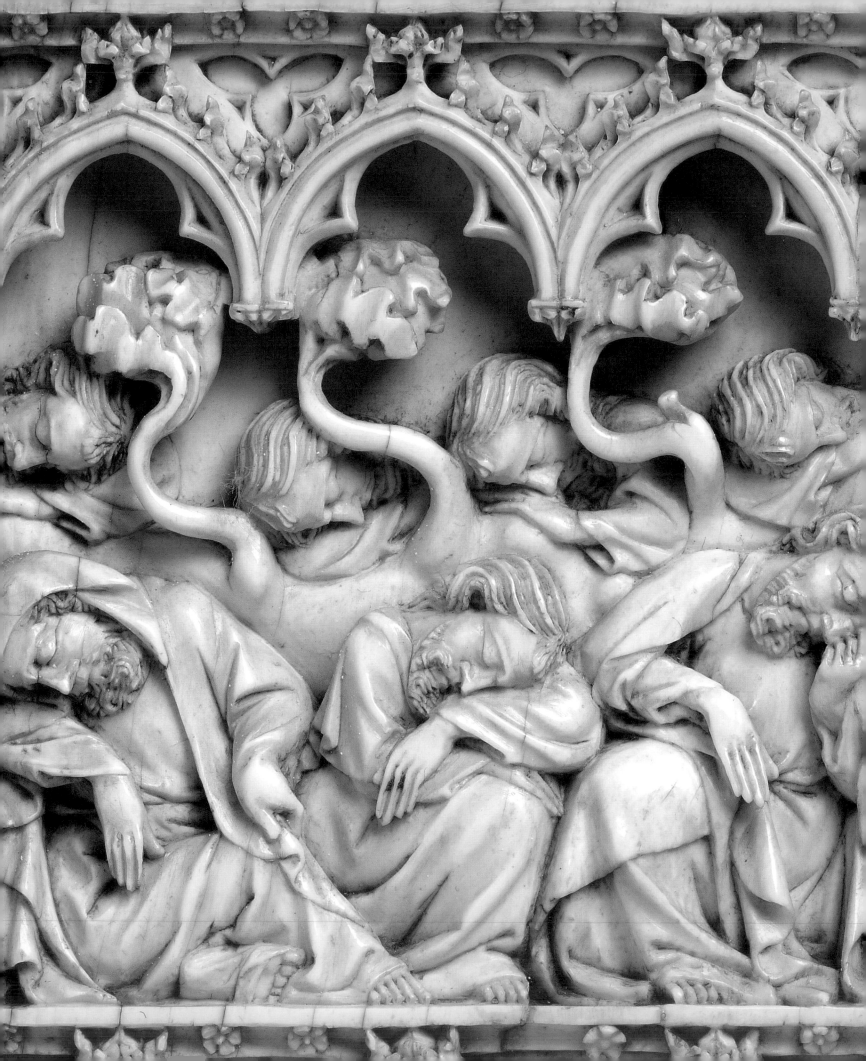

Passion diptychs:
Variants on a theme

Passion diptych in three registers

Paris, c. 1275–1300?
Height 189 mm, width 97.1 mm (closed),
194.5 mm (open), depth 12 mm; weight 448 g

Formerly Spitzer collection; Spitzer sale, 1893, no. 210;
Hohenzollern collection, Sigmaringen, no. 7289;
Robert von Hirsch collection; sale, Sotheby's, London,
June 22, 1978, lot 285

BIBLIOGRAPHY

La Collection Spitzer, vol. 1 (Paris, 1890), no. 96;
Heiner Sprinz, *Die Bildwerke der Fürstlich
Hohenzollernschen Sammlung Sigmaringen* (Stuttgart,
1925), p. 4, no. 7, pl. 5 (inv. no. 7289); *Kurzes
Verzeichnis der im Staedelschen Kunstinstitut ausgestellten
Sigmaringer Sammlungen* (Frankfurt, 1928), no. 246;
The Robert Von Hirsch Collection, vol. 2 (sale catalogue,
Sotheby's, London, June 22, 1978), lot 285;
Koechlin, no. 240
See also Barnet 1997, fig. 25a (Amiens example)

Beneath an arcade of trefoil-headed pointed arches of smooth profile, four in each of the three registers, are twelve scenes from the Passion of Christ. Beginning at the bottom left we see Judas receiving payment for betraying Christ (Matthew 26: 14–15, etc.), with the Betrayal and Peter cutting off Malchus's ear to the right (John 18: 10–11). Moving to the right wing, Christ is brought before the high priest, and buffeted while his head is covered (Mark 14: 56; Luke 22: 64). In the next register at the left Judas hangs from a tree (Matthew 27: 3), his intestines spilling out (Acts 1: 18). Next to him Christ is flagellated at the column while to the right Pilate washes his hands (Matthew 27: 24, 26, etc.). Then we have Christ carrying the Cross, preceded by a woman (the Virgin?) and followed by a figure carrying the nails. This is followed by the Crucifixion: Christ is offered vinegar on a sponge, and observed from the right by a small crowd amongst whom one person indicates him and holds a scroll (probably the centurion who declared, "Truly this was the Son of God": Matthew 27: 54 etc.), while at the left Longinus kneels in prayer, his lance over his left shoulder. In the top register we see the Deposition; the Anointing and Entombment of Christ's body; the *Noli me tangere* with the Magdalene kneeling in front of a gilded tree; and finally Christ harrowing hell, leading Adam and Eve from the hell-mouth while a small devil observes from the right and John the Baptist holds his hands in prayer at the centre. The ivory is extensively, but crudely, re-gilded. On the back is an inventory number of the Hohenzollern collection, 7289, written in black ink.

The combination of scenes has a close but not exact parallel in a diptych at Amiens, France. But stylistically the pair are not so close. The scale and proportions of the figures echo those of the 'Soissons group' ivories, suggesting an attribution of this diptych to Paris in the late thirteenth century. JL

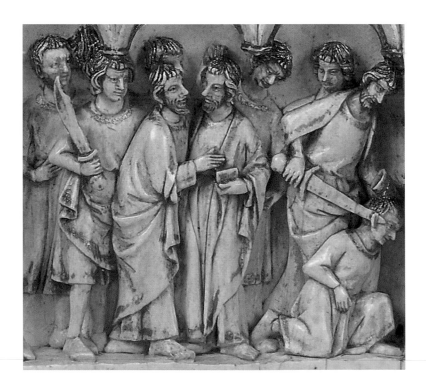

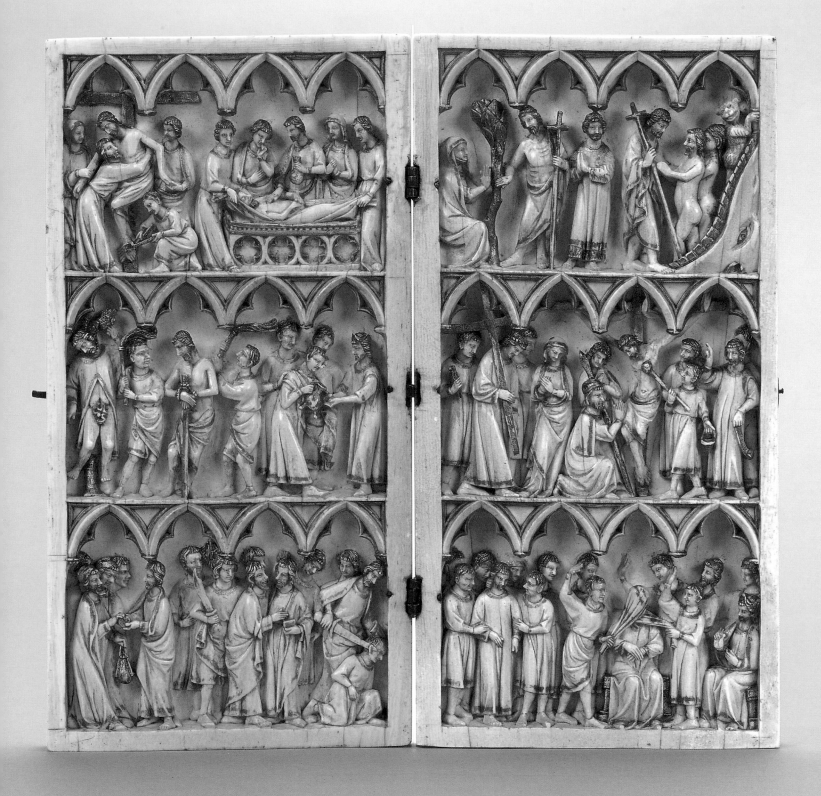

23

The Dormeuil Diptych

Paris, c. 1350–75

Height 251 mm, width 156 mm (closed), 311 mm
(open), depth 12–13.5 mm; weight 1110 g

Formerly Spitzer collection; Spitzer sale, 1893, no. 96;
Oscar Hainauer collection; Dormeuil collection; sale,
Sotheby's, Paris, November 19, 2007, lot 11

BIBLIOGRAPHY

La Collection Spitzer, vol. 1 (Paris, 1890), no. 61;
W. Bode, *Die Sammlung Oscar Hainauer* (Berlin,
1897), p. 82, no. 136; *Exposition d'objets d'art du
Moyen Age et de la Renaissance organisée par la Marquise
de Ganay chez M. Jacques Seligmann* ... (Paris, 1913),
pp. 58–59, no. 114; Koechlin, no. 789; *Collection
Dormeuil. Ivoires et émaux du Moyen Age* (sale catalogue,
Sotheby's, Paris, November 19, 2007), lot 11,
with further references

This Passion diptych is equal in width to the largest surviving ivories, indicating that the material from which it was carved was the most expensive available. After cutting the block into two, the resulting plaques were arranged so that when closed they were back to back. The usual procedure seems to have been to organize the plaques so that they closed face to face. The surface was then planned for three registers, each crowned by a cusped arcade with five hanging capitals and six arcuated apertures. This means that the centre of each composition aligns with a capital, restricting the space available beneath. In every scene Christ is placed beneath an arch, thus never in the centre of the composition, but this, far from being a problem, contributes greatly to a lively sense of movement in these traditional scenes. Beginning with the Raising of Lazarus (an optimistic, but relatively unusual start to a Passion diptych; see also no. 27), the diptych continues with the Entry to Jerusalem, the Washing of the Apostles' Feet, the Last Supper, the Agony in the Garden, the Betrayal and Suicide of Judas, and finally the Crucifixion. The vertical borders of both wings were cut, presumably in the nineteenth century, for decorative intarsia work, perhaps in ebony. We can compare an ivory tabernacle at the Cathedral at Trani (Puglia) which was treated in a comparable fashion. But the cuttings are now filled with ivory plugs, and the result looks messy, which would surely have angered the original craftsman.

The visual complexity of this diptych makes the study of its images especially rewarding. It is only possible here to give a hint as to how such a work might have been viewed. First, compare Judas as he hangs from a tree with Christ hanging from the cross. Both have their heads slumped to the left, but Christ's arms are raised whereas Judas's hang down. Christ's torso is bare but his abdomen and loins are covered. Judas's torso is covered but his abdomen and loins are bare. Longinus kneels before Christ, his hands raised in prayer, much as Christ does when he prays on the Mount of Olives. But Judas, as he accepts the sop from Christ at the Last Supper, kneels with one hand raised in a position that seems almost to be a parody of that of prayer. In his suicide Judas's hands are turned out, like the hands of the soldier arresting Christ, adjacent to the left, but also in an echo of the despairing hands of Mary at the Crucifixion, adjacent to the right.

Among the three-register Passion diptychs, this one is most similar to the diptych at Berlin (Staatliche Museen, inv. no. 634, 635), an object already documented in 1694. But if the two are very close iconographically, they are surprisingly different stylistically. The carving in the Dormeuil Diptych is much more precise and controlled. As with many such situations in the corpus of medieval ivories, this combination of similarity and difference presents a serious obstacle to interpretative strategies. Is one a copy of the other? Are both based on a lost common model? Are they both products of the same workshop? None of these questions seems to get to the heart of the matter. JL

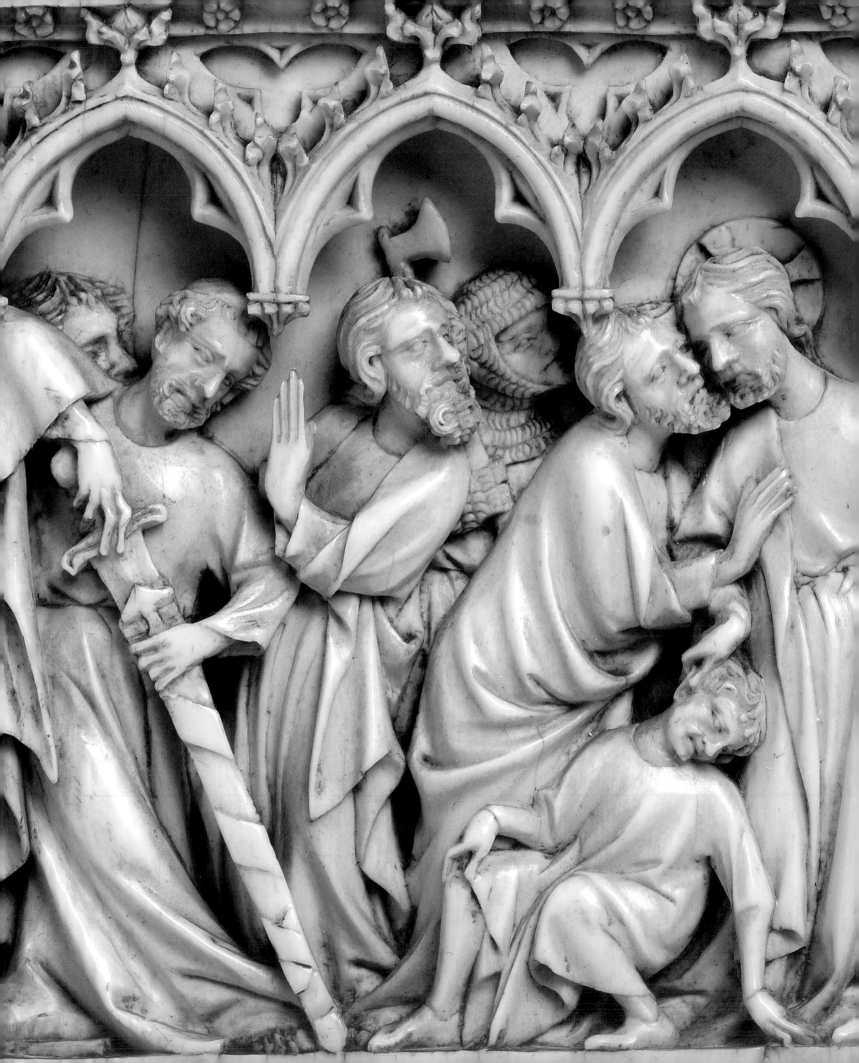

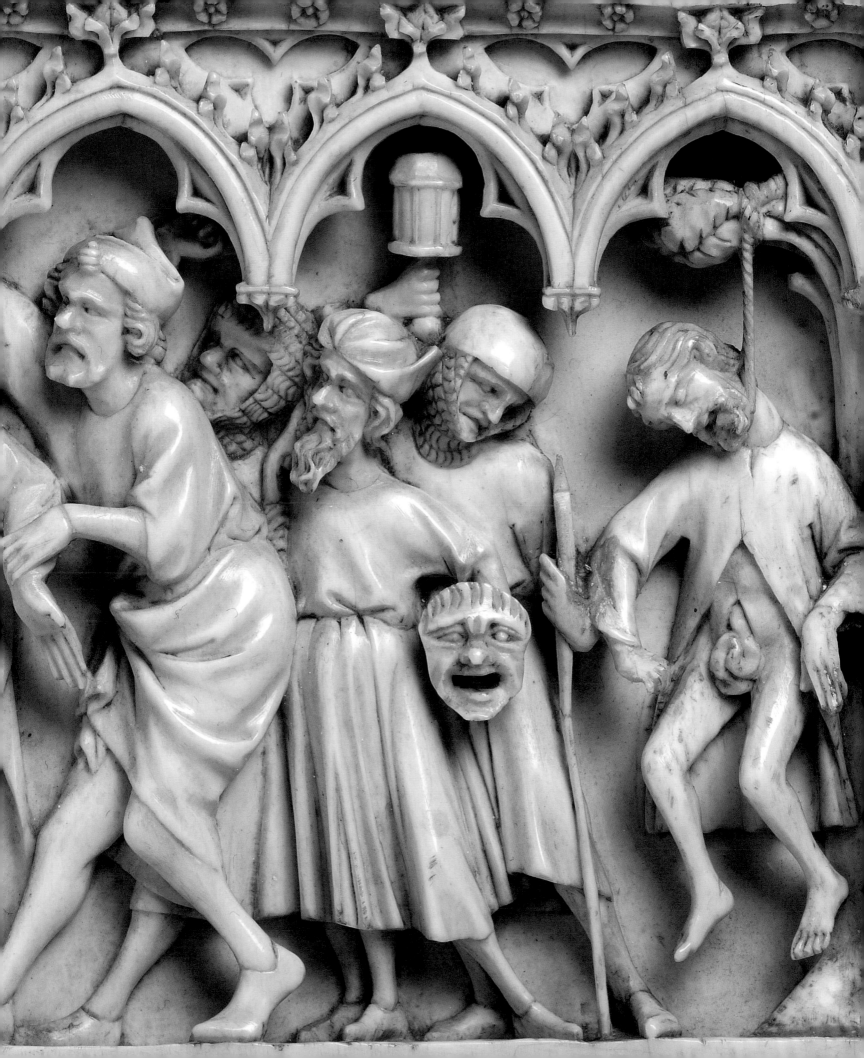

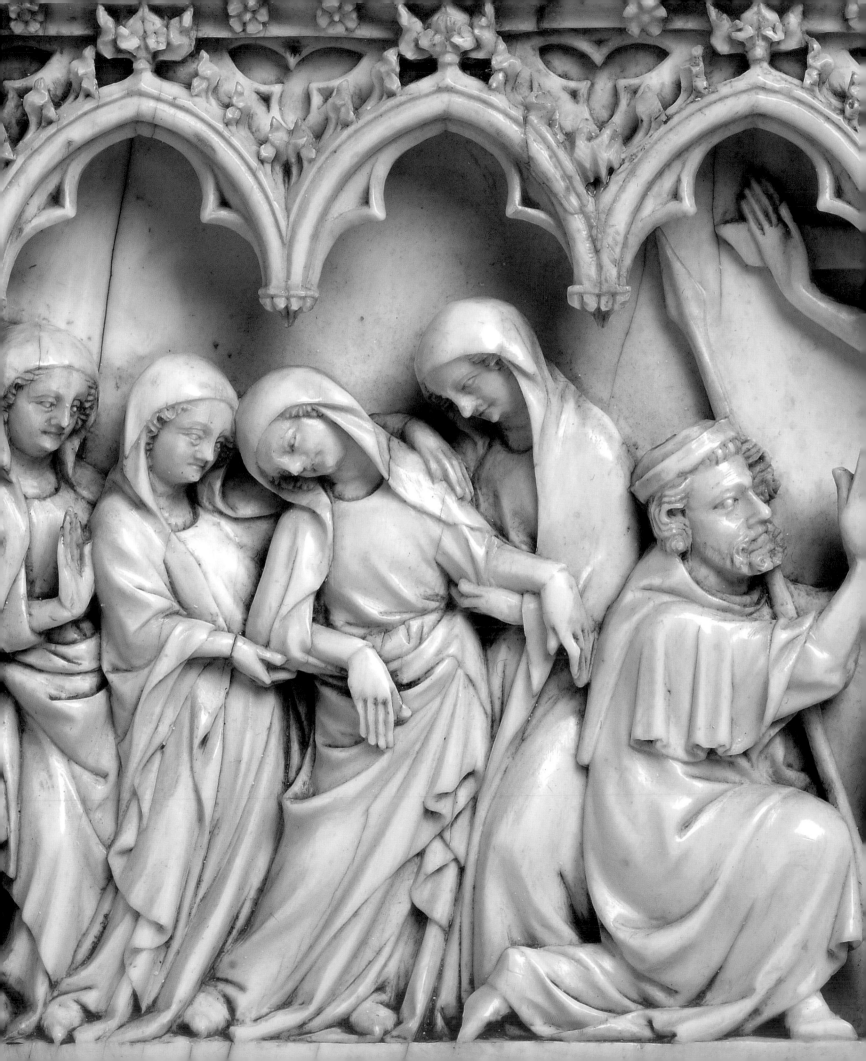

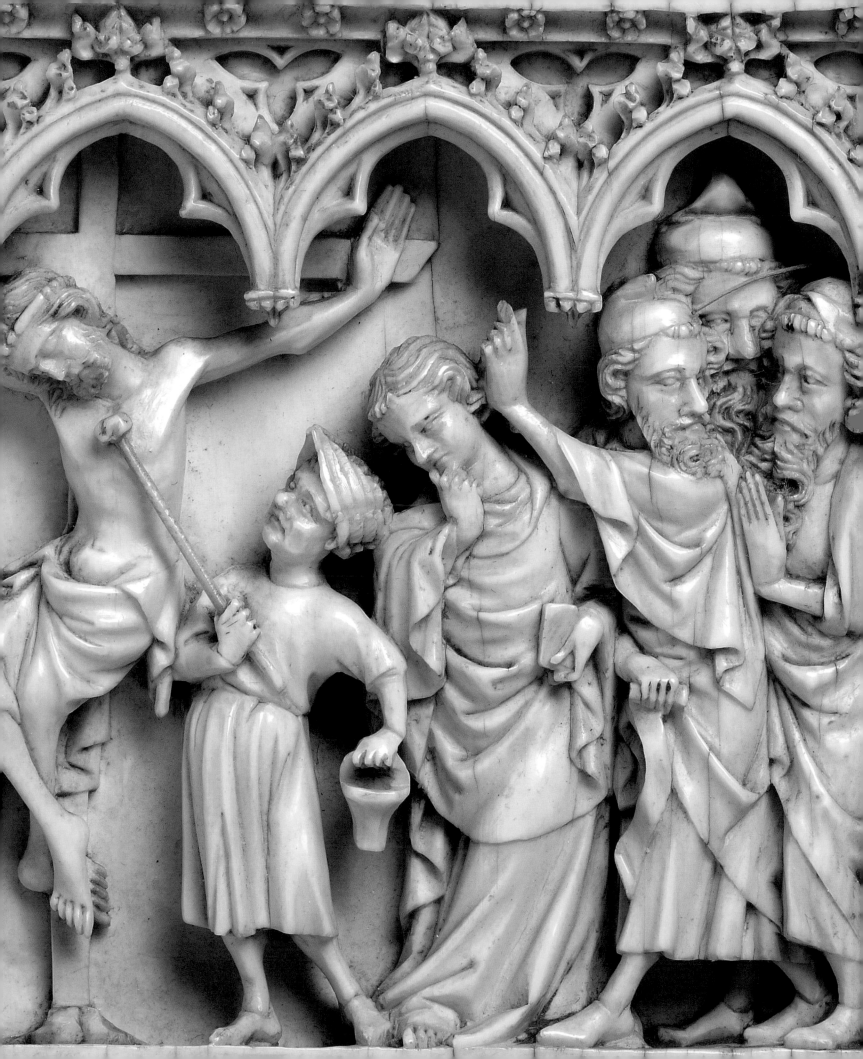

Passion diptych in three registers

Paris or Cologne?, *c.* 1350–75
Height 231 mm, width 114 mm (closed),
231 mm (open), depth 10.7 mm; weight 707 g

Sale, Sotheby's, London, December 13, 2000,
lot 11

BIBLIOGRAPHY

Sale catalogue, Sotheby's, London,
December 13, 2000, lot 11
See also Gaborit-Chopin 2003, no. 188
(for the Louvre example)

This three-register Passion diptych is exceptionally well preserved and very carefully executed. However, the hinges and catches are modern replacements, and the evidence for the original hinging is now hard to see. The composition reads from left to right and from top to bottom. The scenes, set beneath a crocketed arcade of five cusped arches, are very detailed. Only a few such details are noted here. In the Entry to Jerusalem, the diminutive foal, accompanying the donkey on which Christ rides, has lost its head. Next comes the Washing of the Apostles' Feet (John 13: 3–11), with Peter indicating "not only my feet, but my hands and my head as well" (John 13: 9). Then we see the Last Supper, with John reclining on Christ's breast (John 13: 23), while Judas in the foreground takes the sop from Christ (John 13: 26). The row of bare feet visible under the table look odd, but can be parallelled in no. 25 and in part in the Dormeuil Diptych (no. 23). In the Agony in the Garden the Disciples sleep in a variety of poses, while Christ kneels centrally in prayer. The Betrayal includes the usual incident of Peter sheathing his sword after cutting off Malchus's ear. Finally we see the Crucifixion, which includes the figures traditionally identified as Longinus (with the spear), who kneels in prayer, and Stephaton (with the sponge and the vinegar). The pointed faces, and the treatment of the soldiers in the Betrayal with short tunics revealing most of their legs and four buttons at the neck, are characteristic. There are no easily identifiable traces of gilding or pigment. Detailed comparison with the Dormeuil Diptych is particularly interesting.

The Crucifixion has a close relative in a diptych in the Musée du Louvre, attributed to the Meuse/Rhine area, *c.* 1340–50. Radiocarbon dating produced a date of 775 ± 35 years B P, corresponding to a 95% probability of a date for the ivory, when calibrated, within the range 1210–90. J L

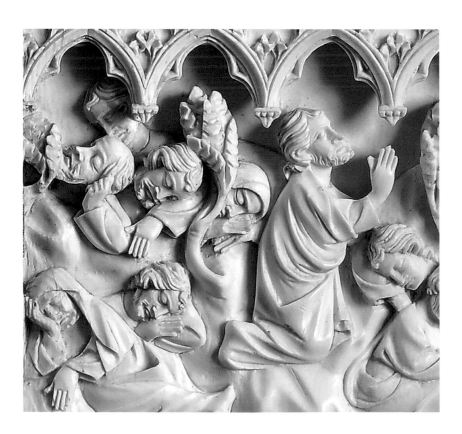

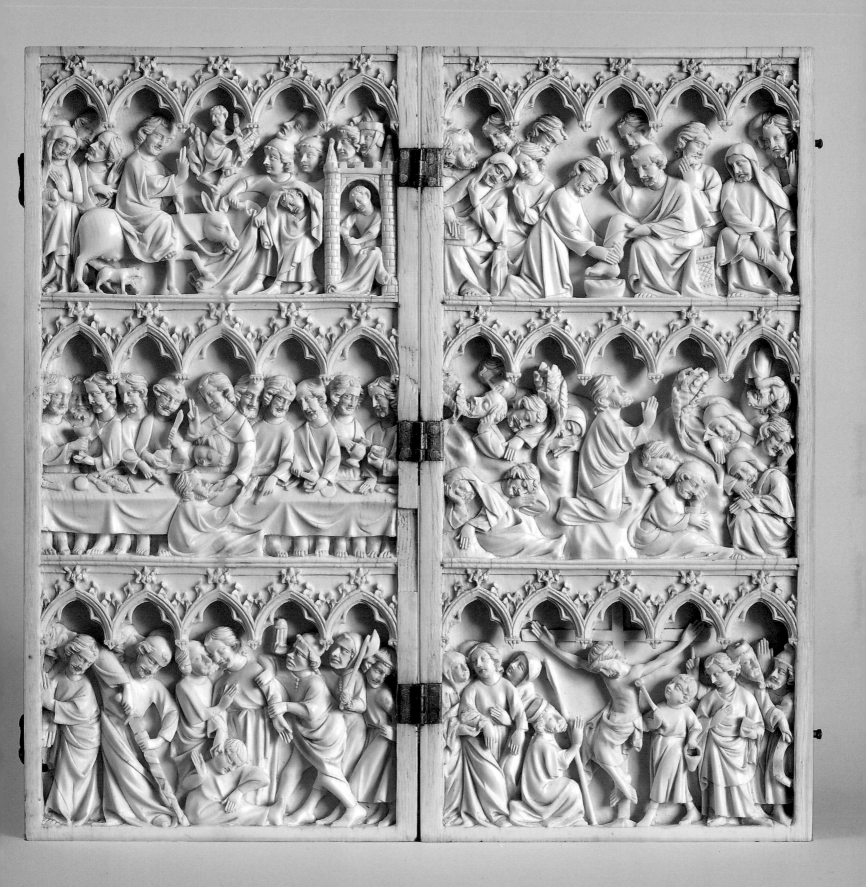

25

Passion diptych in two registers, Entry to Jerusalem to Agony in the Garden

Paris, c. 1350–75
Height 208 mm, width 150 mm (closed),
301 mm (open), depth 19.6 mm; weight 1457 g

Acquired from Maria Baer, London, 1979

This diptych is carved from an exceptionally thick block of ivory, and the width of 151 mm for each wing is close to the limit of what can be obtained from an elephant's tusk. The panels are cut from close to the centre of the tusk, but they are mounted back to back (when the diptych is closed), rather than the more usual face-to-face arrangement. On the back are crudely scratched post-medieval jottings, hard to decipher. Two are in the form of monograms, perhaps of the seventeenth century. One is formed of the letters RBES around the letters AV, and the other with the letters MORUS, in the form of a heart. The diptych is carved in high relief with four scenes in two registers, and figures at an unusually large scale: the Entry to Jerusalem (John 12: 12–15), Christ washing the Apostles' Feet, with Saint Peter indicating his head (John 13: 9), and, in the lower register, the Last Supper, with Judas isolated against the front of the table, John laying his head on Christ's breast (John 13: 23), and only seven other Apostles (for a comparable arrangement with fewer than twelve Apostles see Koechlin, no. 799; sale, Sotheby's, London, July 4, 1996, lot 5). The serried rank of bare feet beneath the table cloth is strange – but compare the similar arrangement in no. 24, and note the alternation of feet that are visible and covered in the Dormeuil Diptych (no. 23). At the right is Christ praying on the Mount of Olives, with eleven sleeping Apostles. Placing the narrative below an arcade of four arches causes the sculptor some problems, most obvious in the Last Supper, as the centre of the composition is aligned with a capital rather than an arch.

The selection of scenes, especially the choice of the Agony in the Garden as a conclusion, is puzzling. There is no evidence to support the hypothesis that the leaves could have once formed part of a tabernacle and been accompanied by further scenes. The two registers correspond to the upper two of the three registers of a Passion diptych such as the Dormeuil Diptych, or no. 24. They make sense visually, and such a large and expensive diptych can hardly be considered the result of a mistake or lazy oversight. The issue remains open. JL

BIBLIOGRAPHY

Treasures of a Collector: European works of art, 1100–1800 from the Thomson Collection (Toronto: Art Gallery of Ontario, 1997)

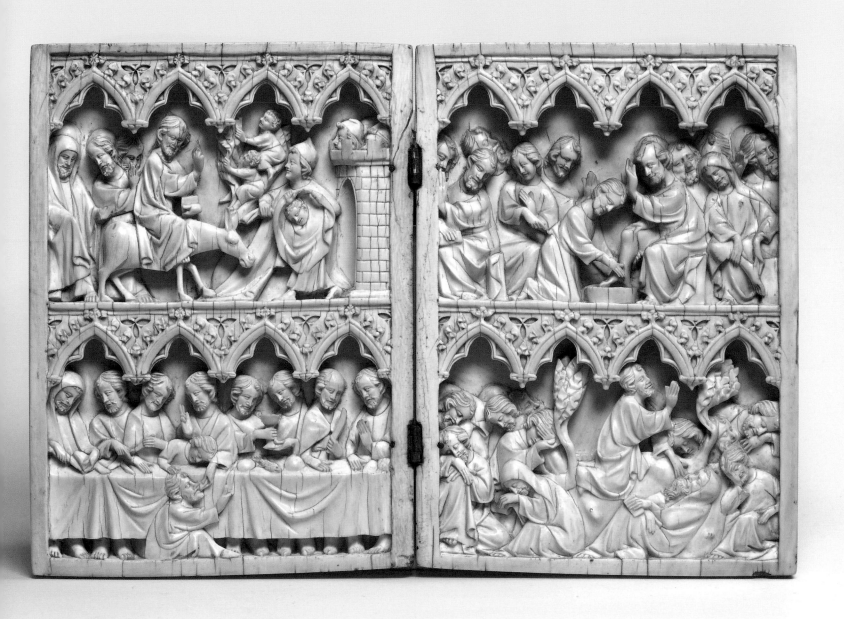

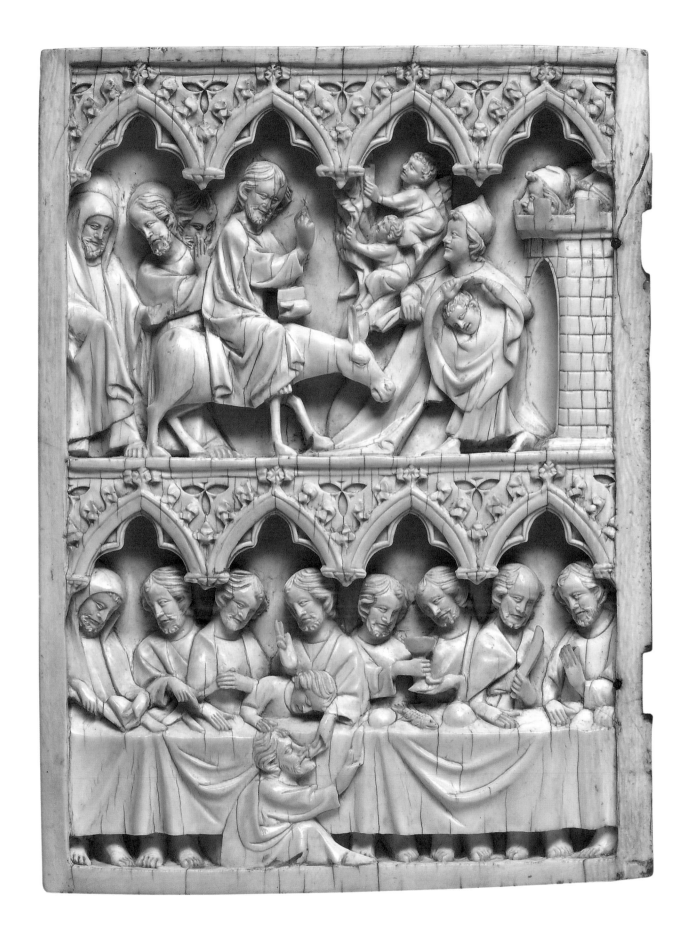

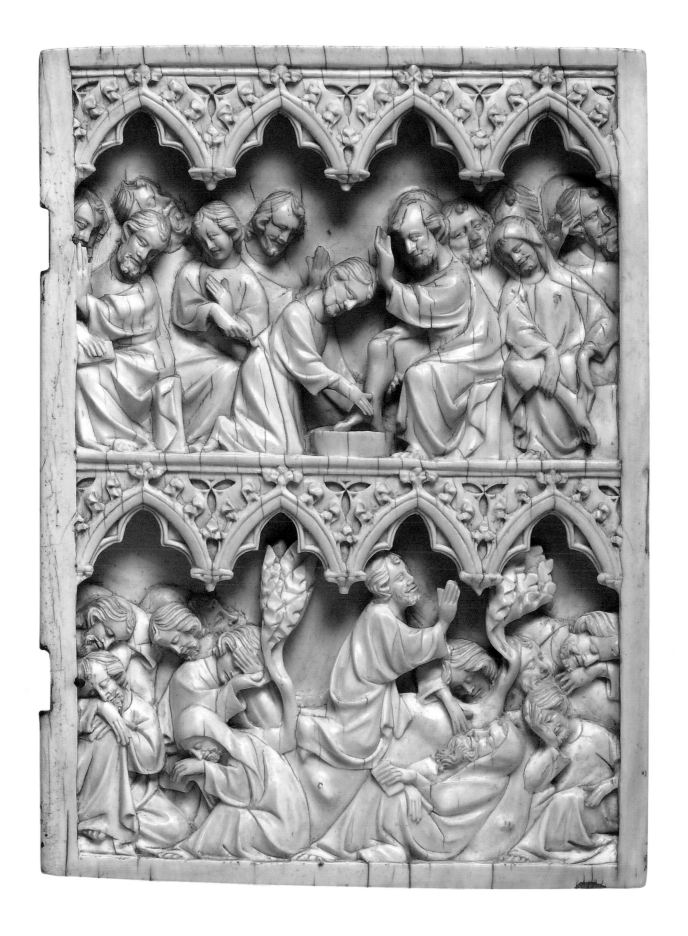

Covers of a set of writing tablets

Paris, *c.* 1350–75
Height 109 mm, width 73.8 mm (each),
depth 7.9 mm; weight 66/67 g (each)

Acquired from Brimo de Laroussilhe, Paris, 2005

BIBLIOGRAPHY

Sale catalogue, Maastricht, 2005, illus. p. 186
See also Bernard Bousmanne, 'A propos d'un
carnet à écrire en ivoire du XIVe siècle conservé
à la Bibliothèque Royale de Belgique', in
"*ALS ICH CAN*": *Liber Amicorum in Memory of
Professor Dr. Maurits Smeyers*, Bert Cardon, Jan Van
der Stock and Dominique Vanwijnsberghe (eds.)
(Paris, Leuven and Budley MA, 2002),
pp. 165–202

These small thin panels have the hollowed-out backs (see illustration) characteristic of writing tablets. The indentation would have been filled with a thin layer of wax, possibly coloured, on which it was possible to write with a stylus. The conspicuous trace of the nerve canal on the back of the right panel would thus have been hidden. Three trapezoidal marks on the back of the left panel suggest that the panels were originally glued to strips of parchment, and additional panels, carved for wax on both sides, would have been provided between what would thus have been the outside panels of a small booklet. The outer sides of the booklet were carved in relief with the Entry to Jerusalem and the Washing of the Apostles' Feet, on the left panel, and the Betrayal and Crucifixion on the right. Thus when the booklet was open and lay written-face down, the narrative proceeded from left panel to right, but when it was closed, the top/front, with the Betrayal and Crucifixion, provided an appropriately limited narrative. The swaying figures in all four scenes provide narrative echoes between scenes.

It is striking that despite its small size the writing-tablet diptych echoes in great detail the content of the much larger Passion diptychs such as the Dormeuil Diptych (no. 23), or no. 24. The crowded group of eleven Apostles around Christ in the Apostles' Baptism is an example of extraordinary skill in relief carving.

Paper labels on the back of both panels with the inscription N. *6043* in a French nineteenth-century script have yet to be traced to a collection. JL

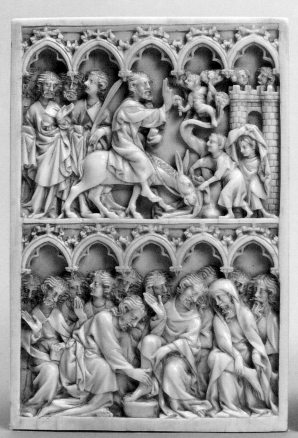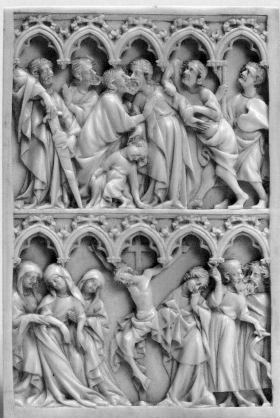

27

Abbreviated Passion diptych

Saxony/Thuringia, *c.* 1350–75
Height 167 mm, width 118 mm (closed), 237 mm
(open), depth 11 mm; weight 562 g (including chain,
c. 15 g?)

Acquired from Galerie Charles Ratton–Guy Ladrière,
Paris, 1992

This is an exceptionally well preserved ivory. It has a relatively unusual combination of scenes, starting at the top left with the Raising of Lazarus (for this compare the Dormeuil Diptych, no. 23). Martha, with knotted veil, and Mary implore Christ's aid. The Apostles react to the smell of the corpse. Lazarus kneels half in and half out of his tomb. To the right Christ enters Jerusalem, the foal beneath the legs of the ass. Below to the left is the Crucifixion, the Virgin pierced by the blood from Christ's side in the shape of a sword (partially broken off): compare Luke 2: 35, "a sword shall pierce thy side." To the right Christ is lowered into the tomb, his torso supported by two of the Maries, while in front of the tomb an Apostle holds Christ's right hand to his lips. The diptych has a silver suspension chain (not original), and part of the left border of the right wing is missing.

This diptych is very close to one in the Czartoryski Museum in Cracow, Poland, and another in Cleveland. All are attributed by Randall to Saxony/ Thuringia and dated to the third quarter of the fourteenth century. Radiocarbon dating produced a date of 535 ± 30 years BP, corresponding to a 95% probability for the ivory of a date, when calibrated, within the ranges 1320–60 and 1380–1440. JL

BIBLIOGRAPHY

Le monde médiéval (exhibition catalogue,
Galerie Charles Ratton–Guy Ladrière, Paris,
March 12–April 12, 1991), pp. 16–17
See also Koechlin, no. 787 (Cracow example);
Randall 1993, no. 146 (Cleveland and other
examples)

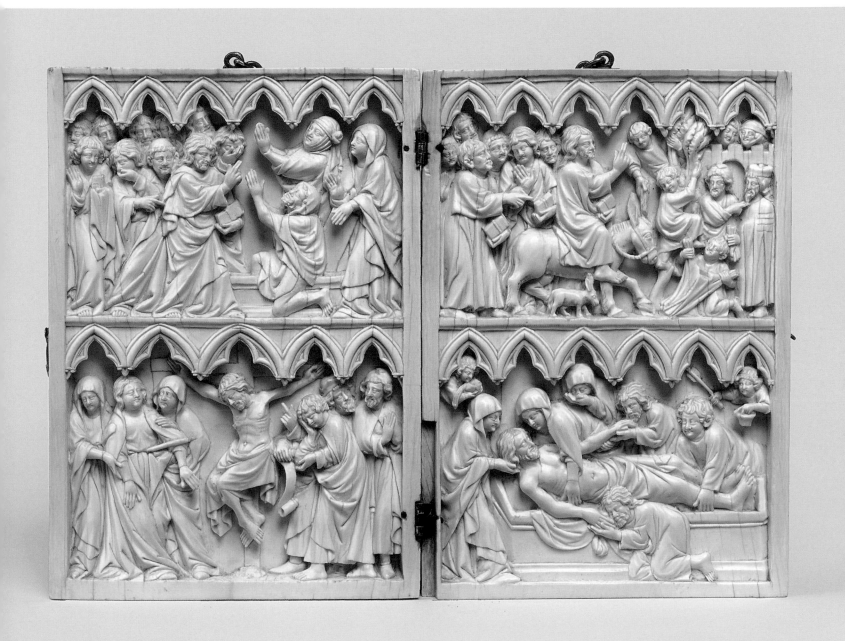

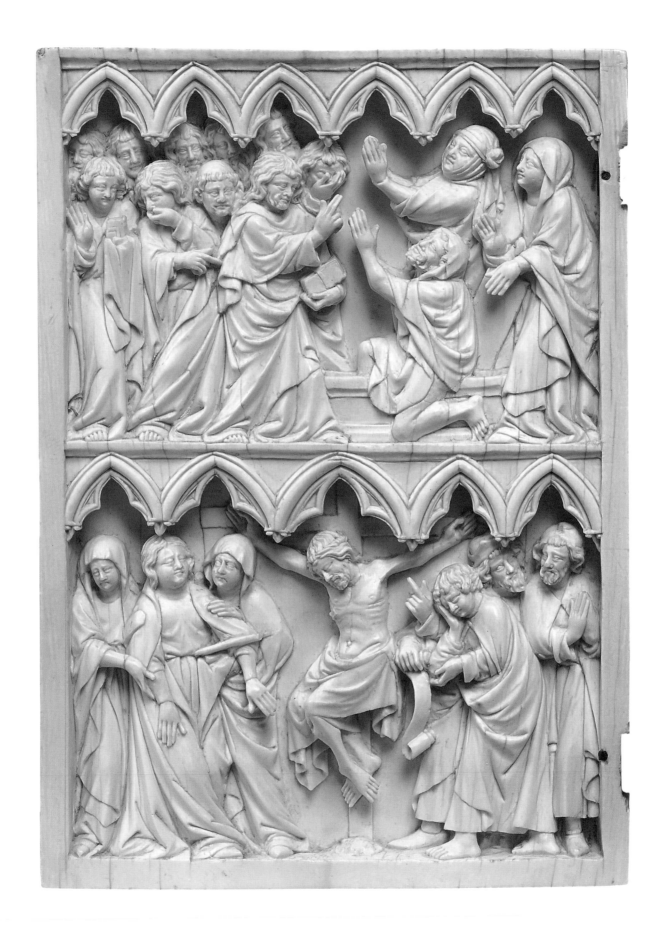

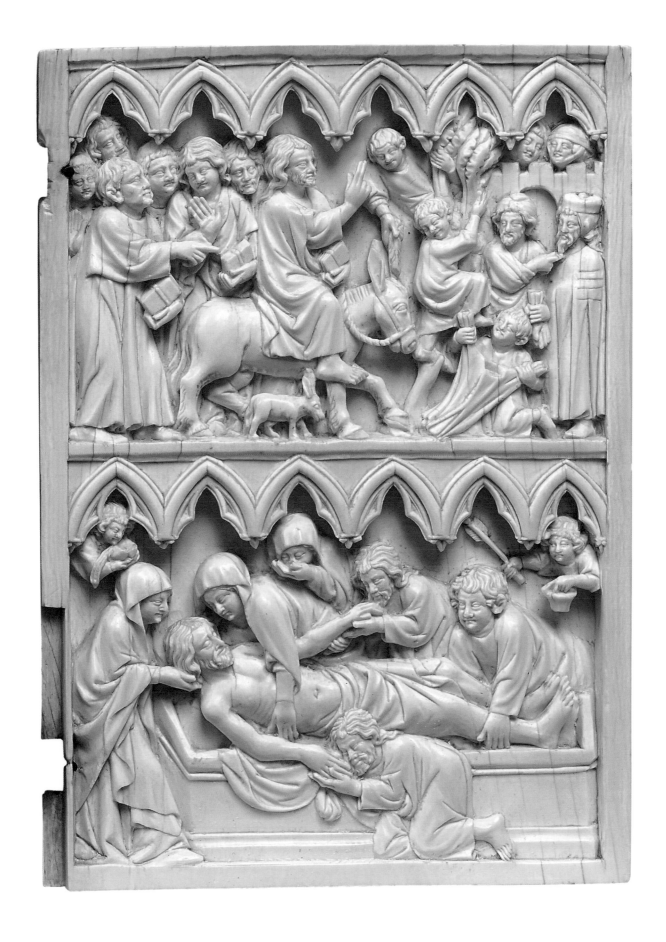

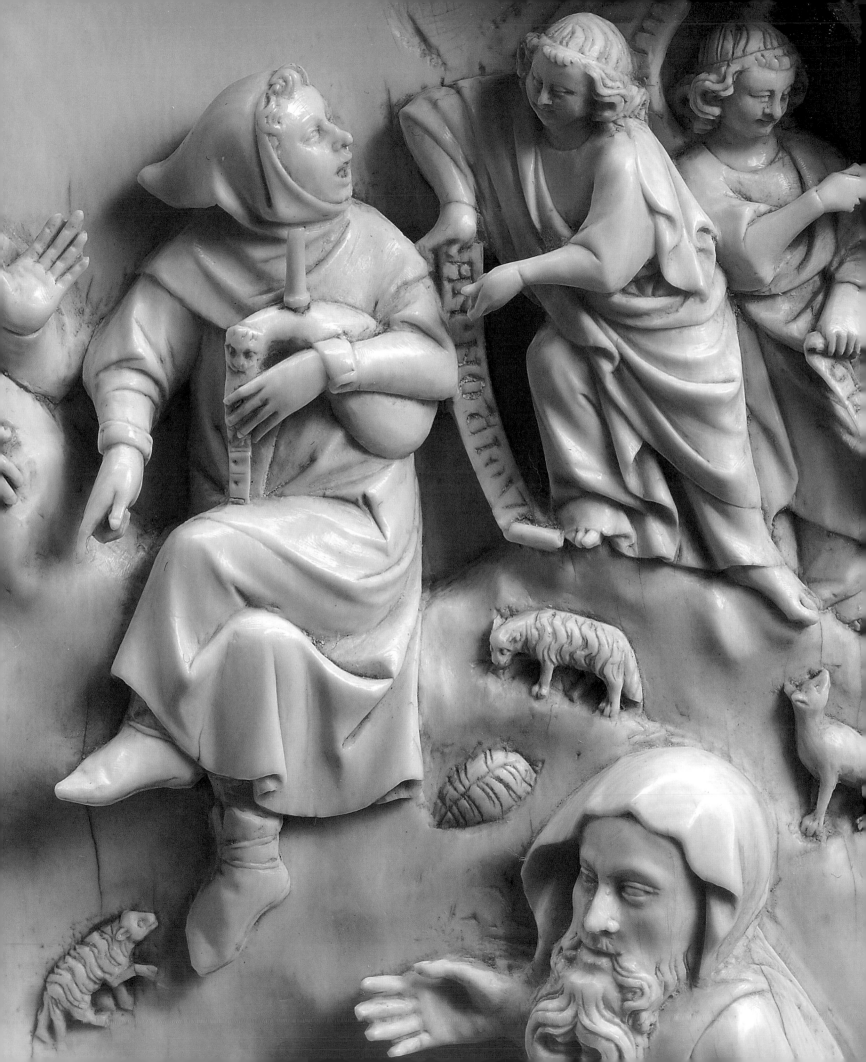

Diptychs with other scenes

28

Diptych with the Nativity and the Last Judgement

Paris, *c.* 1300
Height 182 mm, width 133 mm (closed), 268 mm
(open), depth 18 mm; weight 1181 g

Said to have been in the Leven and Essingen collections,
Cologne (unconfirmed); sale, Renaud-Giquello, Paris,
October 18, 2005, lot 104; acquired from Sam Fogg,
London, 2006

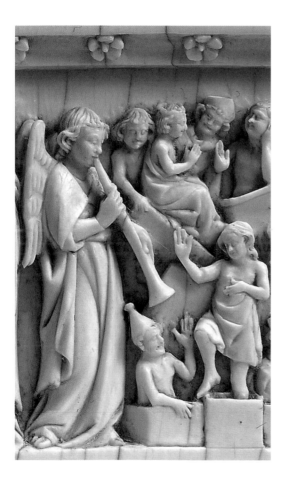

This magnificent diptych was dismissed by Raymond Koechlin in 1924 as a nineteenth-century fake, and this opinion has long been maintained. It was offered for sale in Paris in 2005, when it was catalogued as a work of "*c.* 1820/30." Radiocarbon dating, however, has established that the ivory is indubitably medieval. The date of the ivory is indeed surprisingly early: there is a 95% probability that the elephant from which it was taken died between 1030 and 1220 (900 ± 30 years BP) (test A) or between 1046 and 1219 (880 ± 25 years BP) (test B). Since the diptych appears to have been carved *c.* 1300 obviously an old tusk was used. A number of scenarios to explain such use can be imagined. It is hard to believe that a nineteenth-century forger could have found (or would have wanted to find) a large block of uncut ivory some seven centuries old on which to work. That aspects of the diptych have few if any parallels in surviving works is not in question. But other elements in it find numerous parallels in ivories of which the authenticity has not been doubted. If the authenticity of the present diptych is not accepted, it follows that its closest relatives, such as Musée du Louvre inv. no. OA 2755, which also combines in diptych form the Nativity and Annunciation to the Shepherds with the Last Judgement, must be rejected, too. But the Thomson Collection diptych, it is argued here, is a genuine medieval work.

The diptych is carved from near the centre of a tusk, perhaps avoiding the midpoint, discoloured by the nerve canal (visible at the centre of the lower border of the Nativity). The tablets are unusually thick (18 mm), and this has been exploited by the craftsman, who has carved different elements of the compositions to differing depths. In the spandrels of the arches are the Evangelists and their symbols, carved in relatively low relief (about 3 mm). Matthew and Mark on the left leaf pause from their writing, Matthew to think, Mark to sharpen his quill. Their symbols, the Man and the Lion, appear from the clouds of heaven each carrying a scroll (the text of the Gospel). Matthew appears to be tonsured, and Mark has his head covered, both unusual features. On the right wing are John, with the Eagle, at the left, and Luke and the Calf, at the right. John has long wavy hair and beard, and raises his penknife (oddly in his right hand). Luke is tonsured and appears to be dressed as a monk. Beneath the angel voussoirs to either side, a feature unique to this ivory, the full depth of the material (about 15 mm) is used in a tympanum-like space for the Annunciation to the Shepherds (left) and Christ in Judgement (right). In the lower part of each panel the sculptor returns to a much shallower relief for the Nativity (left) and the Resurrection (right). The kneeling figure of Joseph occupies a middle depth on the left, and the Virgin and Saint John likewise on the right. The lack of balance between the compositions of the two wings is another unusual feature (but compare Louvre OA 2755), and it is disturbing.

The angel voussoirs are composed of six angels per arch, set beneath trefoil-headed canopies. Each of the angels framing the Nativity/

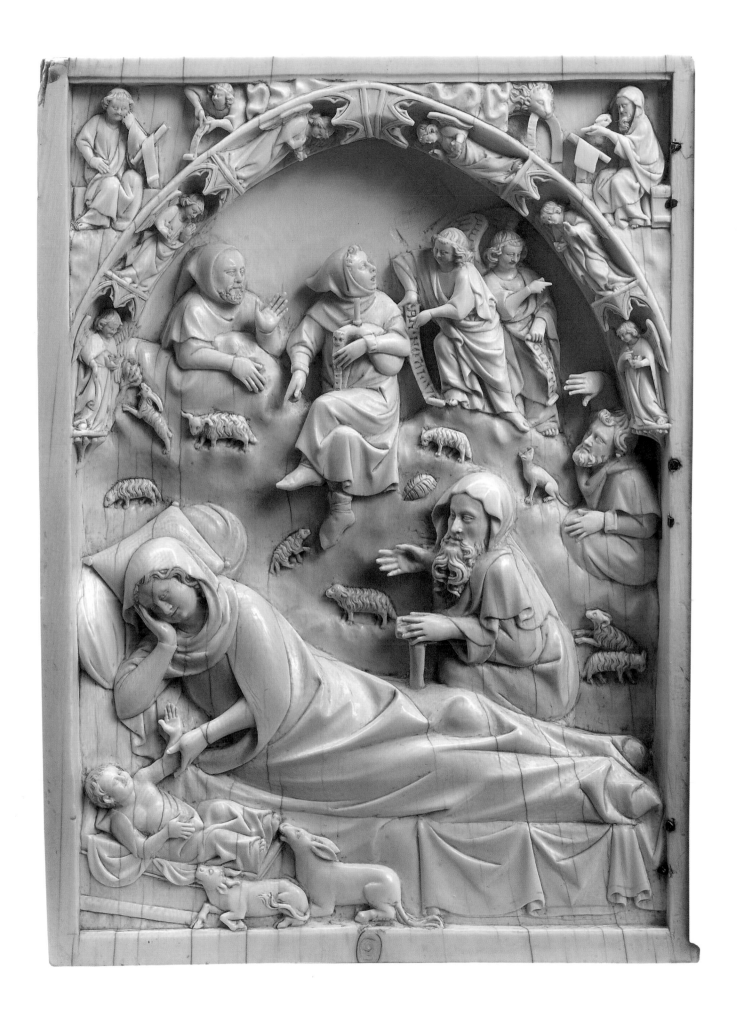

Annunciation to the Shepherds 'tympanum' holds a crown in one hand
(see also the angels in the voussoirs around the Martyrdom of Saint
Stephen on the south portal of the Cathedral of Notre-Dame, Paris).
On the other wing, the angels above the Last Judgement join their hands
in a gesture of prayer (like the inner order of angels in the Last Judgement
of the central tympanum of the west front of Amiens Cathedral).

In the Nativity, the ox and ass kneel before the tomb-like manger
containing the Christ Child. The ass appears to blow on the Child's foot
(as in the *Meditations on the Life of Christ*, a fourteenth-century text by John
of Caulibus). The upper part of Christ's body is bare (a prefiguration of the
Crucifixion), and he raises his left arm towards the Virgin. She grasps his
elbow with her left hand, and supports her head with her right hand. The
elderly Joseph is seated behind, his left hand on a T-shaped stick, his right
extended in acknowledgement. In the rocky landscape are eight sheep,
a dog (at the right) and a goat feeding from the leaves of a tree (at the left).
Above, at the left, a shepherd with a hood appears from behind the hill-
side, looking across at the angels with his left hand raised and his right
hand lowered. Next to him is a shepherd in a complex pose. He sits on
the edge of the rocky ground, his torso frontal, his legs crossed, a bagpipe
under his left arm (its mouthpiece formed of a separate piece of ivory,
inserted), and his right pointing down at the Christ Child. His hooded
head is turned to the right and his mouth is open in speech addressed to
the standing angel alongside. The angel also points at the Nativity, and
carries a scroll inscribed ANNO[N]CIO V[OBIS] (see Luke 2: 10). A second
angel to the right addresses a third shepherd with the text on his scroll:
GL[ORI]A IN [ALTISSIMIS] (Luke 2: 14). This shepherd, unhooded, sits on
the edge of the rocks, looks up at the angel, and raises his right hand to
shield his eyes from the astonishing sight. The distinctive cuffs of two
of the shepherds look 'modern', but can be parallelled, even among
Thomson ivories, in no. 29 and another ivory see page 92.

On the Last Judgement leaf, Christ is seated on a simple throne, his feet
on a walled city (the Heavenly Jerusalem; compare figures in stone from
the Last Judgement of Thérouanne Cathedral, displayed at Le Mans; in
ivory see Rijksmuseum, Amsterdam, inv. no. BK 1992–28). The left half
of Christ's torso is revealed, and the wound in his side is visible. With his
raised right hand he saves the souls on his right, while his down-turned
left hand condemns the sinners on his left to hell. Around his head are
drill holes for the crown of thorns; one ivory thorn survives *in situ*. This is
a highly unusual feature, and possibly a pointer to the Sainte-Chapelle,
where the Crown of Thorns was preserved, but note that the corpus of Christ
from a crucifixion in the Victoria and Albert Museum, inv. no. 212–1867,
attributed to Giovanni Pisano, also has separately inserted thorns. To
either side stands an angel carrying instruments of the Passion – the lance
and three nails at the left, the 'living' cross (with branches lopped off) to

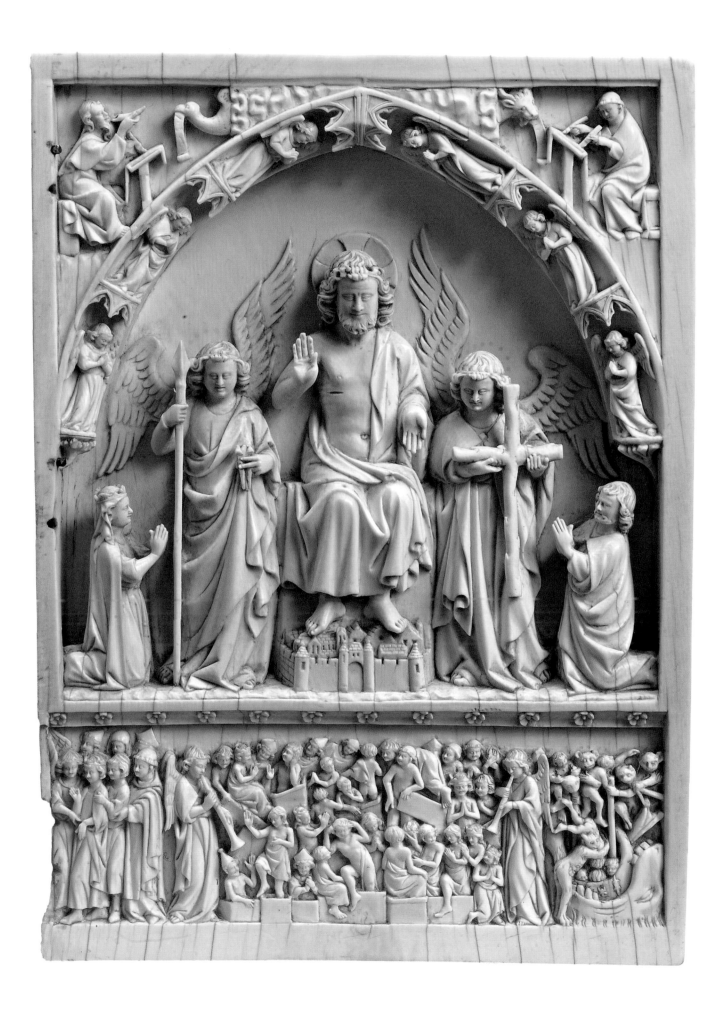

the right. Below, in the lintel-like area, the dead are resurrected. In the centre, flanked by trumpeting angels, numerous small figures rise from their tombs. Popes, bishops, kings and queens are recognizable by their headgear. Some are naked, some lightly clothed. To the left a small group of the saved, headed by a king, are led forward by an angel. A tonsured religious, seemingly a Dominican friar (Saint Dominic?) with a short scapular, also ushers the king forward (contrast the Franciscan – Saint Francis? – in the Last Judgements at the Cathedrals of Amiens, Bourges and Le Mans). At the right, devils force naked souls into the mouth of hell.

The Christ of the Last Judgement can be compared with similar figures with right hand raised and left lowered (*e.g.* Sainte-Chapelle, Paris, upper portal, engraving by Martinet made before 1789/90; Museo Sacro, Vatican; Victorian and Albert Museum, triptych inv. no. 148–1866; a triptych in Lyons; Rijksmuseum, Amsterdam, inv. no. BK 1992–28; and Thomson Collection (left)). The same Christ (compare the drapery fold for fold) has the hands in reversed positions in Louvre OA 2755 and a diptych in the Fitzwilliam Museum, Cambridge. This makes poor sense, for the figures to Christ's right should be saved, not damned (the 'correct' version can be found already in the tympanum at Conques). A third variant is the Christ with both hands raised: this is the typical French Gothic monumental scheme, as in the west portals of the Cathedrals of Paris, Amiens, Poitiers and Bourges. This version is also found in Koechlin nos. 172, 234, 265 and 524.

The condition of the diptych is excellent. There is a break at the lower hinge on the right panel. The three original hinges have been removed and replaced by a continuous rod with flanges and pins occupying the original cuttings and drillings. There are extensive traces of pigment – red and green on the angels' canopies, gold on hair and wings. It can be seen that the sculptor changed his mind about the wings of the announcing angel, but only after the outline of one of them had been sketched out. Presumably the ivory was judged too thin to be worked in relief in this area.

The unusual features of this superlative object suggest that it may have had some particular connection with the Sainte-Chapelle in the royal palace in Paris. JL

BIBLIOGRAPHY

Koechlin, vol. I, p. 283, note 2: "*Nous savons dans une collection française un diptyque, évidemment inspiré de celui du Louvre, où l'arcature a été transformée en une voussure ornée d'angelots, sous laquelle, au Jugement dernier, la Résurrection des Morts figure comme le linteau d'un portail monumental; l'ivoirerie ne nous offre aucun décor analogue et il convient de se méfier d'un aussi extraordinaire décor*"
See also Koechlin, no. 37 (Vatican); no. 43 (Victoria and Albert); no. 55 (Lyons); no. 276 (Fitzwilliam); no. 783 (Rijksmuseum example); *John of Caulibus, Meditations on the Life of Christ*, F.X. Taney, A. Miller, C.M. Stallings-Taney (eds.) (Asheville NC, 2000), p. 25 (motif of the ass blowing); Barnet 1997, no. 34 (Victoria and Albert Museum example)

29

Diptych wing, The Nativity and Annunciation to the Shepherds

Paris, *c.* 1325–50
Height 138 mm, width 101.3 mm, depth 8.6 mm
(spacing of hinges 00, 30, 40, 100, 110, 139 mm);
weight 165 g

Formerly Samuel Bing, Paris, in 1908; Galerie
Charles Ratton–Guy Ladrière, Paris; acquired 1992

BIBLIOGRAPHY

Koechlin, no. 777; *Le monde médiéval* (exhibition
catalogue, Galerie Charles Ratton-Guy Ladrière,
Paris, March 12–April 12, 1991), pp. 16–17

This left wing of a diptych is very close in style and iconography to the Nativity and Annunciation to the Shepherds wing of no. 28. Its companion piece was probably either a Last Judgement (see no. 28 and its comparanda) or a Crucifixion (two ivories in the Thomson Collection – one illustrated below – and Koechlin no. 453). The back shows signs of planing and keying for adhesive on all four edges, suggesting that at some date the ivory was mounted. The panel was cut from close to the centre of a tusk, and traces of the nerve canal are visible on the back. It is well preserved apart from damage around the mortice and locking pin cuttings for the upper hinge.

Detailed comparison with no. 28 is interesting. Most obviously, the angel voussoirs of this ivory have been replaced by the usual cusped arches with crocketed gables. Elements of no. 28 omitted in this panel include the wings of the angels, the goat and tree at the far left, and the sheepdog at the right. Apart from details in the position of hands and arms, the two are otherwise very similar. An element of the shepherds' clothing that appears at first sight unusual is the turned-back cuffs. But these can be found on the central shepherd of no. 28, and in other versions of this scene (*e.g.* the left panels of the two diptychs from the Thomson Collection).

Radiocarbon analysis of the ivory (545 ± 30 years BP) revealed two possible dating brackets (calibration of the raw data rules out a short intervening period). There is a 95% probability that the elephant died between 1310 and 1360 or between 1380–1440. Within the earlier of the two dating brackets, the most probable date for the harvesting of the ivory is 1330–45. JL

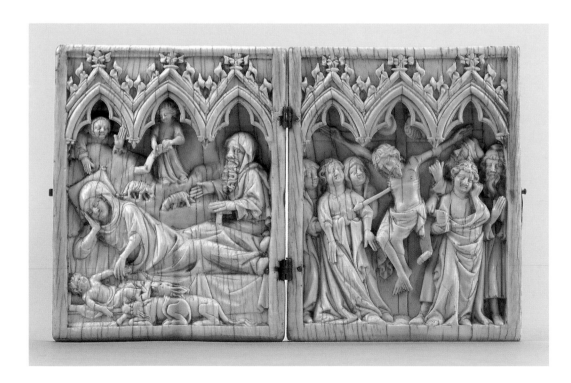

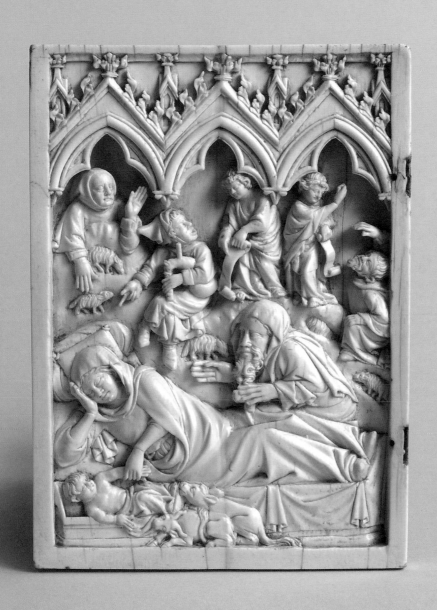

30

Diptych of the Death, Assumption and Coronation of the Virgin

Paris, c. 1300–25
Height 109 mm, width 67 mm (closed),
134 mm (open), depth 10 mm (bottom),
8 mm (top); weight 154 g

Formerly Heugel collection, Paris; acquired from
Daniel Katz, London, 1988

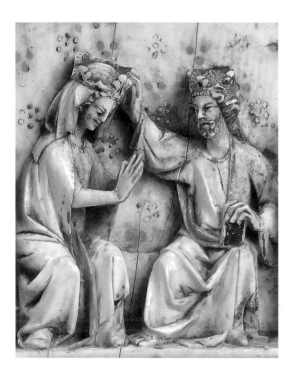

This small diptych, extensively decorated with gilding (on hair, beards and hems) and some polychromy (notably red on lips and cheeks; also some yellow and blue) focuses on the cult of the Virgin in four scenes. Starting at the lower left, we see the Apostles, observed by two angels with covered hands, crowd round her funeral bier, and two of them hold the shroud in which she is wrapped. The Virgin's face has been worn to an almost featureless smoothness by repeated touching (perhaps kissing?). Above, her soul, represented as a naked child, is carried to heaven by Christ, accompanied by two angels with hands raised in prayer, and two further angels at smaller scale, above, swinging censers. On the right panel, below, the Virgin is seen again (at small scale), in a three-dimensional mandorla, supported by angels, again ascending towards heaven and observed by two angels (this is her bodily assumption). Above she is crowned by Christ, the two of them seated on a throne, flanked by two standing angels, with the sun and moon above. The gilded decoration of the background combines rather loosely executed three-point designs (the product of restoration) with much more elegant rosettes of six round petals arranged in a hexagon around a central seventh circle (these are original). Probably the majority of the rest of the gilding and polychromy is also the result of restoration. The lower part of the frame of the right wing has been broken by the hinge and a piece of ivory replaced.

The diptych was catalogued by Koechlin (no. 214) when it was in the Heugel collection in Paris. Koechlin made comparisons between this diptych and triptychs in the Louvre, in Amiens and in the Le Roy collection (nos. 210, 211, 213). But a much closer comparison can be made with a small diptych (each wing 113 × 59 × 10 mm) acquired by the Louvre in 1986 (Gaborit-Chopin 2003, no. 110). In addition to the closely comparable iconography, the Louvre diptych, like this one, appears to have been hinged with simple interlocking rings, rather than the usual and much neater arrangement of tenons morticed in the ivory.

In view of the close comparison with the Louvre ivory, this diptych can also be attributed to a Parisian workshop, but probably should be dated a little later, say c. 1300–25. A label glued to the outside which reads "No. 209. Diptyque en ivoire" perhaps refers to the Heugel collection. JL

BIBLIOGRAPHY

Koechlin, no. 214; Gaborit-Chopin 2003, p. 318, fig. 110a; *Daniel Katz Limited. 1968–1993*, Peter Laverack (ed.) (London, 1992), pp. 10–11

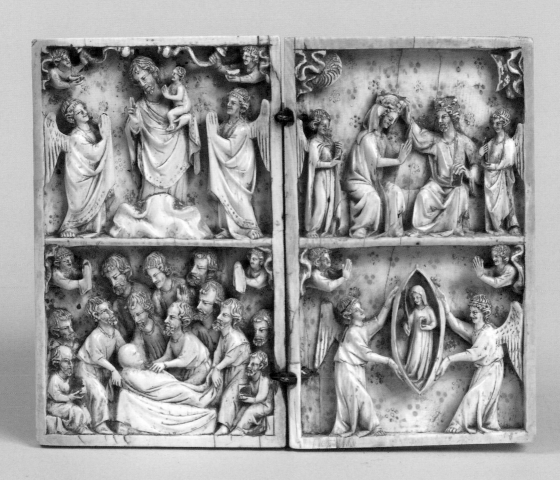

Diptych with the Virgin and Child and Crucifixion

Paris or Cologne, *c.* 1350–75
Height 170 mm, width 100.4 (closed),
200 mm (open), depth 15.9 mm; weight 574 g

Acquired from Sam Fogg, London, 1997

BIBLIOGRAPHY

Unpublished
See further Barnet 1997, no. 43 (Baltimore example); Gaborit-Chopin 2003, no. 166 (Louvre example)

This relatively large diptych supplies the viewer with the two most popular medieval images – the Virgin and Child and the Crucifixion. The type of image of the Virgin, flanked by candle-bearing angels, is sometimes termed the *Vierge Glorieuse* or the Glorification of the Virgin. The diptych is executed on two thick tablets, cut from the centre of the same tusk. All four vertical edges of the diptych as folded have been chamfered off. At first sight this feature might seem to be explicable by the limitations imposed by the curvature of the tusk, but this is not the case, as the cutting is perfectly even and does not taper (as the curving tusk would require). The result is notably neat. The panels show no signs of a device to hold them closed, suggesting that the diptych may have been stored in a close-fitting bag or case when not in use. Perhaps the chamfering of the edges was done so as to facilitate sliding the folded diptych into and out of such a container. The original silver hinges have been replaced by similar hinges in base metal, which have left a rusty stain on the ivory. Other cuttings or drillings on the hinging edges, of uncertain purpose, have been filled.

Beneath a cusped arch surmounted by a crocketed gable, pinnacles and deep trefoil 'oculi', the compositions of the two wings are very carefully balanced. At the left the tall figure of the Virgin is crowned by an angel flying down from heaven. She holds a book in her right hand and supports the Christ Child on her left arm. The Child holds a fruit in his left hand and extends his right across the Virgin's chest. They make no eye contact. To either side stands an angel with one wing raised, as though to frame the Virgin and Child, and the other wing, very foreshortened, folded down and visible on the edge of the frame. The figures are very well preserved. Only the candles, which once stood in the candlesticks held by the angels, are lost. Drill holes in the top of the candlesticks show that the candles were made separately, and then inserted and glued in position. On the right wing is a three-figure Crucifixion. The cusped arch provides a frame behind which Christ hangs from the Cross, and angels holding the sun and moon are just visible. The Virgin bows her head and acknowledges her son with her left hand, while seeming to abandon hope with her right hand. Saint John holds his Gospel (an echo of the Virgin on the other panel), turns his head away from Christ and rests his chin on his fist.

There are now no traces of gold or polychromy. The panels have been cut deep into the ivory, leaving only a very thin background. Extensive cracking and some splitting has occurred. Despite these signs of ageing, the extraordinarily subtle ways in which the movements, gestures and drapery of the figures enliven the composition reward close and extended study.

Comparable ivories have been attributed to the 'Berlin Master' – notably Walters Art Museum, Baltimore, inv. no. 71.214 a–b, which is thought to have been made in Cologne, *c.* 1350–75. But it might be prudent to leave this attribution open for the present: compare Musée du Louvre, inv. no. OA 2601, which is attributed to Paris. JL

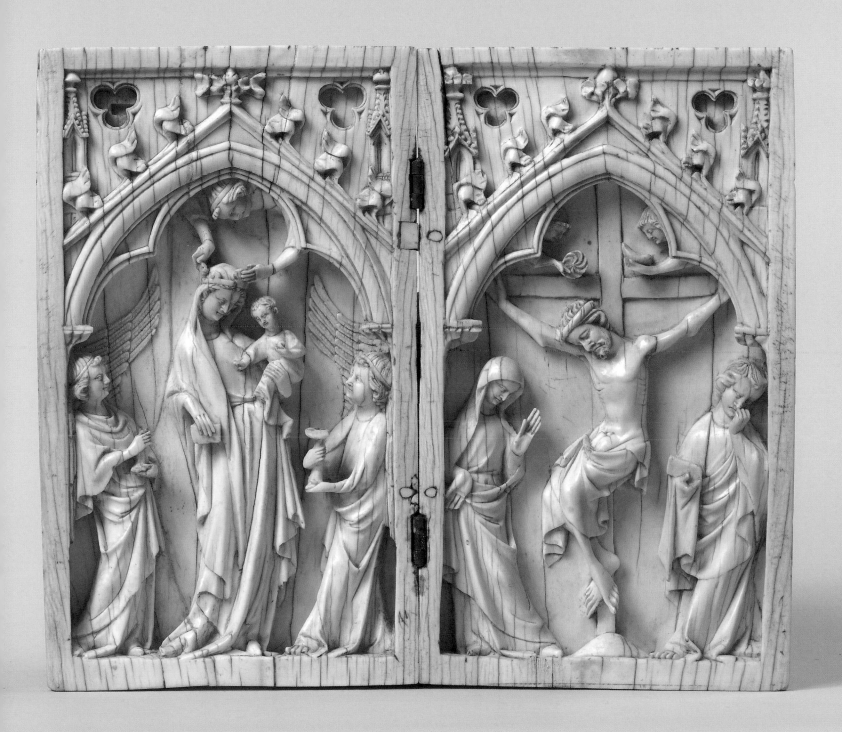

Variant Passion diptych

Northern France, *c.* 1325–50
Height 220 mm, width 140.3 mm (closed),
281 mm (open), depth 10.7 mm; weight 696 g

Formerly Marquis de Ganay and Comtesse de
Béhague collections; sale, Sotheby's, Monaco,
December 5, 1987, lot 176

This large diptych, extracted from near the centre of the tusk, contains four scenes per wing. The overall rectangle is subdivided into four similar rectangles by a horizontal moulding and narrow columns, integral with the ivory block. Although hinged as a diptych, the choice of scenes, especially their conclusion, might seem more appropriate to a larger ensemble. The narrative reads from left to right across the lower half of the left wing, then across the upper half, then across the upper half of the right wing, and then down and across its lower half. First we see the payment to Judas (Matthew 24: 14–16), followed by the Betrayal. Then above we see the Flagellation of Christ, followed by Christ carrying his cross (the *Via crucis*). Moving to the right panel we have the Crucifixion and Deposition, followed below by the Anointing of a diminutive Christ, and the Maries, wearing wimples, at the Tomb, on which the angel sits.

Characteristic of this ivory is the large scale of the figures, and the narrow faces with high cheekbones, sharp noses and pointed chins. It is notable that, in the Betrayal, the same portrait type is used for Jesus, Judas and Peter. The fact that the column of the Flagellation, which is integral to the block, lacks both base and capital, looks odd and possibly 'unmedieval,' but a close parallel can be found in the same scene in a diptych in the Bibliothèque municipale at Amiens, which is also very similar overall in its iconography to the present diptych. For the diminutive Christ of the Anointing compare the Sissons Diptych in the Victoria and Albert Museum (Koechlin, no. 38), and Koechlin, nos. 39, 265.

Radiocarbon dating produced a date of 855 ± 35 years BP, corresponding to a 95% probability of a date for the ivory, when calibrated, within the range 1130–1250. JL

BIBLIOGRAPHY

Collection de Martine, comtesse de Béhague, provenant de la succession du Marquis de Ganay (sale catalogue, Sotheby's, Monaco, December 5, 1987), lot 176
See also Koechlin, no. 240 (Amiens example)

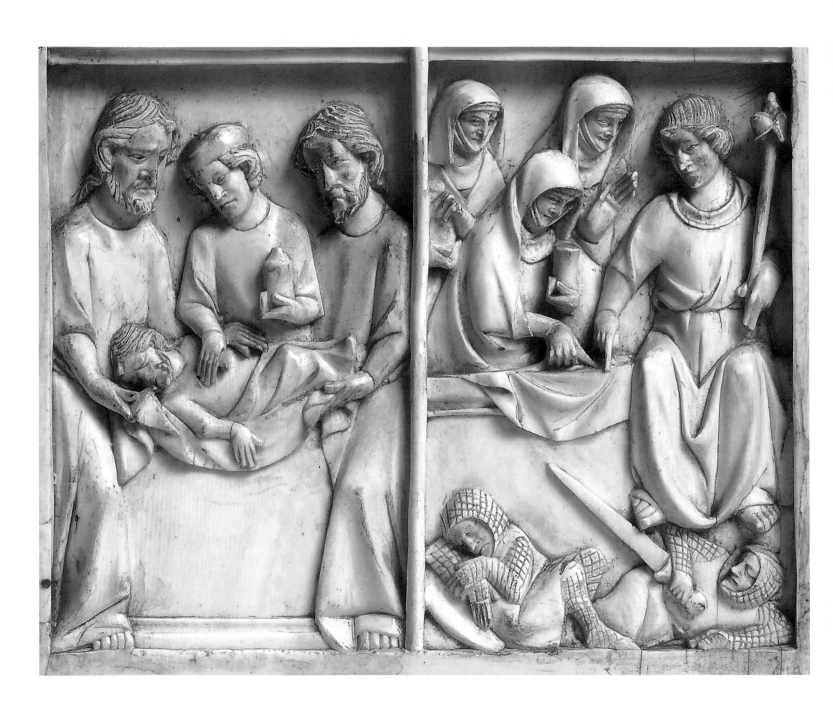

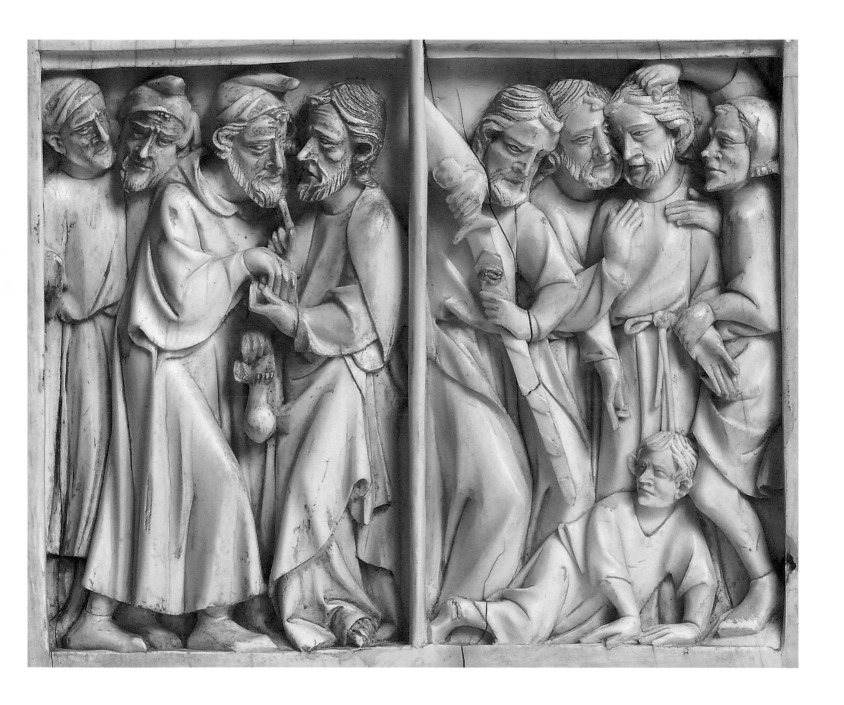

33

Wings of a triptych with scenes of Christ's Passion

Northern Italy or southern France?, *c.* 1300?
Height 329 mm, width 75.8 mm, depth 14.8 mm;
weight 326/327 g (each)

Sale, Sotheby's, London, March 18, 1976, lot 18

BIBLIOGRAPHY

Sale catalogue, Sotheby's, London, March 18,
1976, lot 18
See also Longhurst 1927–29, p. 12 and pl. VII
(Victoria and Albert example)

These tall panels were originally mounted as the wings of a triptych. Interestingly, they were originally painted on the backs. When open the wings present four deeply carved scenes from the Passion of Christ – reading up the right panel, the Flagellation and Christ with Simon of Cyrene carrying the cross; then presumably a large Crucifixion occupying the missing centre; followed in narrative sequence, reading (in this case) down the left wing, by the Deposition from the Cross and the Anointing of Christ's Body. The body of Christ in the Anointing is notably small. The scenes are set beneath two arcades of different curvature, originally elaborated with undercut cusping tracery, now mostly broken and lost. Deeply undercut trefoils and quatrefoils decorate the spandrels and the stepped shrine-like tomb into which Christ is lowered. If we turn the ivories over to reveal the outside of the wings (or doors), identifiable as such by the traces of closures (the original closure in the middle and two later closures above and below), the surface has shadowy traces of painted and gilded compositions. Reading from left to right and upwards, we see Christ rising from the Tomb, the Maries at the Tomb, the Harrowing of Hell, the *Noli me tangere*, and two kneeling angels in prayer (but with no signs of wings; less probably, this might have been an Annunciation).

The question of the lost central panel is puzzling. It is possible that it was a single ivory block, albeit very large (330 × 152 mm): compare a triptych in the Victoria and Albert Museum, inv. no. 141-1866, in which the central panel of the Virgin and Child measures 305 × *c.* 150 mm. Although the ivory wings show no signs of the usual tenon hinges, inserted at 45°, this could be because ring hinges were used.

In terms of technique, comparison can be made with an ivory triptych in Lyons (Koechlin, no. 55), which has a carved central panel combined with painted and gilded wings. JL

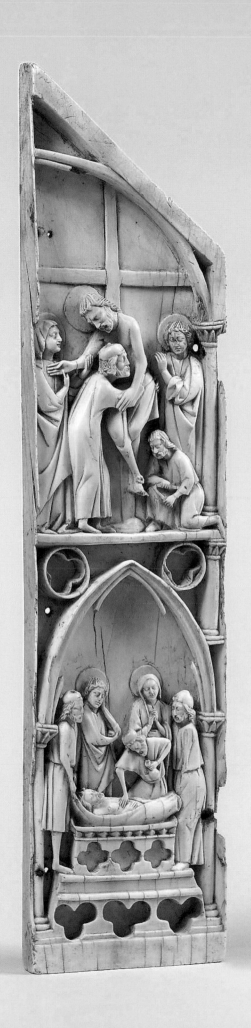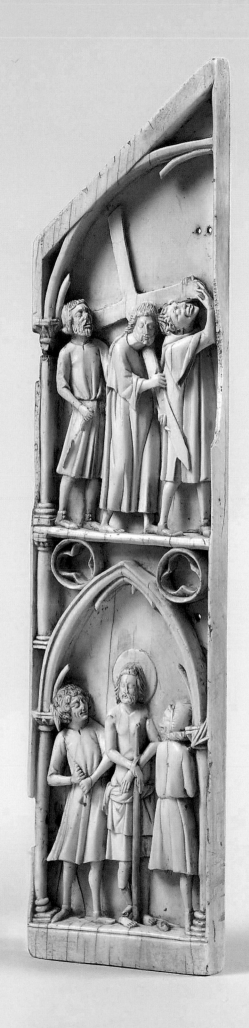

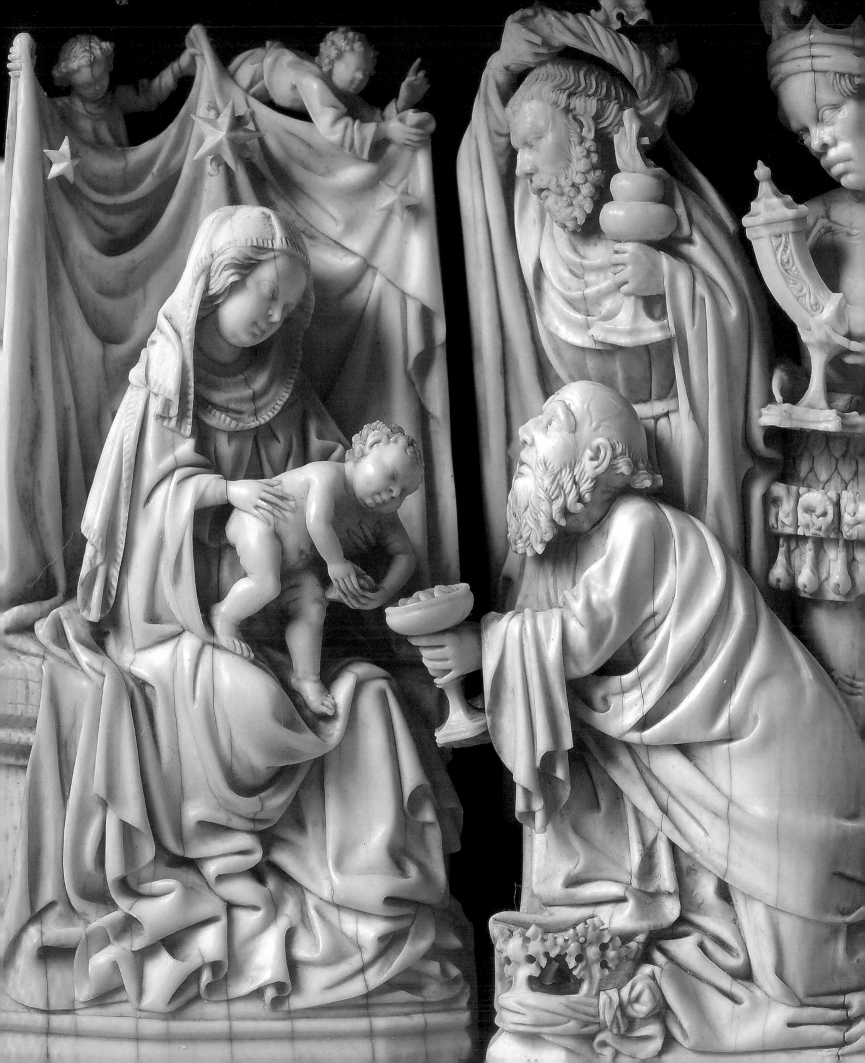

Fragments of larger ensembles

34

Panel from a tabernacle or altarpiece, The Arrest and Entombment

Northern Italy (Veneto?), *c.* 1350–1400
Height 202 mm, width 107 mm, depth 8 mm
(dimensions of inner panel: height 190 mm,
width 97 mm); weight 230 g

Acquired in London, 1992

BIBLIOGRAPHY

Unpublished
See further Randall 1985, no. 351 (Baltimore
example); Barnet 1997, no. 49 (Victoria and
Albert triptych); Longhurst 1927–29, pl. LIII
(Victoria and Albert diptych); Zastrow 1978,
no. 46 (Milan example)

This unusual panel has been carved with a thin projecting flange of ivory on all sides (broken on the left side and at the top right corner), which effectively functions as a kind of base plate. The back of this flange has been neatly scored to receive adhesive. The simple carved border of the image is undercut on all four sides, to ensure increased security in a mounting framework of some sort. Probably the panel was arranged with other scenes from the life of Christ on a tabernacle or altarpiece. The alternative, that it might have been mounted as a book cover, is improbable, given the iconography. The two scenes, the Betrayal (above) and the Entombment (below), are flanked by carefully executed spiral columns, which support a complex flattened trefoil arch decorated with a moulding that is repeated on the horizontal division between the two scenes. In the resulting spandrel-like spaces are busts of four bearded figures holding scrolls, doubtless Old Testament Prophets.

The iconography of both scenes is unusual. At the right of the Betrayal two soldiers in helmets and armour are stretched on the ground (John 18: 6, "they went backward and fell to the ground"). The incident of Peter cutting off the ear of Malchus with a knife (rather than the sword of the French tradition) is at the far left. The beardless Judas contrasts in physiognomy with Christ, whose outer garment is pulled taut by a soldier at the left. In the Entombment, three Apostles and the Magdalene(?) support Christ's tightly wrapped body as it is inserted into a sarcophagus, partly visible in a cave at the right. In the foreground the seemingly pregnant Virgin swoons with the pain of childbirth, and is supported by two seated women, one seen from behind. Some of these odd details are reminiscent of Giotto's wall-paintings in the Arena Chapel at Padua, especially the bulky women in the foreground. There is no sign of gilding, but the hair (not the beards) is painted yellow, and the pupils of the eyes are picked out in black.

The panel can be attributed to a North Italian (Veneto?) workshop in the second half of the fourteenth century. The Entombment has a very close parallel in an unusual triptych, made of bone rather than ivory, now in the Walters Art Gallery, Baltimore. The wings of the Baltimore triptych are in their turn virtually identical to the wings of an ivory triptych in the Victoria and Albert Museum, inv. no. 143-1866, which has a Coronation of the Virgin in the centre. Also closely related are a small diptych in the Victoria and Albert Museum, inv. no. A566-1910 (each wing 105 × 78 mm), a small panel of the same dimensions in the Cloisters, inv. no. 1971.49.4 (106 × 78 mm), and a tabernacle in Milan (Museo delle arti decorative). All these objects were made for different contexts. The Betrayal and Entombment mounted with other scenes on the '*edicola*' now in Milan are particularly close in iconography to the present panel. But the Thomson ivory is a work of unquestionably superior craftsmanship. JL

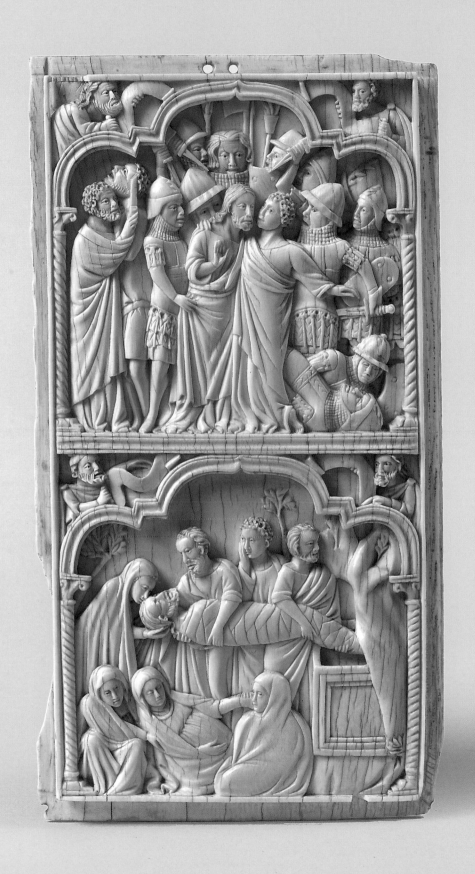

35

Figures from the Betrayal and the Ascension

Northern France, c. 1325–75?

(a) height 119.7 mm, width 54.2 mm, depth 5.7 mm; weight 41 g
(b) height 121.8 mm, width 54.6 mm, depth 11.3 mm; weight 67 g
(c) height 112.7 mm, width 59 mm, depth 6.4 mm; weight 69 g
(d) height 111.8 mm, width 60.7 mm, depth 5 mm; weight 52 g

Sale, Christie's, London, December 8, 1987, lots 18–19 (unsold); acquired from Maria Baer, London, 1988

These four polychromed ivories have been removed from a tabernacle or altarpiece of some sort, where they would have formed part of a more extensive narrative of the Life of Christ. They have not been cut out of rectangular framed compositions (*ajouré*), as they each have a conspicuous base composed of undulating ground, which formed an integral part of the composition. The backs of the plaques are keyed for adhesive. All four are carved on ivory from the root of the tusk, which provides relatively thin curving panels when the softer dentine from the centre of the tusk is scraped and hollowed out. The first pair of ivories forms part of a Betrayal. Judas identifies Christ by his embrace and makes to kiss him on the cheek. A soldier in a short tunic grasps Christ's right hand in his left hand, and with his right holds aloft a lamp (missing) to illuminate the scene (John 18: 3). To the left is a crowd of three Jews, with various weapons, observing the

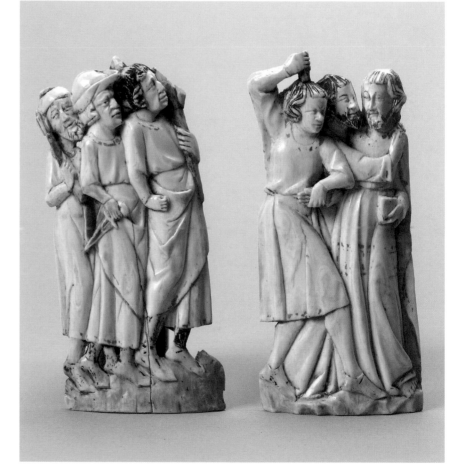

Betrayal. These two groups might have been accompanied by at least one more, with further soldiers flanking Christ at the right, and possibly two further groups – of Peter cutting off Malchus's ear to the far left, and the suicide of Judas to the far right. The other composition shows Peter and Paul (identified respectively by keys and sword) each at the head of five disciples. The figures turn their heads to gaze upwards at the ascending Christ, now missing but originally central.

There are extensive remnants of gilding and polychromy. The ivories appear to pre-date the Burgundian or Flemish altarpieces of *c.* 1400 which used small groups of figures in this way. They also pre-date the Embriachi ivory and bone altarpieces which used small groups of figures on separate panels in a related manner. For comparable pieces see Gaborit-Chopin 2003, nos. 144–46. J L

BIBLIOGRAPHY

Sale catalogue, Christie's, London, December 8, 1987, lots 18–19

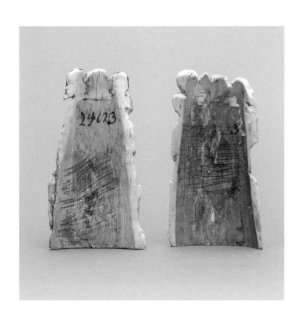

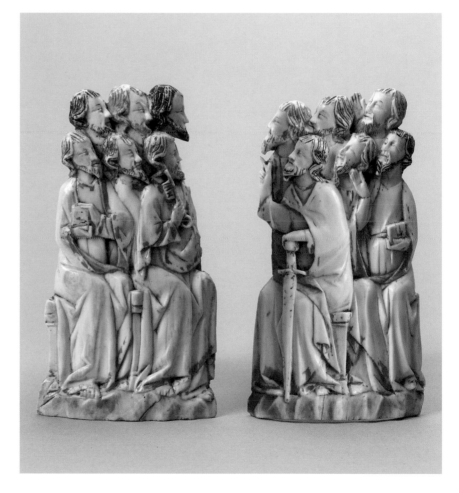

36

The Adoration of the Magi, remounted as a pax

Middle Rhineland, *c.* 1450
Metalwork approx. height 227 mm,
width 130 mm, depth 87 mm

Formerly John, Lord Malcolm of Polltaloch;
S.J. Whawell and L.M. Loewenstein, London;
Ruth and Leopold Blumka; acquired from
Ruth Blumka 1986

BIBLIOGRAPHY

Bronzes and Ivories (exhibition catalogue,
Burlington Fine Arts Club, London, 1879),
no. 263; Poltalloch sale (sale catalogue,
Christie's, London, May 1, 1913), lot 17, with
illustration; *Gothic Art in Europe* (exhibition
catalogue, Burlington Fine Arts Club, London,
1936), no. 104, pl. XXVI; Carmen Gómez-
Moreno, *Medieval Art from Private Collections*
(exhibition catalogue,The Cloisters, Metropolitan
Museum of Art, New York, 1968), no. 82;
Liebieghaus Museum alter Plastik, *Kunst um 1400
am Mittelrhein. Ein Teil der Wirklichkeit* (Frankfurt
am Main, 1975), pp. 115–16, no. 6, fig. 94
See also Ines Dresel, Dietmar Lüdke and Horst
Vey, *Christus and Maria. Auslegungen christlicher
Gemälde der Spätgotik und Frührenaissance aus der
Karlsruher Kunsthalle* (Karlsruhe, 1992), pp. 140–47,
no. 22 (the Karlsruhe panel painting)

This remarkable object consists of two distinct elements, the metalwork setting and the two ivories that comprise the Adoration of the Magi. As currently reconstructed the object appears to be intended to function as a pax, a liturgical implement to receive the kisses of the faithful during Mass. But the use of gilded base-metal for the setting (all except the small silver angel at the top) is inconsistent with the value and expense implied by the exceptionally careful carving of the ivory. The current arrangement, therefore, appears to be modern, like the metalwork itself. The ivories were already mounted in this fashion, however, when exhibited in 1879. It can also readily be appreciated that the delicate craftsmanship of the ivory would be at great risk of damage if the item were routinely kissed. Nor does the Adoration of the Magi appear consistent in iconographic terms with a function as a pax: the leading king, for example, is not represented making as if to kiss the Christ Child.

The Adoration scene shows superlative attention to detail. The extensive undercutting has left many areas of extreme fragility, and the crowns of the two standing Magi are broken in numerous places (in a manner that makes no sense in the current arrangement, in which these details are protected by the metalwork). The Virgin enthroned is protected by a cloth supported by two wingless angels. Into the cloth are inserted three stars. The naked Christ Child leans forwards towards the chalice, filled with hosts, held by the kneeling king. The king gazes up at Mary, not the Child. His crown is on the ground. Behind him, his two companions wait their turns. The first removes his crown and holds a chalice. The second, represented as a black-skinned 'Moor,' holds a magnificently decorated drinking horn. His armour is exceptionally complex, and around his waist is a belt of skulls. Given the angles of the gazes of all three Kings it seems plausible that originally the two ivory panels were not mounted, as now, on the same base line, but that the Virgin and Child were somewhat higher.

A close comparison for the Virgin and Child can be found in an ivory in the Liebieghaus in Frankfurt. For the scene of the Adoration of the Magi comparison can be made with a panel painting at Karlsruhe by the Master of the Salem Altar, *c.* 1500, perhaps made at Konstanz.

Radiocarbon dating results for the ivory for the Magi group were 565 ± 35 years BP, which when calibrated gives a date of 1300–1430 with 95% confidence. The Virgin and Child group produced a result of 595 ± 40 years BP, which, when calibrated, gives 1290–1420 with 95% confidence. JL

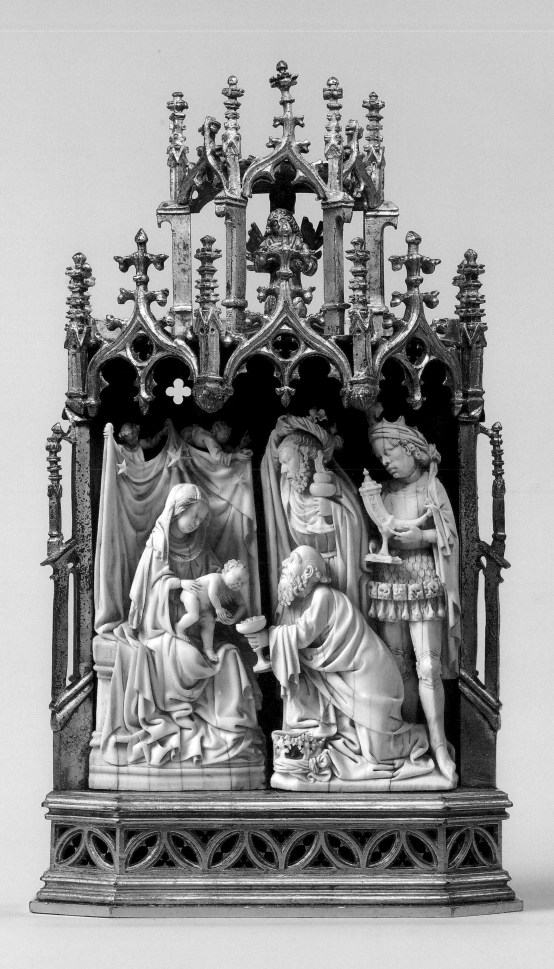

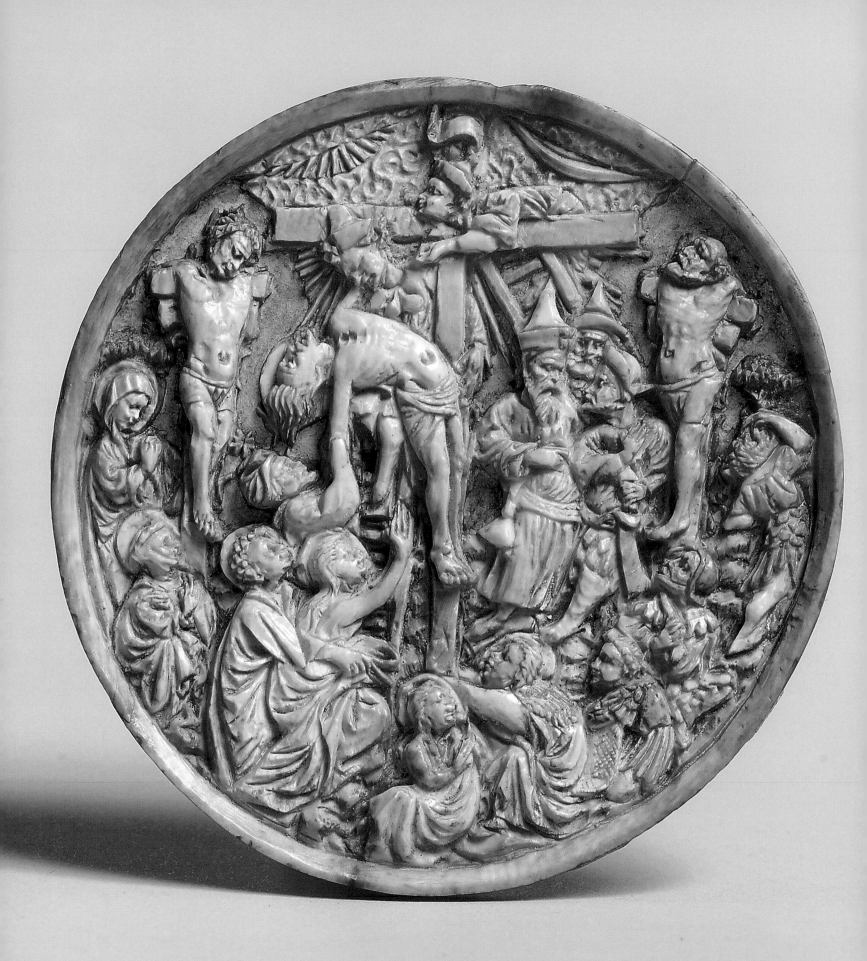

Medallions and roundels

37

Double-sided ivory medallion with the Annunciation and Saint George

Paris, *c.* 1400–20
Diameter 47.5 mm, depth 17.2 mm (overall);
weight 58 g (in total)

Sale, Sotheby's, London, December 9, 1993, lot 10

BIBLIOGRAPHY

Sale catalogue, Sotheby's, London,
December 9, 1993, lot 10
See also *Meisterwerke aus Elfenbein der Staatlichen
Museen zu Berlin* (Berlin, 1999), no. 57

This beautiful pendant would have been worn suspended from a chain around the neck. It is composed of a thin disk of ivory, worked on both sides, set under rock crystal in a silver-gilt medallion. (It is possible the rock crystal has been replaced with glass.) The ivory is so extensively painted on both faces that it is difficult to be sure, at first glance, what material has been used. The extreme shallowness of the relief is also striking.

On the principal face is an Annunciation. The Virgin sits in a high-backed chair, a book open on a lectern before her. She crosses her hands on her chest in a gesture of acceptance. The angel, kneeling at the left, holds a scroll with the beginning of her message: *Ave gracia* (Hail, [full of] grace). A bust-length figure of God the Father appears above, releasing the infant Christ towards Mary. A cherub or seraph observes from behind Mary's chair at the right. On the opposite face Saint George rescues the princess from a dragon. His dappled-grey horse occupies much of the image. Wearing plate armour and over-large spurs, Saint George lances the dragon with a vertical thrust. Around him are the king and queen and other spectators.

This object is remarkable for having retained its metalwork setting. It was possibly made for a member of the Burgundian court in the early fifteenth century. Comparable pendants can be found, for example, at the Staatliche Museen, Berlin, and the Museo Bargello, Florence, but these objects are less skilfully executed. JL

38

Roundel of the Descent from the Cross

Northern France or Flanders, c. 1400–20
Height 62.8 mm, width 60.4 mm, depth 3.7 mm;
weight 10 g

Sale, Sotheby's, London, December 10, 1987,
lot 263

BIBLIOGRAPHY

Sale catalogue, Sotheby's, London,
December 10, 1987, lot 263
See also Paul Williamson in Barnet 1997, no. 67.
Paul Williamson is preparing a study
of this group.

This small, disk-like object is one of more than fifty such roundels to have survived. It is carved on an exceptionally thin piece of ivory, with the main parts of the background cut away (*ajouré*). A substitute for the ivory background was then provided by attaching a sheet of parchment to the back. This was painted blue (it has deteriorated). There are also traces of gilding, and the ivory ground is painted green, but much of the ivory surface of the figures is now without pigment. The complex multi-figured composition shows Christ being lowered from the cross, seemingly by Nicodemus and Joseph of Arimathea. Christ's body arches violently from the waist and his hair hangs down. To either side are the two thieves on their crosses. A group of Jews argue at the right, and across the foreground are various soldiers, the Magdalene, Saint John, the Virgin and the Maries, mostly in poses suggestive of their grief. A central cloudy triangle in the upper part of the composition represents heaven.

In stylistic terms the extreme emotionalism of the Descent can be compared with manuscript illuminations of the 1420s and 1430s by the Paris-based 'Maître de Rohan' (Rohan Master). Such roundels were in some cases intended to be mounted in sequence on reliquaries. There are comparable examples in the Victoria and Albert Museum, inv. no. 605-1902, Amsterdam, Cologne and a private collection in London. J L

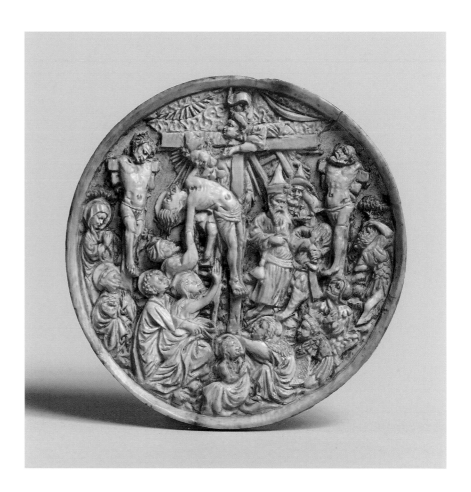

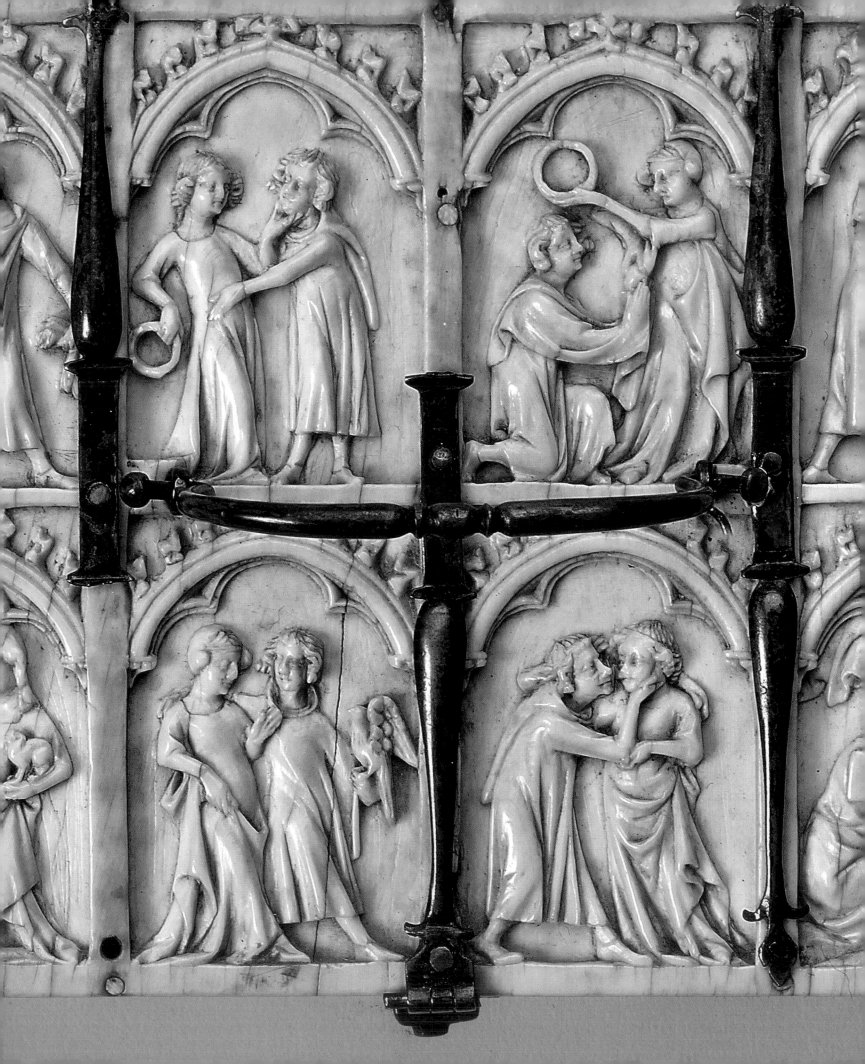

Domestic and personal items

39

Set of carving and serving knives

Paris, *c.* 1350
Carver handle: height 109 mm, width 30.4 mm,
depth 16.3 mm (overall length 315 mm)
Server handle: height 106 mm, width 36.9 mm,
depth 20.6 mm (overall length 315 mm)

Acquired from Sam Fogg, London, 2005

BIBLIOGRAPHY

Unpublished

This set of two knives is housed in its original decorated leather case, now lacking the top. Each knife consists of three parts – steel blade, enamelled silver ferrule and ivory handle. The pointed carving knife would have been used first. Its handle shows a struggle between a young man and two lions, one of which he stabs in the mouth with his sword while it attacks him from below, while the other springs onto his head from behind. The enamels show battles between two grotesque dragons and a dragon and a lion, together with coats of arms (not yet identified). After the food was carved it would have been served on the flat-ended spatula-like knife. Its ivory handle is decorated near the ferrule with small scenes of hunters, one with a hawk, the other spearing an animal. In the centre of the handle are medallions with dragons, and at the top a human head flanked by dragons and topped by lions(?) back to back with a large beast with open mouth. The enamels on this knife include a dragon facing a grotesque human head on short legs. JL

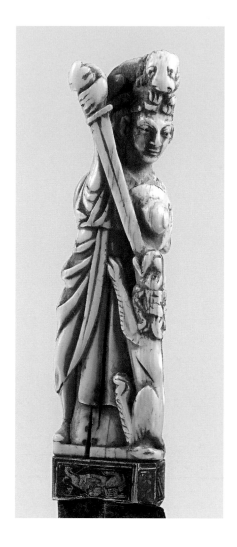

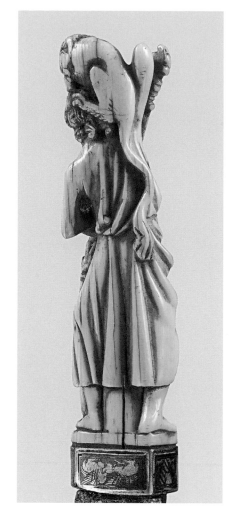

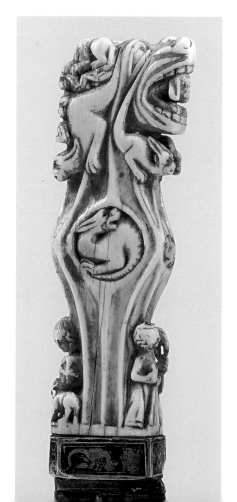

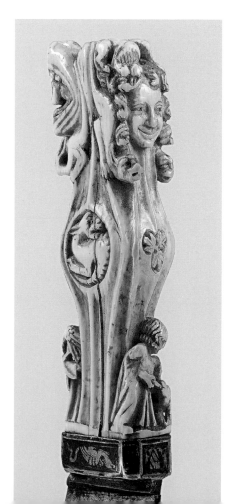

40

Ivory box with scenes of romance

Northern France, *c.* 1325–50
Height 53.4 mm, width 133.9 mm, depth 94.7 mm;
weight 295 g

Collections of Francis Douce, Sir Samuel Rush
Meyrick of Goodrich Court, and Spitzer; sale,
Sotheby's, London, March 22, 1966, lot 21

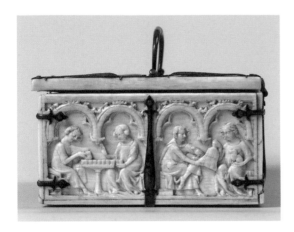

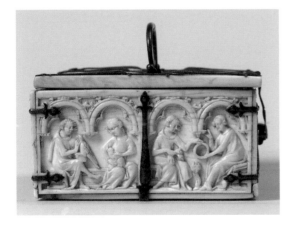

BIBLIOGRAPHY

Samuel Rush Meyrick, 'The Doucean Museum',
Gentlemen's Magazine (April 1836), p. 384, no. 15;
La Collection Spitzer, vol. I (Paris, 1890), no. 80,
illus. p. 53; Koechlin, vol. II, no. 1269; sale
catalogue, Sotheby's, London, March 22, 1966,
lot 21

This ivory box is preserved in excellent condition. It is decorated in two registers on the top, and in a single register on all four sides. The box is held together with silver straps and hinges, most of which are functional, but the outer strips on the lid are merely decorative. The base has been assembled in modern times from a large fragment of another, larger casket, and a smaller plain piece of ivory. The decoration of the top and four sides comprises pairs of figures beneath cusped arches. It does not appear to provide a continuous narrative. On the front the square panel for the catch is supported by a kneeling figure to each side, a man at the left, a woman to the right. Beyond, to the left is a man with a hawk on his wrist 'chucking' the chin of a woman holding a crown. To the right the man and woman hold one another's right hands and chuck one another's chins. Moving round the box we encounter a couple playing a board game, and a man with a hawk giving a gift to a woman holding a lapdog. On the back, a couple converse beneath a tree, she is seated and holding a circlet, he is kneeling; next they stand and embrace, she holds a lapdog; next she stands and places a circlet over his head while he kneels; next they both stand and hold the circlet between them. On the short side the couple are seated in both scenes. On the left the man strokes his hawk, and his leg swings up in a suggestive manner; the woman fondles the dog on her lap. Finally the man holds his gloves and they hold the circlet between them. On the lid are eight further scenes. First the man chucks the woman's chin while she holds her lapdog. Next she holds the circlet and chucks his chin while he touches her abdomen. Next he kneels before her while she holds the circlet over his head. Then he embraces her with his left arm, and inserts his right hand into her skirts. In the lower register she embraces him and holds her lapdog. Next he embraces her and holds his hawk. Next he kisses her. Finally he kneels before her in armour, hands raised in a supplicatory feudal gesture, and she lowers his helmet onto his head.

The box was attributed by Koechlin to northern France in the first half of the fourteenth century, but this was based on the description by Molinier in his catalogue of the Spitzer collection (1890), as Koechlin was unable to trace the original.

Radiocarbon dating produced a date of 705 ± 30 years B P, corresponding to a 95% probability of a date for the ivory, when calibrated, within the ranges 1250–1310 and 1350–90. JL

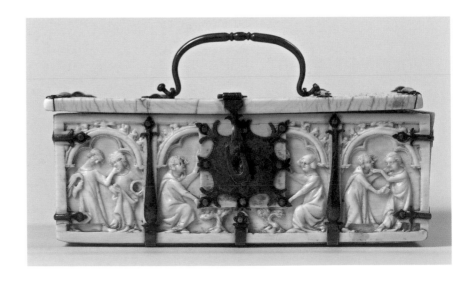

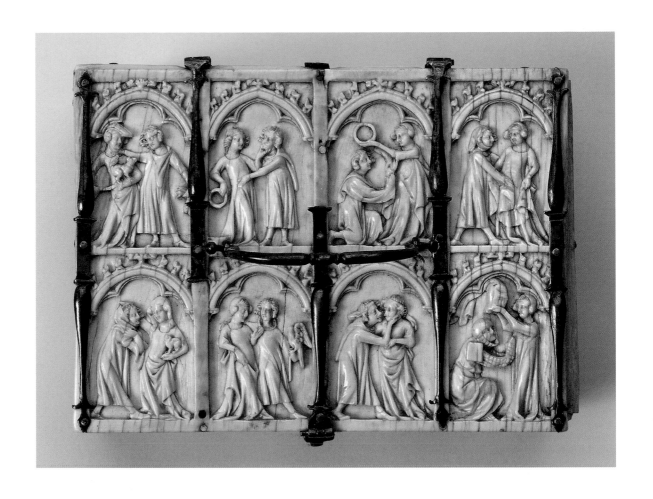

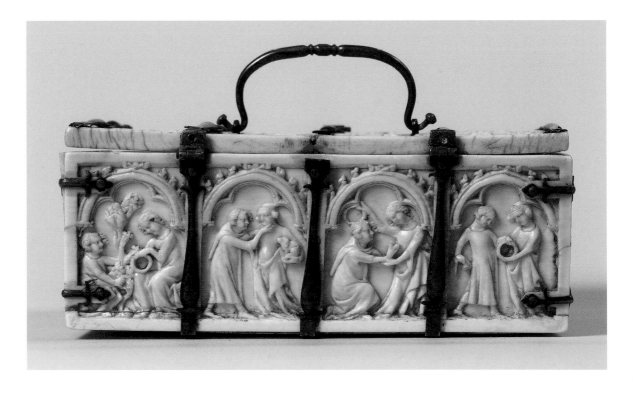

41

Ivory mirror back with scenes of romance

Paris, *c.* 1325–75
Height 135 mm, width 121 mm,
depth approx. 10 mm; weight 140 g

Lord Acton, Aldenham Park, until 1945; sale,
Christie's, London, December 7, 1993, lot 18;
acquired from Sam Fogg, London, 2002

BIBLIOGRAPHY

Sale catalogue, Christie's, London,
December 7, 1966, lot 18

Ivory mirror cases carved with scenes of romantic encounter were produced in large numbers for the wealthy – primarily, it is thought, for women. They were constructed in a standard fashion: a thick block of ivory was divided horizontally into two and then the halves were hollowed out to receive one or possibly two circular silver mirrors. The mirrors themselves have all been removed to be melted down and recycled, and only their cases remain. The ivory lid and base were cut with a bayonet mount, so that the two halves would remain securely closed until one was twisted against the other. Because the mirrors were circular, it might be thought that the ivory disks for their covers would have been cut vertically through the tusk, but this was not the case. The sculptor began with a horizontal slice, sometimes rectangular rather than a true square. The result can be seen clearly in the present example, where the four beasts at the corners of the block are of very different sizes and shapes because of the limitations of the curving material. These beasts, of a type frequently found in the margins of contemporary manuscripts, are integral and functional: by their knobbly shape they provide something on which to gain a purchase when twisting to open the case, and perhaps they also show you which way to turn the cover to open it. Had the ivory been cut vertically as a cross section of the tusk, the entire composition, including the beasts, would have to have been inscribed within the circumference of the tusk, and a great deal of ivory would as a result have been wasted. By working with horizontal slices almost no ivory was wasted.

The circular field of the mirror case is divided approximately into two halves with a leafy ground line for both. In the upper half, a pair of lovers embrace in the centre, the man caressing the woman's face and grasping her left hand. To the left he kneels in a prayer-like gesture before her, and she holds a crown above his head and pulls her clothing provocatively across her body. At the right a suitably romantic atmosphere is provided by a man playing a portable organ. In the lower register the usual roles of men and women have been reversed. Three ladies astride powerful horses gallop from left to right. Two hold hawks on their wrists, while the third has a lure. Her hawk has captured some prey, which is recovered by a kneeling huntsman. At the far left a second huntsman sounds a horn, and the first hunting lady, who wears a wimple, a sign of piety, whips her horse vigorously. The images reflect attitudes rather than a specific narrative: love is a hunt, women are not always the passive partners. An early-nineteenth-century cartouche has been painted in the aperture for the mirror. JL

42

Ivory chesspiece: queen

Germany, *c.* 1350–1400
Height 62 mm, width 45 mm, depth 28.5 mm;
weight 43 g

Sale, Sotheby's, London, May 18, 1967, lot 22

BIBLIOGRAPHY

Sale catalogue, Sotheby's, London, May 18,
1967, lot 22
See also Barbara Drake Boehm and Jiri Fayt,
Prague: the Crown of Bohemia, 1347–1437 (exhibition
catalogue, Metropolitan Museum of Art, New
York, 2005), no. 61 (Metropolitan chesspiece)

This small seated figure of a queen with her hair braided in the locks typical of the later fourteenth and early fifteenth century sits on a low-backed throne, broken at the left side. She wears a crown atop a veil, drawn back and knotted elegantly at the back of her head. With her right hand she feeds a nut to a large squirrel which sits upright on her lap. With her right hand she steadies a staff, the top of which, originally secured by a strut to her mantle, has broken off. The mantle is draped loosely round her shoulders, and held together by drawstrings with tasselled ends which hang down between her breasts. She turns her head to look to the right of centre. The back of the throne is decorated with an overall pattern of diagonals enclosing an angular fleur de lys in a diamond-shaped space. A comparable chesspiece with a king of similar size (height 63 mm) seated on a similar throne is in the Metropolitan Museum (formerly Kofler-Truniger collection, no. S37). It is attributed to a German workshop.

Radiocarbon provided a date for the ivory of 690 ± 30 years BP. Once calibrated the date (with 95.4% probability) corresponds either to 1270–1330 (61.6%) or to 1350–90 (33.8%). JL

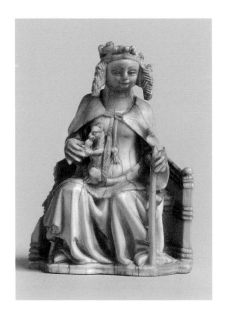 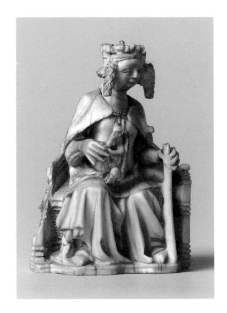

43

Ivory comb

Northern France or Flanders, *c.* 1450?
Height 152 mm, width 169 mm, depth 6.5 mm;
weight 170 g

Exhibited British Archaeological Association, March
18, 1885; sale, Sotheby's, London, July 10, 1975, lot 12

This very large comb is in excellent condition. The overall design for such
an object was standard – broader teeth for removing tangles in the hair
and/or beard; fine teeth for removing fleas and lice. Such combs could have
liturgical use, but the iconography of this example makes it clear that it
was intended for use in a domestic environment. On one side is the Castle
of Love, in which we see a fashionably dressed couple, accompanied by a
servant(?). At the right, above the castle door, another woman in a fancy
headdress gestures towards three men and three women, who approach
from the right. The first couple embrace and look at each other. Then the
narrative appears to become more complex: a magnificently clad gentle-
man advances towards the castle, accompanied by his wife, who holds his
arm. But she turns away from him and appears to offer a bunch of flowers
to a man, who follows her, but who appears by his gesture to decline the
gift. Meanwhile the third man is pursued by his wife. On the other side
we see a procession to the Fountain of Youth. The fountain is a circular
stone-built structure with a central column. In it are two naked couples,
taking the rejuvenating waters. Towards the fountain comes a four-
wheeled carriage drawn by a mule (with huge ears) and a horse. The
animals are driven by a bearded man on the horse, who cracks his whip
over the mule. In the carriage are four far from beautiful elderly women.
Ahead of the mule walk another elderly couple, the man supporting
himself on a stick.

 Two combs in the Victoria and Albert Museum are comparable. One has
the Fountain of Youth (inv. no. 231.1867) and the other is in a style very
close to that of the present comb (inv. no. 230–1867). JL

BIBLIOGRAPHY

Sale catalogue, Sotheby's, London, July 10, 1975,
lot 12
See also Longhurst 1927–29, pl. XLIX (Koechlin
nos. 1151, 1153); Gaborit-Chopin 2003, no. 251

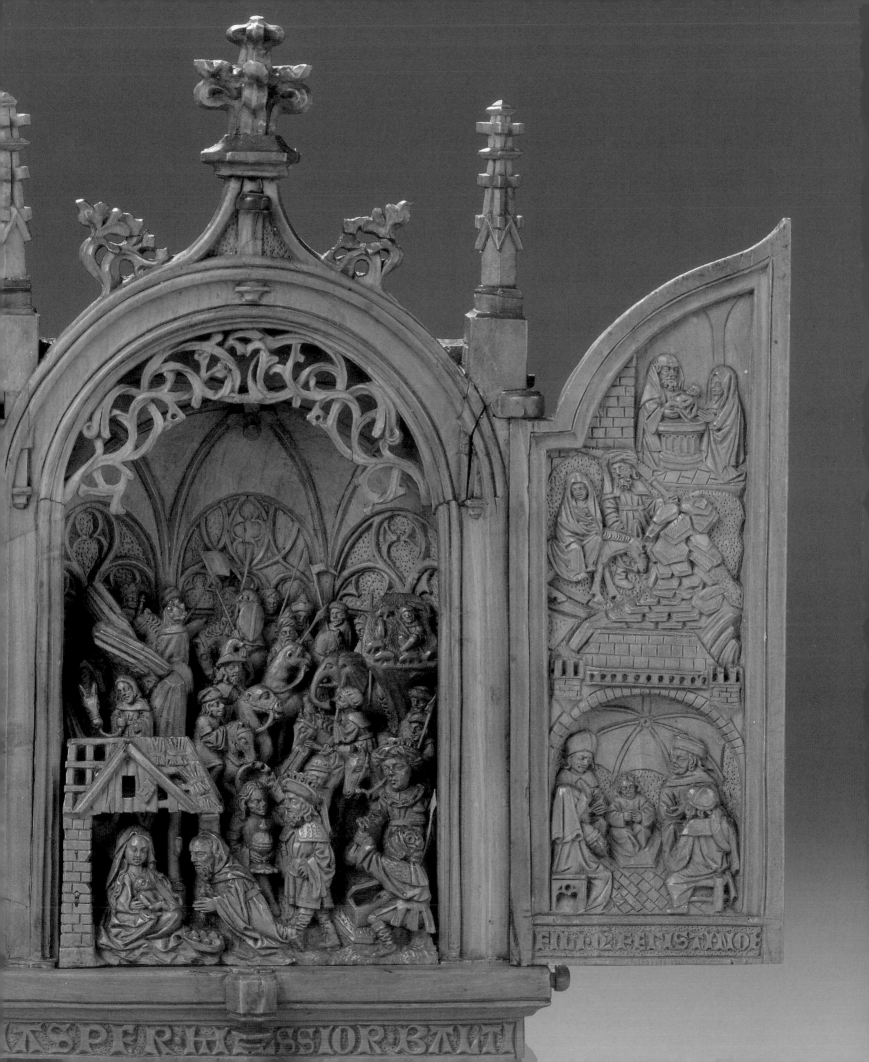

Private devotion

Images were used to strengthen faith through acts of prayer and contemplation. The spiritual life of both religious and lay people in the Middle Ages was developed both through publicly performed ritual as well as by private prayer. Beginning in monasteries and convents, this use of images spread to the lay world through active propaganda by monks and friars. Two Cistercian writers, Bernard of Clairvaux (1090–1153) and William of Saint Thierry (c. 1085–1148/9), both stressed that individual prayer, an intensely personal and private experience, was an essential part of a personal striving for perfection.

The mystical tradition that began with the Cistercians continued in the thirteenth century with the friars, both Dominican and Franciscan. Saint Francis stressed the need for service to fellow humans and also creatures. The active participation of the laity in the worship of God was encouraged both by sermons and liturgical drama. Sermons were given in the vernacular and were often accompanied by mime to initiate the faithful in the mysteries of the faith. Theatrical performance evolved from the liturgy and, at first, consisted of para-liturgical plays performed at Christmas, Easter and Whitsun which enabled the faithful to understand the mysteries of those feasts.

Lay people were taught to pray and this was achieved through the encouragement of the tertiary orders and confraternities who carried the ideals of the Franciscans and Dominicans into the outside world. Confraternities were created for the special veneration of a saint, or the Holy Sacrament – the body and blood of Christ. It was through the use of wall paintings, stained glass and illuminated manuscripts that the relationship of image with prayer came to be understood by the laity in relation to personal devotion.

The services and personal prayers contained in Books of Hours, a prayer book that followed the services of canonical hours of the day, were often illuminated with miniature pictures. These were especially important since the user may not have entirely understood the words. Books of Hours were often read in a private chapel or an inner chamber. Such rooms might well include an ivory or a painted diptych which could accompany the owner on his or her travels. Some objects were made so that the owner might wear them, such as pendants formed as triptychs to be suspended as jewellery.

Reliquary pendants acted as a focus for devotion through the relics or images of saints they contained, while prayer beads provided a discipline and structure for private prayer. Such were often treasured personal possessions, passed down through generations. JC

BIBLIOGRAPHY

James H. Marrow, *Passion Iconography in Northern European Art of the Late Middle Ages and Early Renaissance* (Kortrijk, 1979); Henk van Os, *The Art of Devotion in the Late Middle Ages in Europe 1300–1500* (London, 1994)

44

Diptych with the Annunciation and Christ as the Man of Sorrows

Peris Goncal (1380–1451) of Valencia
early 15th century
Tempera on walnut panel, 41.9 × 23 cm

Bob Haboldt & Co., New York; acquired from
Sam Fogg, London, 2002

BIBLIOGRAPHY

Unpublished
See further M. Heriard Dubreuil, 'Importance de
la peinture Valencienne autour de 1400', *Archivio
de Arte Valenciano* (1975), pp. 13–21 (artistic context
in Valencia); A. Galilea Anton, *La pintura gotica
espanola en el Museo de Bellas Artes de Bilbao* (1995),
pp. 88–103, fig. 53 (Pedro Nicolau's altarpiece);
M. Natale, *El Renacimiento Mediterraneo* (exhibition
catalogue, Valencia, 2001), pp. 153–56, no. 2
(the *Annunciation*)

This diptych was painted for personal devotion. It shows the Annunciation to the Virgin Mary on the left and Christ as the Man of Sorrows to the right. It spans the life of Christ and enables the devotee/viewer to concentrate on the gift of Christ and his painful and redemptive death. The Annunciation showed that God had found the means by which he could send his Son down to earth, and the Resurrection that Christ had by his sacrifice atoned for Original Sin and the Fall of Man.

The panel was painted in Valencia in Spain by Peris Goncal, also known as Gonzalo Perez Sarria. He was trained in the circle of Pedro Nicolau, a painter active in Valencia from 1390 to 1408. After the death of Pedro in 1408 he founded his own studio in Valencia. Very active in the first half of the fifteenth century, he painted numerous altarpieces commissioned by various towns, especially Valencia. The only surviving examples of his documented work are four fantasy portraits of the Aragonese sovereigns in the Museum of Catalan Art in Barcelona; these once formed part of a series of fifteen executed in 1427 to decorate the panelling of the council room in Valencia's city hall. Unlike those, this work was painted for personal devotion. It shows Gabriel in white, with long hair, kneeling and offering the Virgin a lily in both hands. The words *Ave Maria* are painted in white on either side of the lily. The Virgin, dressed in black with a white veil set back on her head, turns in surprise. The scene is shown in a hexagonal chamber, and the dove of the Holy Ghost hovers above the pair in the centre of the vaulting. Outside the windows of the chamber hangs a red drapery, from behind which angels stare. On the other side of the diptych a thin Christ stands in the tomb, displaying his wounds with hands resting on the rim of the sarcophagus. In front there are a hammer and chisel; behind are angels carrying the symbols of the Passion.

The closest comparisons are to a small panel attributed to Peris Goncal in the Museum of Fine Arts, Valencia, showing *The Annunciation* and dated *c.*1405–10, and the Annunciation scene in Pedro Nicolau's Altarpiece of the Seven Joys of Mary, *c.*1398, in the Bilbao Museum of Fine Arts, which has the same intense colours, graceful figures and engraved haloes set high behind the heads.

The painting shows the different artistic influences at work in Valencia at this period. From Italy are derived the depiction of the Annunciation in an open architectural setting and the position of Gabriel. The way in which the Virgin's veil is set back on her head and the placing of God the Father are derived from French fourteenth-century illuminated manuscripts. The intense colours, graceful figures and golden haloes set high behind the heads are typical of Valencian art around 1400. JC

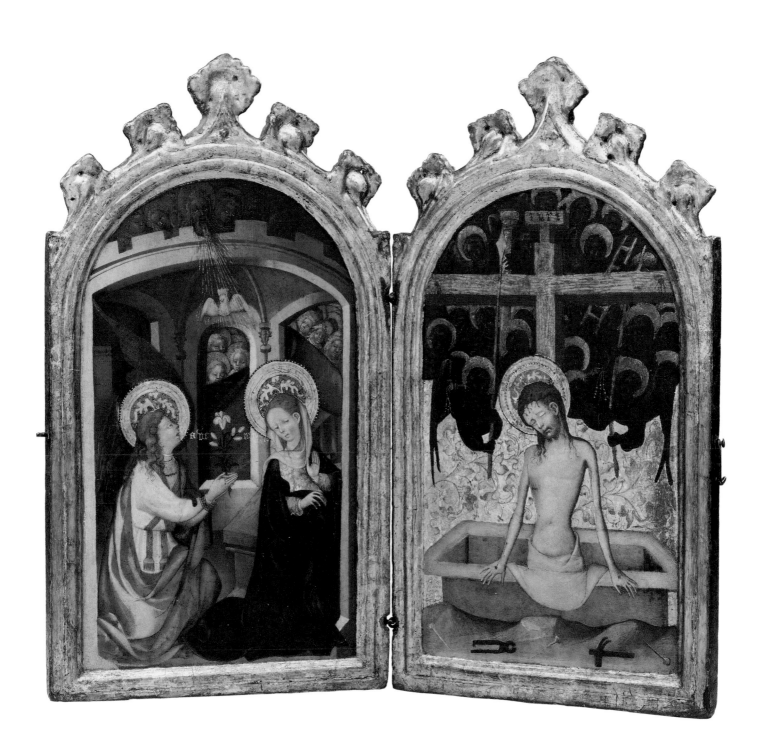

45, 46, 47

Ivory chaplet beads
(Memento mori)

45 Northern France or Flanders, *c. 1500–25*
Height 73.5 mm, width 33.2 mm, depth 37.9 mm;
weight 52 g

Sale, Sotheby's, London, December 15, 1977, lot 234

46 Germany, *c. 1520*
Height 38.9 mm, width 28.7 mm, depth 36.4 mm;
weight 23 g

Acquired from H.S. Wellby Ltd., England, 1986

47 Northern France or Flanders, *c. 1540*
Height 39.6 mm, width 34.6 mm, depth 32.5 mm;
weight 26 g

Acquired from Stephen Foster Antiques,
England, 1995

BIBLIOGRAPHY

45: sale catalogue, Sotheby's, London,
December 15, 1977, lot 234
46: unpublished
47: unpublished
See further Paul Williamson, 'Medieval Ivory
Carvings in the Wernher Collection', *Apollo*
(May 2002), pp. 17–22, esp. p. 21 and figs. 16–17
(Wernher Collection example); Rudolf Berliner,
Die Bildwerke des bayerischen Natoinalmuseums, IV,
*Die Bildwerke in Elfenbein, Knocken, Hirsch- und
Steinbockhorn* . . . (Augsburg, 1926), no. 79
(Munich example); Randall 1985, no. 367
(Baltimore example); Longhurst 1927–29,
pl. LXV (Victoria and Albert example);
Barnet 1997, no. 78 (Detroit example)

These three beads are associated with the recitation of prayers. They are drilled through the centre, and would have been strung together with others on a chain, probably of silver (compare Victoria and Albert Museum, inv. no. 281–1867; Metropolitan Museum, New York, inv. no. 17.190.306; and an example in the Wernher Collection), and hung from a belt when not in use. Probably they were each the terminals of their chains. 'Chaplet' is the generic term for such a chain of prayer beads (probably ten in total). Chaplets were associated with the recitation of short prayers, often in multiples, such as the *Paternoster* (Our Father) or *Ave Maria* (Hail Mary). Hence they are sometimes termed Paternoster cords. The other term that is regularly found in modern descriptions is 'rosary', but this is best avoided, as originally 'rosary' referred to a long and much more complex devotion to the Virgin. The three beads were intended to increase the ardour and sincerity with which the prayers were recited by reminding the devotee of his or her mortality (*memento mori*) in an unforgettable image of death and bodily decay.

The three beads take slightly different forms. No. 45 is the most grisly. Two heads are arranged back to back. One appears to be from a recent cadaver, and grimaces in a tortured expression, its bulging half-closed eyes particularly unpleasant. The other is a skull, its flesh consumed by worms, toads and lizards. The division between the two heads is marked by a narrow scroll with a text in German which crosses the forehead of the dead man, laid over what may be his shroud. It reads: *Wie der Not der biteren Todes aller noch* (As the anguish of bitter death is greater than all others). The deeply undercut carving of the details on the skull makes the object very fragile, and it shows no signs of the wear that would have resulted from frequent use. A near identical bead in Munich bears a similar inscription and the date 1522: *Der Not der biteren Tot aller nocht oberst 1522*.

No. 46 takes a different form, and has three faces. A handsome male head with curling beard and short locks of hair of classicizing appearance wears a wreath. The second facet depicts a woman with braided hair, knotted at the front. And the third is a skull with worms entering and leaving the sides of the mouth. The bead is highly polished and shows signs of much handling. It is certainly from the same workshop that produced a bead in the Walters Art Museum, Baltimore, inv. no. 367, and a string of beads in the Victoria and Albert Museum, inv. no. 281–1867. But in the Walters bead the male head carries a crown of thorns, and therefore is certainly Christ, and hence the woman must be the Virgin. The treatment of the skull, however, is virtually identical in all three, and all three have the odd feature of three leaves carved at the joins between the three heads at the top.

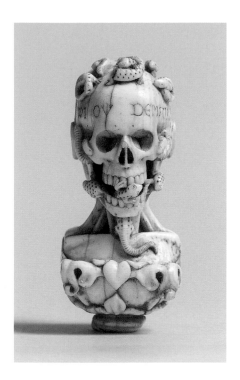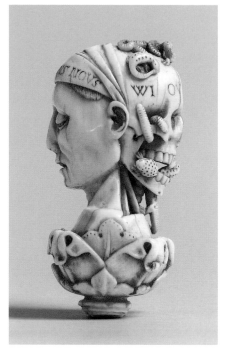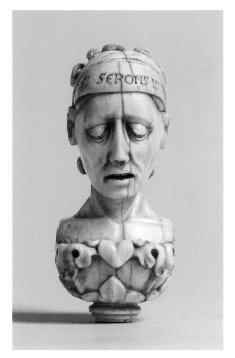

The third such bead, no. 47, shows little sign that it has been used. It is a superbly executed piece and comes from the same workshop, perhaps even from the same string, as one in the Detroit Institute of Arts. It represents a woman's face, mouth open and eyes downcast on one half of the bead (probably she has just died), and a horrific skull on the other. It is set in a leafy cup, and drilled vertically for the chain of the string of beads. This bead has an inscription running round the forehead of both figures in French: *ANSI SERONS NOUS / WI OU DEMAIN* (Thus shall we be, today or tomorrow). The letters are picked out in red and the inscription begins on the side of the recently deceased, on the headdress that is tucked behind her ears. The lizards, worms and toads that crawl through the apertures of the skull are virtually identical to those on the Detroit bead. The latter has an inscription in Latin, located on the top rim of the leafy cup in which the head is placed. It is also in red and although less carefully carved uses the same characteristic letter forms (such as the A). It reads O *MORS Q[UAM] AMARA E[ST] / MEMO[RIA] TUA* (O death, how bitter is your recollection). Again, the inscription begins on the living side of the head.

Passing a worm-eaten skull through your fingers as you recited a prayer would certainly have concentrated the mind. JL

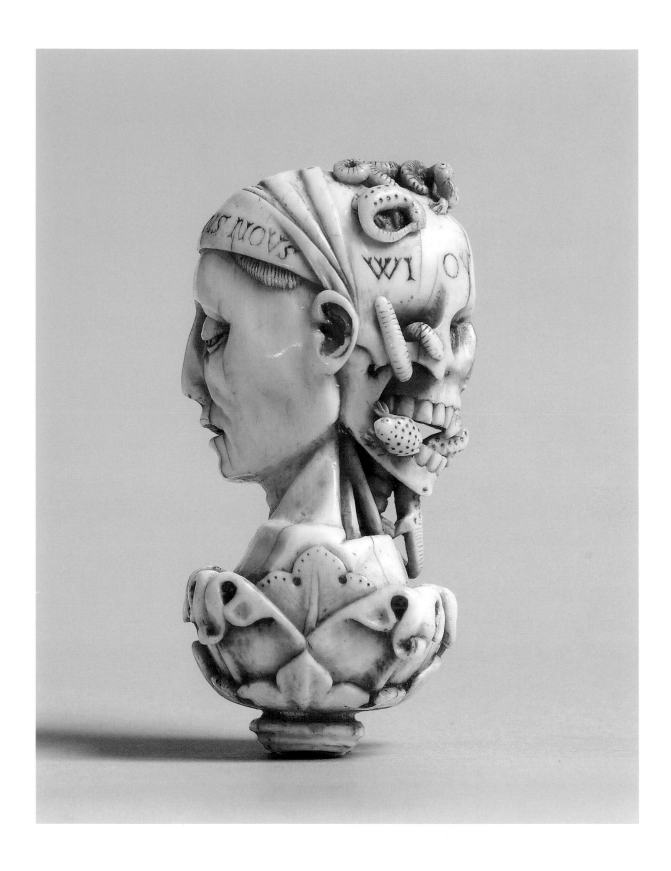

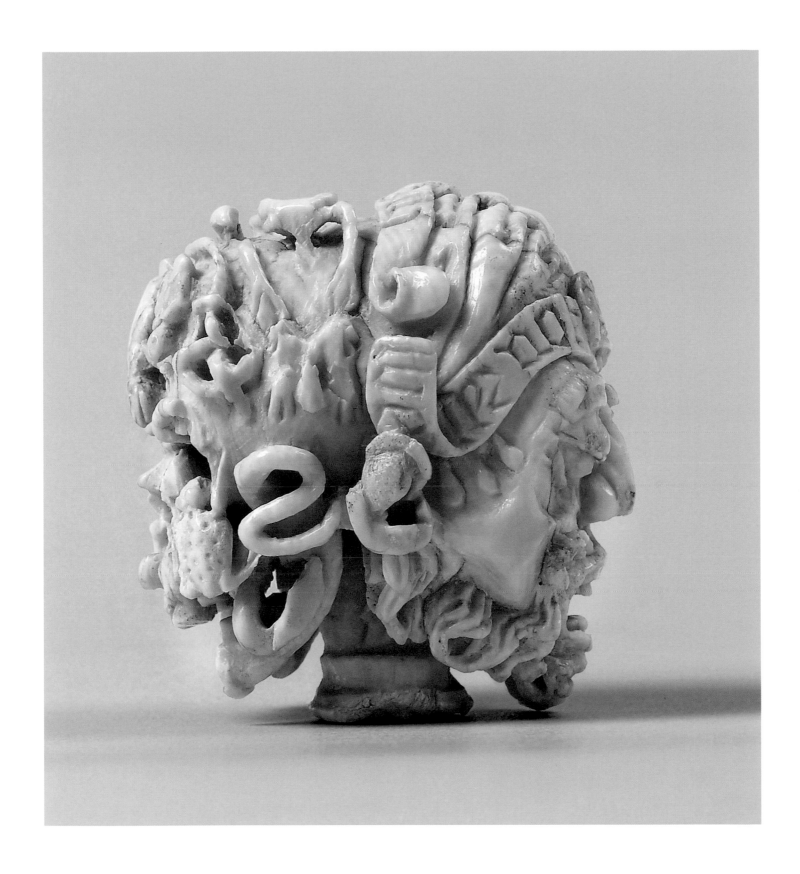

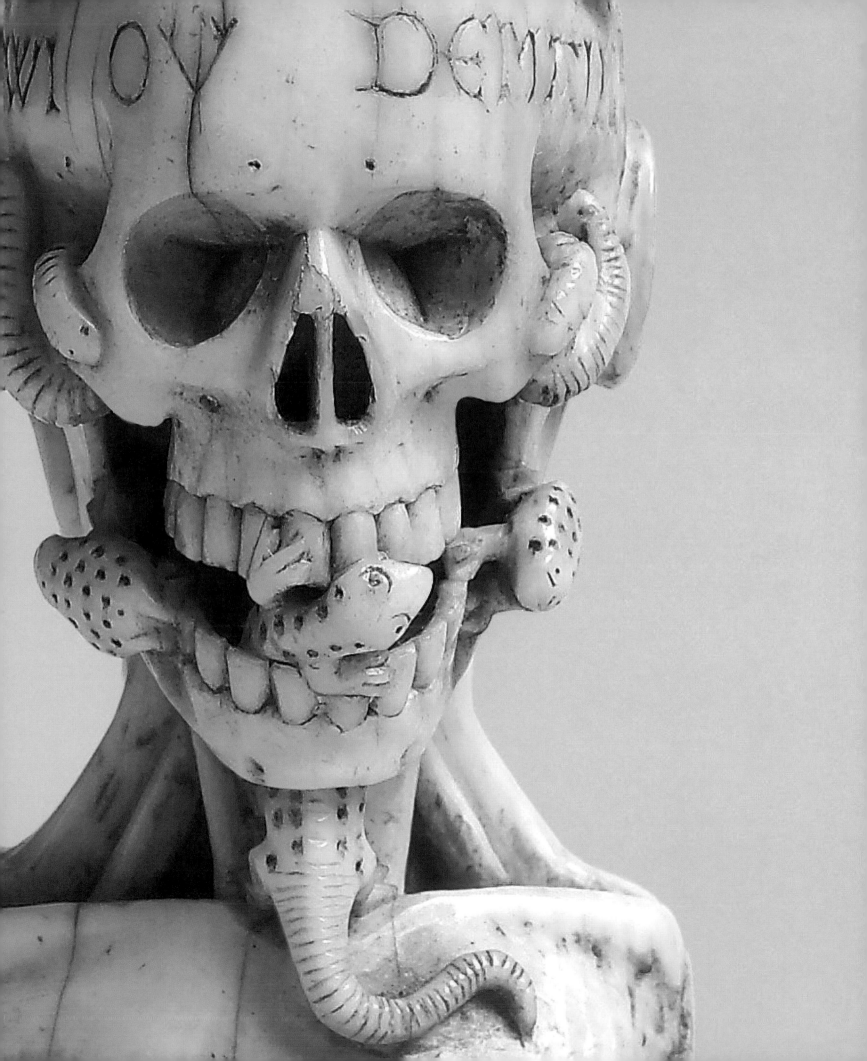

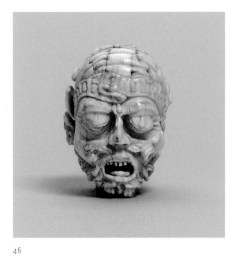

46

 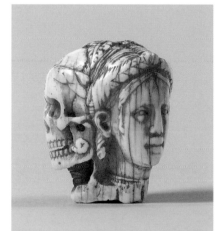

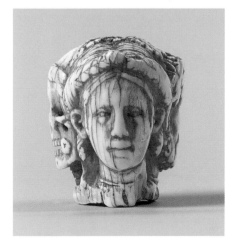 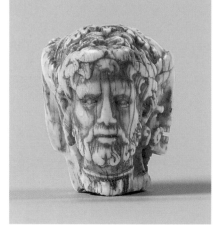

47

48, 49, 50

Three boxwood prayer beads

48 Flanders, 1515
Diameter 51 mm

Sale, Christie's, London, April 21, 1982, lot 159

49 Flanders, late 15th/early 16th century
Diameter 64 mm

Acquired from Blumka Gallery, New York, 1997

50 Flanders, late 15th/early 16th century
Height 127 mm, width 76 mm (open)

Formerly Rothschild collection France;
acquired from Blumka Gallery, New York, 1997

Small and delicately carved boxwood beads were often attached to chaplets (see nos. 45–47), and were most popular in the period from the end of the fifteenth century to about 1530. When opened, these minutely carved beads provided an aid to devotion, containing incredibly delicate and minute carvings of the figures of saints and scenes from the life and the Passion of Christ. Most boxwood prayer beads were carved in Flanders; Picardy and northern France were still known around 1600 for their ample supply of the slow-growing *buxus sempervirens*.

Such finely carved wood sculptures were regarded as wonders of human achievement and were eagerly collected. Inside some prayer beads the main scene may be hidden behind shutters. The opening of them reveals the interior or heart of the nut and allows the worshipper to enter into the episode depicted. This act of opening or closing is reminiscent of the opening or closing of a prayer book or even a large altar. The miniature format of the prayer beads emphasizes the personal and intimate character of their purpose during private worship.

Of the present three beads, no. 48 shows a *memento mori* skull which opens to reveal carvings of the Entry into Jerusalem and the Road to Calvary. The clasp has the arms of Joachim I, Margrave of Brandenburg (1499–1536), and is dated 1515. The two carvings of no. 49 show the Queen of Sheba before Solomon on his Throne and the Three Magi offering their gifts at the Epiphany. The Adoration of the Magi also appears on the triptych (see no. 51) and on a boxwood bead in the Waddesdon Bequest in the British Museum. The two carvings of prayer bead no. 50 show the Gates of Heaven and Hell and, beneath, the Trinity surrounded by angels. JC

BIBLIOGRAPHY

Unpublished
See further *A Sense of Heaven*, Frits Scholten and R. Kalkenburg (eds.) (exhibition catalogue, Henry Moore Institute, Leeds, 1999); Antje Kosegarten, 'Inkunablen der gotischen Kleinplastik in Hartholz', *Pantheon*, XXII (1964), pp. 302–21, at p. 302 (French source for boxwood); *Catalogue of the Waddesdon Bequest*, Sir Charles Hercules Read (ed.) (London, 1902), p. 115, no. 238 (Waddesdon bead)

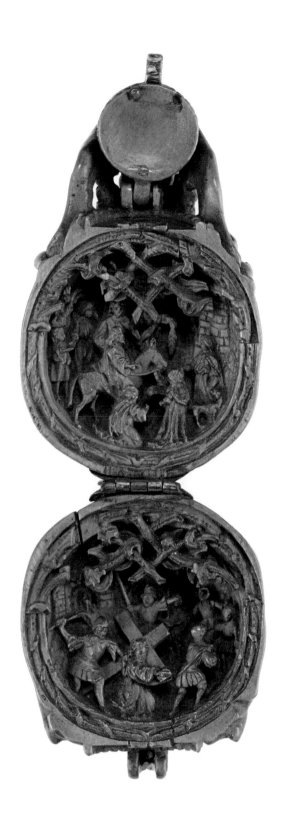

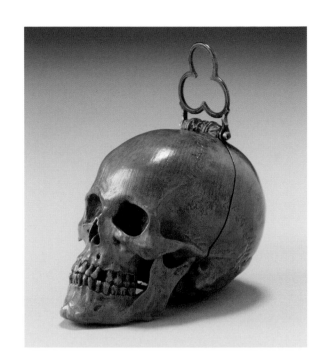

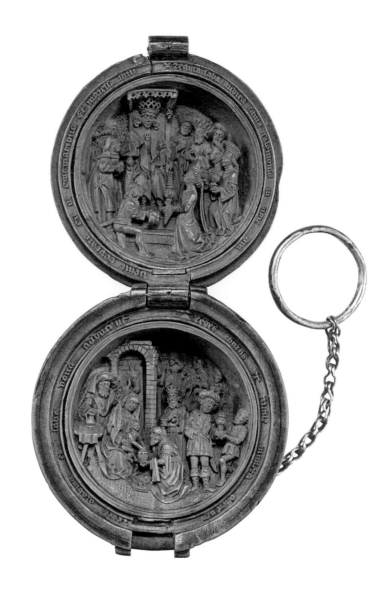

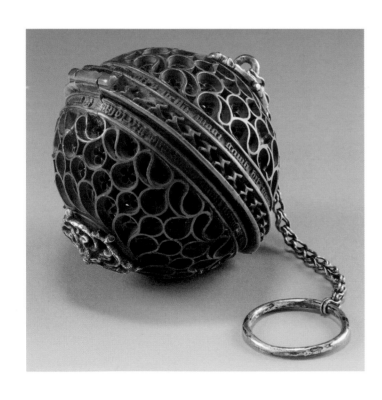

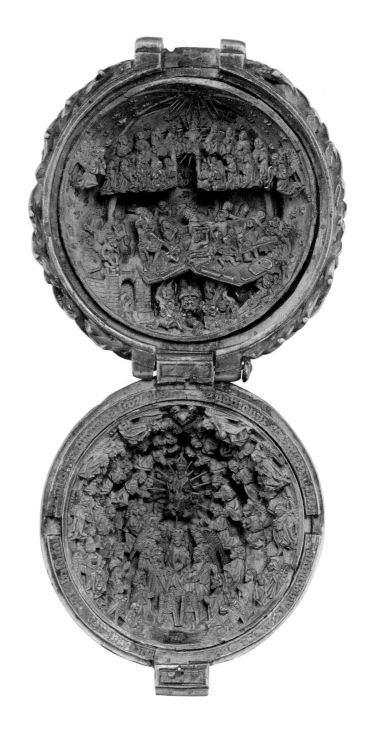

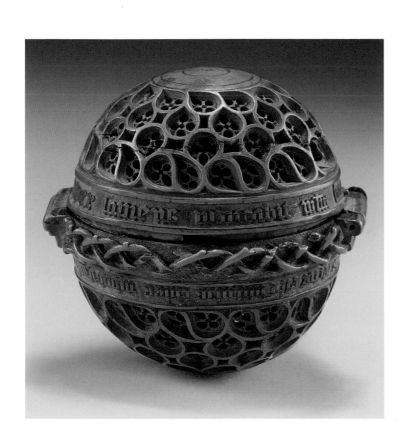

51

Miniature portable altar with the Adoration of the Magi

Northern Netherlands, c. 1510–20
Boxwood, height 15.4 cm, width 13 cm (open),
depth 4 cm

Acquired from Blumka Gallery, New York, 2000

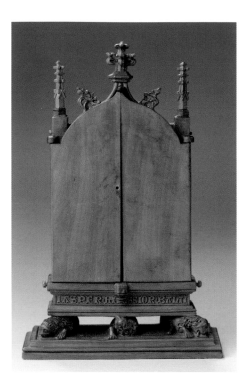

BIBLIOGRAPHY

Unpublished
See further Jaap Leeuwenberg, 'De gebedsnoot
van Eewert Jansz van Bleiswick en andere
werken van Adam Dircksz', in *Miscellanea Josef
Duverger* (Ghent, 1988), pp. 614–24; Paul
Williamson, *Netherlandish Sculpture* (London:
Victoria and Albert Museum, 2002), nos. 44 and
49; *Catalogue of the Waddesdon Bequest*, Sir Charles
Hercules Read (ed.) (London, 1902), p. 115, nos.
238 and 239; *A Sense of Heaven*, Frits Scholten and
R. Kalkenburg (eds.) (exhibition catalogue,
Henry Moore Institute, Leeds, 1999) (the
Rijksmuseum and Copenhagen examples)

This fine boxwood triptych shows, when open, in the central panel, the Adoration of the Magi. Beneath the legend reads IASPER MELSSIOR BALTISAR. (Caspar Melchior Balthazar). The panel to the left shows angels, the arrival at the inn at Bethlehem and the Nativity (with the Christ Child on the ground amidst rays of light). The legend beneath reads ET TU BETHLEE' IUD... (And thou Bethlehem, in the land of Judah, art not the least among the princes of Judah; Matthew 2: 6). On the other side is the Circumcision, the Flight into Egypt and Christ in the Temple. The legend reads FILI QI FERISTI NOS... (Son, why hast thou thus dealt with us?; Luke 2: 48).

There are at least four other related boxwood triptychs. One, now in the British Museum (Waddesdon 232), has the date 1511. Another, in the Rijksmuseum, Amsterdam, has the Virgin and Child with Saints Barbara, Catherine, Christopher and George. Christopher and George are on the back of the outside wings, so that they appear when it is closed. A third, in the Statens Museum in Copenhagen, has a Crucifixion in the middle with the Carrying of the Cross to the left and the Deposition to the right; the Entombment, underneath, is flanked by donors. The last, in the Metropolitan Museum, New York, has the Crucifixion and the Resurrection flanked by Old Testament scenes prefiguring Christ.

These triptychs have been ascribed by Jaap Leeuwenberg to the southern Netherlands and to the workshop of Adam Dirksz. He envisaged this workshop producing some eighty small objects, mainly single prayer beads, but including some complete chaplets as well. A boxwood bead in Copenhagen bears the name of the maker *Adam Theodrici*, translated by Leeuwenberg as 'Adam Dirksz.' Many of the beads have scenes of Christ carrying the cross, with similar iconography – for instance, the gates of Jerusalem have two horsemen riding out one with a mitre and the other with a turban, the leading horse bent low. Christ is usually hauled along by a soldier with a rope with the other end over his shoulder. All the Crucifixion scenes have similar details, such as the T-shaped cross, the two thieves with upright arms, one of the women around John with a turban tied under the chin with a scarf, soldiers with whorled helmets, many blowing trumpets and with shields on their backs.

Richard Marks has observed that, where heraldry can establish the patronage of these micro-carvings, it points to the North rather than the South Netherlands. A flat pendant in the British Museum (Waddesdon 239) and a pendant now in the Louvre, Paris, were both made for members of the Glymes family of Bergen op Zoom in North Brabant; a pendant in the Rijksmuseum was the property of Eewert Jansz. van Bleiswick of Delft, and a bead in the British Museum was made for Jacques de Brosele, Lord of Gouda, and his wife Ursula de Foreest (Waddesdon 238). However, this may only indicate a fashion for such pendants in the north rather than the south. Paul Williamson has pointed to more convincing parallels with the

northern rather than the southern Netherlands, particularly the tracery, the figure style and the distinctive spindly trees. As result he concludes, "It seems most likely that there were a number of different workshops, probably located in various towns through the Northern Netherlands and the Lower Rhine, that were involved in the making of the existing micro-carvings."

The importance of the flat pendant in the British Museum is that it can be dated to between 1510 and 1514, since it has two coats of arms carved integrally with the frame of the upper relief showing the Crucifixion. These arms refer to the families of the Glymes of Bergen op Zoom and Laurin, and more specifically to Dismas de Berghes (Glymes) and his wife, Marie Laurin, who are shown kneeling to the left of the cross on the relief. They married in 1510 and Dismas died in 1514, so the pendant must have been made between those dates. JC

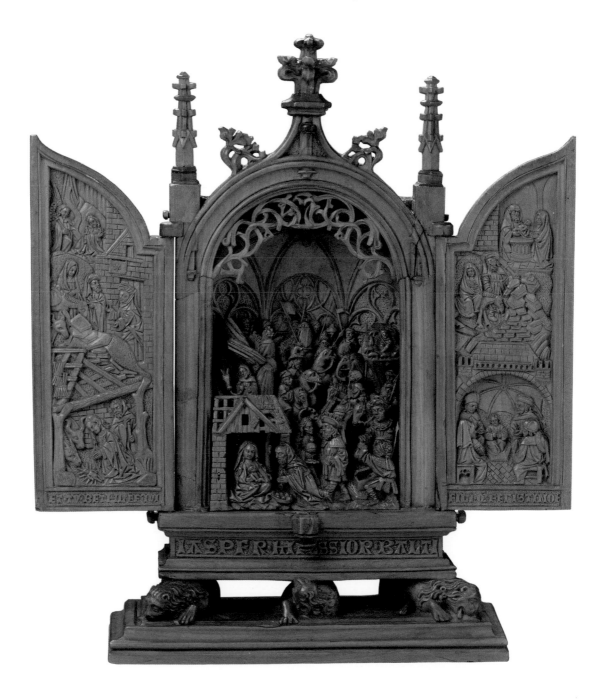

52

Two silver cruets

Poland or Germany (East Prussia), *c.* 1500
Silver-gilt, height 24.5 cm

Formerly Anselm Rothschild collection, 1866;
Blumka Gallery, New York; acquired 2000

This pair of silver cruets formed part of the liturgical plate for the celebration of the Mass. They were used for the water and the wine, since one has the letter *A* for *aqua* and the other *W* for *vinum*. They are very decoratively and elaborately made pieces of silver, and might be described as being in an exuberantly baroque style. They have spiral gadrooning (lobed decoration consisting of convex curves) of the foot and body stem, splayed cusped feet, garlands around the body of the vessel, and a curved handle and a spout in the form of a dragon's head.

Spouts with dragons' heads are known in other collections, notably a rock crystal ewer in the Rijksmuseum, Amsterdam (RBK 17101) and a pair of cruets in the Würtembergisches Landesmuseum, Baden Würtemburg, Germany (1968/773a + b). There is another vessel with a dragon's spout in the Victoria and Albert Museum, which is dated to around 1400–30. Gadrooning is seen on the New College, Oxford, salt. Dragon's head spouts occur on secular vessels, such as the Burgundian silver cruet in the British Museum.

The polylobed bases of the present pair are characteristic of Central European silverwork of the end of the fifteenth and early sixteenth century. All the distinctive features of these two cruets are parallelled in a pair of cruets once in the church of the Adoration of the Virgin in Kościan, south of Poznań in Poland. Another pair was in the church of Saint Catherine at Braniewo (Braunsberg), but disappeared in 1945. Both these pairs have the distinctive openwork skirts. The lower part of the gilding of the wine container is a slightly different to that of the water container, and the quality of the engraving suggests that it may have been replaced in the second half of the sixteenth century and re-gilded at that time. There is a shield held by angels which also appears on the base, but the arms have not been identified. The object may have been made for stock and then the arms added later. Also in the decorative scheme of the wine cruet are the initials *IMBA*. These have not been identified, but might indicate the place of production. JC

BIBLIOGRAPHY

J.M. Fritz, *Goldschmiedekunst der Gotik in Mitteleuropa* (1982), pls. 642 (Wurttemburg), 648 (Victoria and Albert); F. Shestag, *Katalog der Kunstsammlung der Freiherrn Anselm von Rothschild* (Vienna, 1866), p. 28, no. 192

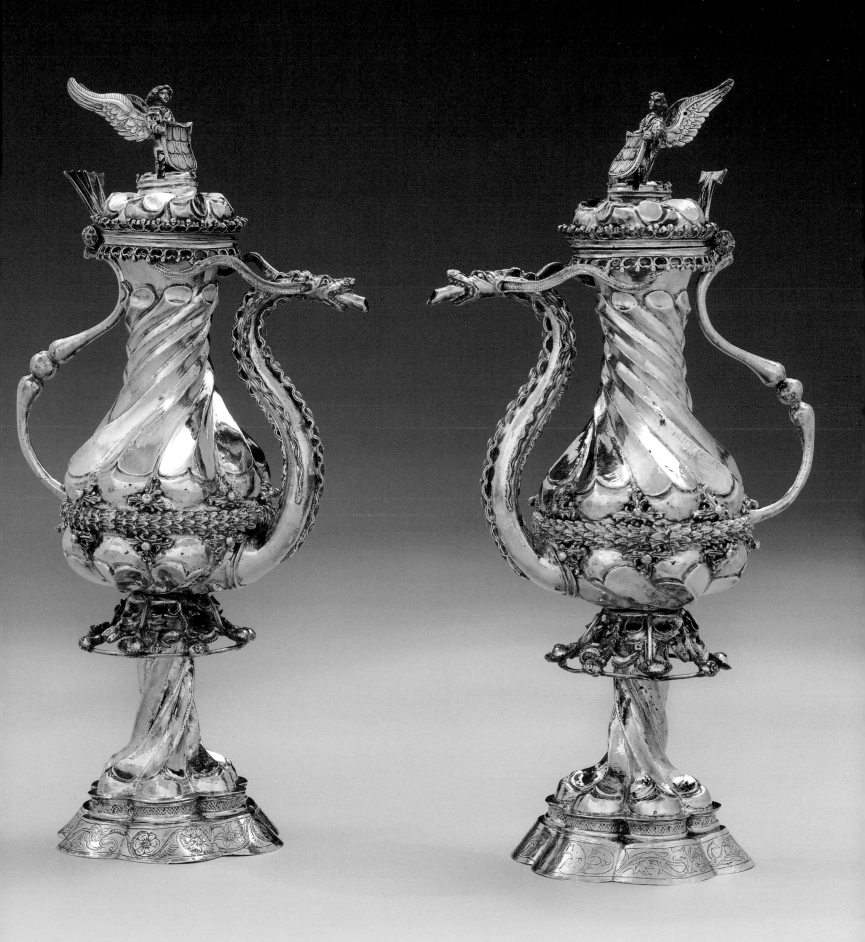

Fragments of major works

53

Two large painted carved oak ceiling bosses

England, 15th century
Diameter of each 57 cm

Sale, Sotheby's, London, October 29, 2003,
lot 101; acquired from Sam Fogg, London, 2005

From their size and exceptional quality, these two magnificent carved oak ceiling-bosses must have come from a major building, most probably a major monastic house. They decorated the joints of the beams, to which there were attached by pegs.

One shows a yale, a mythical goat-like creature with two horns, which has the body of an antelope with a lion's tail. Its particular property was the ability to swivel each horn independently, which gave it a great advantage in defending itself. This example has lost the end of one of the horns, possibly because it was projecting too far outwards. The yale is trapped with its horns in a bush. The creature was adopted as a supporter of the arms of John, Duke of Bedford (died 1435), brother of Henry V, who subsequently used it as his own badge. John died childless in 1435, and in 1443 his earldom of Kendal was granted to Sir John Beaufort. The yale was then used as a badge by the Beaufort family, of whom the most distinguished was Lady Margaret Beaufort, mother of Henry VII. The other boss is carved with a four-petal rose in the midst of twisting foliage. Both bosses are hemispherical in shape, though the rose boss is higher and the carving is more undercut. The rose boss has a mark of the number three incised on the back. The rose may be either a red rose for Lancaster or a white one for York.

The use of naturalistic leaves, the deep carving and the shape of these bosses suggest a date in the late fifteenth century. Yales are found on pew ends in fifteenth-century East Anglia, an area notable for the extraordinary dexterity of its woodcarving. A very fine series of wooden bosses, pegged to arches, is to be found at Salle church, Norfolk. The projections around the edge of these two bosses may be parallelled on 'poppy-head' bosses at the top of bench ends such as those at Saint Nicholas, Kings Lynn, and also on the wooden crosier found in Saint Stephen's Chapel, Westminster, that may have belonged to Bishop Lyndewode (now British Museum). JC

BIBLIOGRAPHY

Unpublished
See further E.S. Prior and A. Gardner, *An Account of Medieval Figure-sculpture in England* (Cambridge, 1912); C.J.P. Cave, *English Roof Bosses* (Cambridge, 1948); H. Stanford London, 'Minor Monsters: the Yale', *The Coat of Arms*, III (1954), pp. 90–93

54

Reliquary of Saint Christopher

Germany, probably Augsburg, made for the
monastery of Kaisheim, Germany, dated 1493
Silver, height 47 cm

Given to the monastery in 1497; sold after
secularization in 1802; Soltykoff collection; sold to
the Wernher Collection, 1861; sold Christie's, London,
July 5, 2000, lot 53

BIBLIOGRAPHY

J.M. Fritz, *Goldschmiedekunst der Gotik in
Mitteleuropa* (Munich, 1982), pls. 729 and 731;
Works of Art from the Wernher Collection (sale
catalogue, Christie's, London, July 5, 2000,
lot 53): *Holbein in England* (exhibition catalogue,
Tate Britain, London, 2004), p. 44, no. 6;
Jeffrey Chipps Smith, *The Art of the Goldsmith in
Late Fifteenth-Century Germany* (exhibition
catalogue, Fort Worth, 2006)
See also *Hans Holbein der Ältere und die Kunst der
Spätgotik* (exhibition catalogue, Augsburg, 1965);
Jacopo de Voragine, *The Golden Legend*, trans.
William Granger Ryan (Princeton, 1993), II,
pp. 10–14 (the story of Saint Christopher);
The Way to Heaven: Relic Veneration in the Middle Ages,
Henk van Os (ed.) (The Hague, 2000),
pls. 154–56 (the Osnabruck altar)

This statue of Saint Christopher is one of the most striking and moving
depictions of the saint walking across a turbulent river. Staggering under
the weight of the tiny Christ, Christopher is bowed down with his cloak
streaming out in the wind behind him. He grasps his huge staff with
his left hand and looks up at the silver naked Christ on his shoulder. The
aged face of the saint, with tangled gilt beard, is an expressive study of
weariness and apprehension.

Saint Christopher was the patron saint of pilgrims and travellers.
He was a giant who wished to put his strength at the service of the most
powerful king on earth. He was advised to serve Christ by carrying
pilgrims on his back across a swift-running river. One night a child
appeared and asked Christopher to carry him across. The giant set out
but only reached the other side with the greatest difficulty, for the Child,
"who bore the whole weight of the whole world on his shoulders," grew
heavier and heavier at each step. It was only the following morning that
Christopher realized who his passenger had been, when the staff which
the Child had told him to plant in the ground blossomed as a date palm.

Saint Christopher had an important power of protection, since it was
believed that anyone who saw an image of Saint Christopher would not
die of a sudden death that day. Therefore there were many images of
Saint Christopher; sometimes they were wall paintings, sometimes small
portable pilgrim signs or souvenirs, and sometimes silver statues.

The Cistercian abbey church in Kaisheim, near Donauwörth, once
possessed three silver statues, all of which survived the secularization
of the German monasteries and their holdings around 1803. They were
a *Virgin and Child* (1482) now in Berlin, a *Saint Sebastian* (1497) in the Victoria
and Albert Museum, London, and the present statue. They show late
Gothic German silver sculpture at its finest. The two saints are posed more
dramatically than the Virgin and Child. In the church of Osnabruck there
was a gilt *Virgin and Child* on the altar flanked by twelve *Apostles*, and it may
be that all three Kaisheim statues originally graced the altar of the
monastery church, with the two saints flanking the Virgin and Child.

The top of the hexagonal base is engraved with a Latin inscription
which reads: 'Saint Christopher, your virtues are so strong, Georg Abbot
of Kaiserheim, vassal of God (?), that those who see you in the morning
can smile at night. 1493.' On the reliquary are the initials A.M.K which
stand for Abraham Mendlin, Kaisheim. On a lower band are engraved the
initials F H Z S for Friedrich Herzog zu Sachsen and the names CHRISTOF
HERZOG (Christopher, Duke). So Abraham Mendlin, custodian of the
abbey of Kaisheim, commissioned the *Saint Christopher* on behalf of George,
the abbot of the monastery, and Frederick the Wise, Elector of Saxony,
donated funds for its creation. A possible source for the design of the figure
is a roundel of the saint engraved by the Master HS, who was working in
Nuremberg around 1500 and himself copied masters such as Schongauer
and Lucas Cranach the Elder. J C

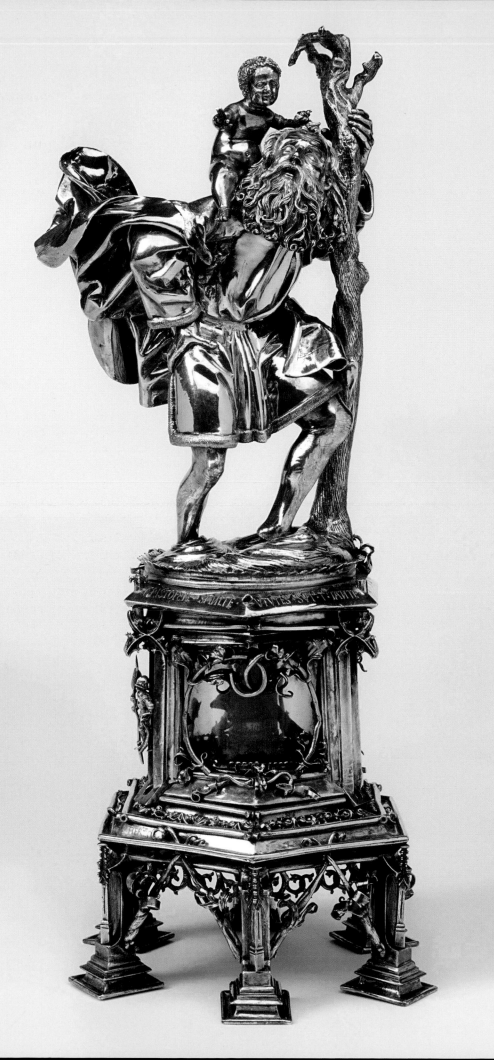

AUTHORS

Professor John Lowden (JL) teaches at The Courtauld Institute of Art, London.

John Cherry (JC) was formerly Keeper of Medieval and Later Antiquities at the British Museum, London.

WORKS CITED IN ABBREVIATED FORM IN THE TEXT

Peter Barnet (ed.), *Images in Ivory: Precious Objects of the Gothic Age* (exhibition catalogue, Detroit Institute of Arts, 1997)

Danielle Gaborit-Chopin, *Ivoires médiévaux, Ve – XVe siècle* (Paris: Musée du Louvre, 2003)

M.H. Longhurst, *Catalogue of Carvings in Ivory*, 2 vols. (London: Victoria and Albert Museum, 1927–29)

Raymond Koechlin, *Les Ivoires gothiques français*, 3 vols. (Paris, 1924)

Richard H. Randall, *Masterpieces of Ivory from the Walters Art Gallery* (New York, 1985)

Richard H. Randall, *The Golden Age of Ivory: Gothic Carvings in North American Collections* (New York, 1993)

F. Steenbock, *Die kirchliche Prachteinband im frühen Mittelalter* (Berlin, 1965)

Paul Williamson, *The Thyssen-Bornemisza Collection: Medieval Sculpture and Works of Art* (London, 1987)

ACKNOWLEDGEMENTS

Special thanks for their assistance in the preparation of this volume are due to: Gemma Allen, Anastasia Apostolou, Barbara Butts, Christina Corsiglia, Lisa Ellis, Christine Kralik

FRONT COVER

Ivory statue of the Virgin and Child (detail of no. 18)

BACK COVER

The Malmesbury Châsse (no. 8)

PHOTOGRAPHY

The photographs of the objects were taken by
Matt Pia, London, UK
Michael Cullen, Peterborough, Ontario

First published November 2008 by Skylet Publishing in association with the Art Gallery of Ontario

ISBN 9781903470 80 0
 9781903470 86 2 (5 volume boxed set)

Produced by Paul Holberton publishing, London
www.paul-holberton.net

Designed by Philip Lewis

Origination and printing by e-graphic, Verona, Italy